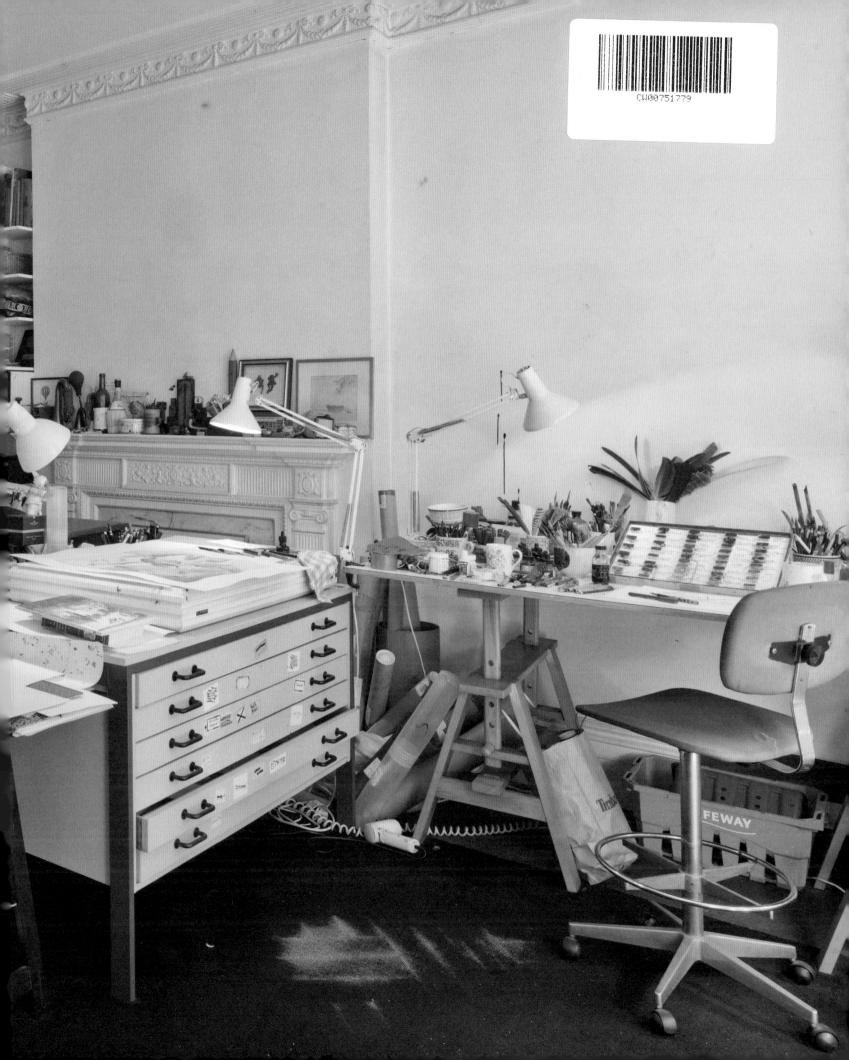

Quentin Blake *Beyond the Page*

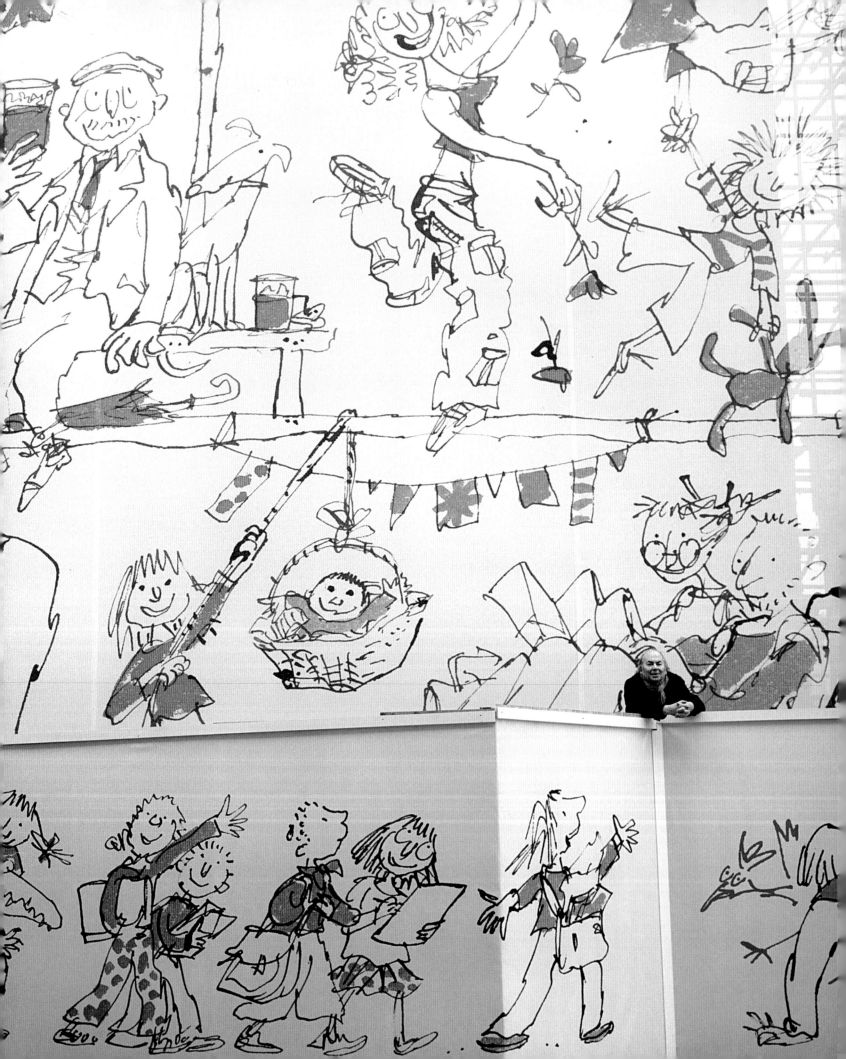

Quentin Blake *Beyond the Page*

Tate Publishing

First published 2012 by order of the Tate Trustees
by Tate Publishing, a division of Tate Enterprises Ltd,
Millbank, London SW1P 4RG
www.tate.org.uk/publishing

A catalogue record for this book is available
from the British Library
ISBN 978 1 84976 083 6

Distributed in the United States and Canada
by ABRAMS, New York
Library of Congress Control Number: 2012947076

Designed by Atelier Works
Colour reproduction by DL Imaging, London
Printed by Toppan Leefung in China

Jacket artwork by Quentin Blake, 2012
Jacket back flap: photo of Quentin Blake in front
of the Petit Palais entrance gates
Endpapers: Quentin Blake's studio photographed by
Andrew Dunkley and Marcus Leith, Tate Photography
Page 2: Quentin Blake leaning over the hoardings
at St Pancras station

Credits

Andersen Press 62
Argent 2, 184
Atlantic 110
Alexis Burgess 208–9
The Book Bus 188, 190
Chris Beetles Gallery, London 10
Circonflexe 150–1
Egmont 76–83, 164
The Folio Society 147, 158–9
Editions Gallimard 148–9, 155–7
Harper Collins 70–5, 112
Jonathan Cape/The Random House Group
 8, 11, 53–6, 100–1, 111, 152 (bottom)
Linda Kitson 200–1, 203–4, 241
MacLehose Press 154 (right)
Mondadori 173–6
The National Gallery, London 180
Osborne & Little Ltd 142¬–5
Pavilion/Anova Books Group 64–5
Puffin Books 90, 93–5, 99
Random House 57, 58–9, 60–1
Red Fox/The Random House Group 63
Rue du Monde 152 (top)
Shortlist Media Ltd 108–9
Walker 66–9, 84–9, 154 (left)

Photo credits

Ross Ashton 192
Michael Walker/Troika 2, 184–5
Tate Photography/Andrew Dunkley and
 Marcus Leith 95, 98

For
GK
and for
CZ

Thank you

Each of the projects described in this book has at its centre something drawn by hand.
At the same time there isn't one that came to fruition as anything but a collaboration, and
consequently I am aware of a huge debt of gratitude: to everyone mentioned by name in the
text, and to many – editors, publishers, curators, writers – who alas are not. The publishers are
all acknowledged at the end of this book, but I would like to salute here not only Walker Books
and the Andersen Press for their enterprise, but most significantly Jonathan Cape, Puffin Books,
Gallimard Jeunesse and the Folio Society, with whom my association goes back thirty years
and more. Individuals need to be mentioned too: Michael Wilson of the National Gallery; Gilles
Chazal of the Petit Palais; Stephen Barnham and Dr Nick Rhodes of the Nightingale Project.
And not least Ghislaine Kenyon and Claudia Zeff: both of them have been enormously generous
comrades and collaborators and I am vividly aware of my debt to them for their time, energy, initiative
and counsel.

My thanks are also due to the team in my office, which has included Colleen Collier, and
Catherine Gray, but is now Vicki Bingham, Nikki Mansergh, Cecilia Milanesi and Liz Williams.
It is their complementary talents, their dedication and their enthusiasm that are essential in
keeping this show on the road.

I would also like to take this opportunity of expressing my admiration for the skill and dedication
of the officers and trustees of the House of Illustration, a project that I am proud to be part
of, and which we all hope will soon establish itself as our national centre and home for the art
of illustration.

A heartfelt thankyou is also due to Roger Thorp and Nicola Bion of Tate Publishing for their
support, expertise and understanding; and to Quentin Newark and Daniela Meloni for their
brilliant work on the design of this book.

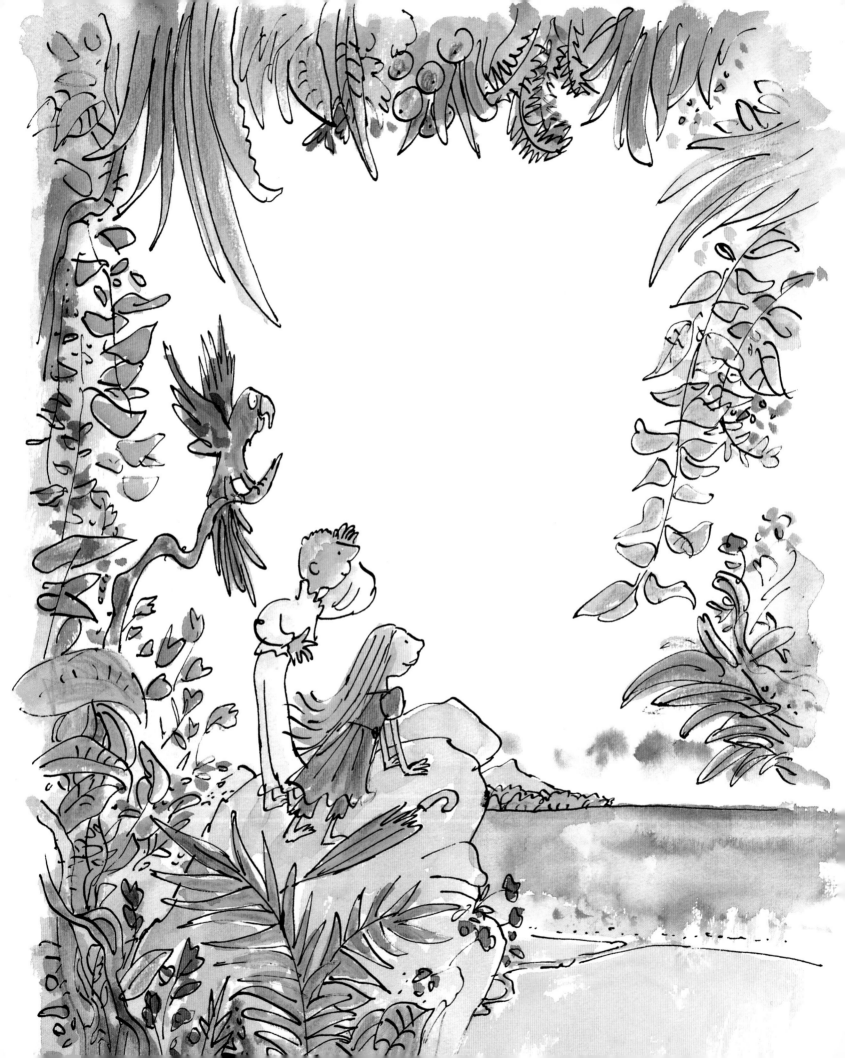

Onto the Wall

In 2001 I put my name to a book called *Words and Pictures*. The illustrations in it were all examples of my work over the previous fifty years. However, they were not arranged chronologically; I used them to accompany a sequence of observations about various aspects of illustration as I had experienced it, particularly in books: of different techniques of drawing; of the choice and distribution of illustration through a text; of the adaptation of style to the mood of an individual text; the interpretation of characters; the sequence of pages; the use of colour, and so on.

This book is not that sort of survey. It is concerned most of the time with the work that I have carried out (with a few backward glances) since the publication of that earlier book in 2000. It includes work from books, magazines and other similar publications, but its main interest for me, and I hope for the reader, is the move on to the walls of galleries, museums, hospitals and other public spaces.

The simplest way for an illustration to get on to a wall, of course, is for it to be framed and put it into an exhibition. This is what has been happening too many of my illustrations over the past fifteen years or so at the Chris Beetles Gallery in Ryder Street, St James's. I can remember how I first came to find myself there. Roald Dahl's book of reminiscences, *My Year*, needed a different kind of illustration from anything else I had done for his works. Originally written as a series of introductions to the months of the year, in the *Roald Dahl Diary*, these essays about life in the country were subsequently brought together as a book. No call for the familiar caricature or exaggeration here; what was needed was a series of atmospheric pictures that might almost suggest that they were done in front of the subject itself. In finding the suitable views and moments, establishing the right mood of observation and reminiscence, I did many more pictures

Cover illustration for 'Jack and Nancy'

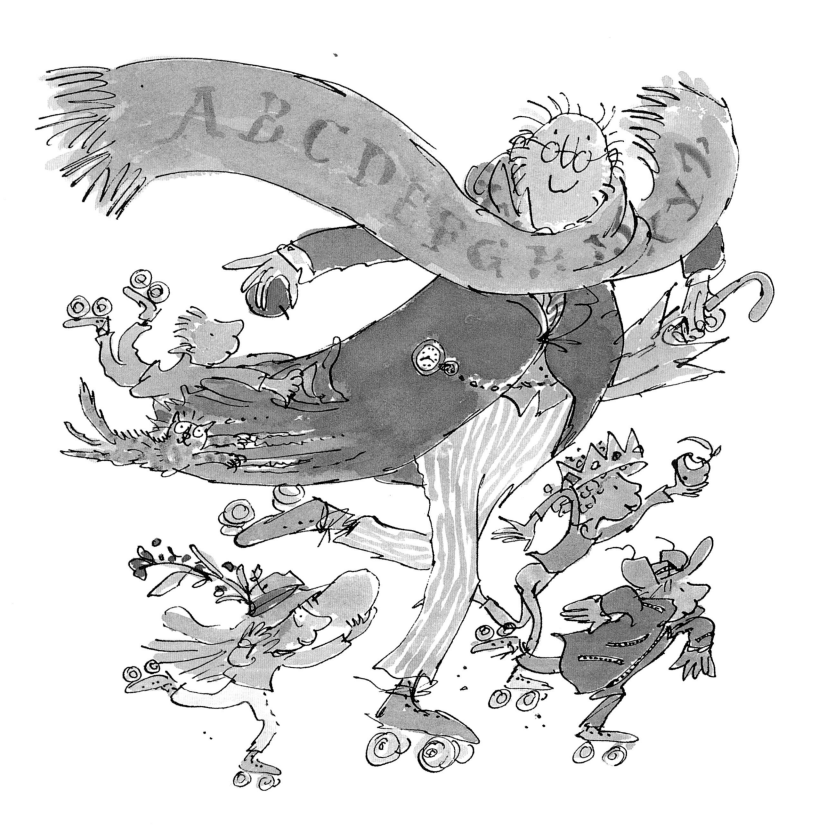

Cover illustration for Chris Beetles Catalogue

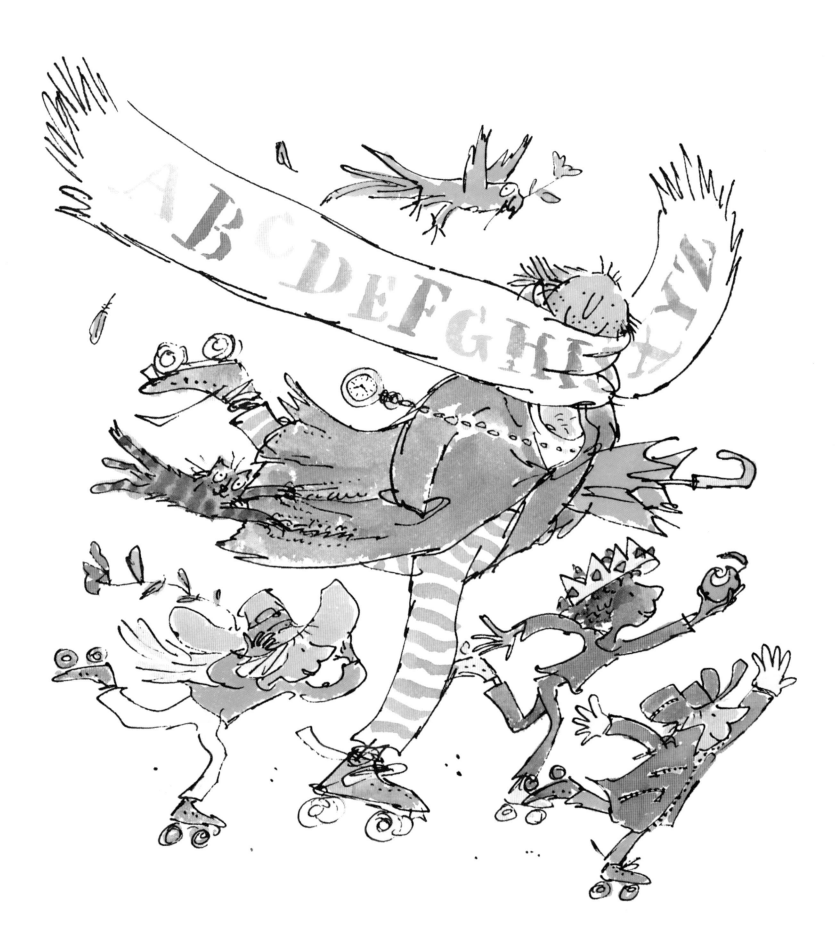

Cover illustration for 'Quentin Blake's ABC'

than were needed – sometimes several on the same theme. As I had been involved with the Roald Dahl Foundation since its inception, I thought it might be useful to sell these extra works to benefit that charity and so I found myself in the gallery talking to Chris Beetles himself. He immediately accepted the notion but went on to suggest that I might like to extend the venture to include some of my other works for my own benefit. But how many works would he need? 'About a hundred and fifty.'

Initially I found it hard to regard it as a possibility, but I delved in portfolios and plan-chest drawers until I had amassed a sufficient number of items for a show. I have better information for a subsequent show in 1996, and the substantial catalogue which Chris Beetles produced for the occasion is in front of me now. I can see, turning the pages, that by far the majority of illustrations are alternative versions of pictures which appear in published books. I see also that in a couple of introductory pages I explained how that came about. Unpublished drawings are in effect of two kinds: demonstrable failures, often only a quarter advanced, which go into the wastepaper basket; and works that might be thought of as contenders. When one version is finished, even one that would perfectly well pass muster, I may set about another in the hope of drawing the thing with more panache, or coming upon some minor felicity. Sometimes this works; sometimes the second version tells me what was right about the first. None of this is a matter of policy – it is instinctive and it would take an effort of will not to do it. It incidentally and conveniently supplies work for sale in exhibitions, and it is clear from the 1996 catalogue that most of the works are of this kind or (another consideration) of suitable quality but which didn't fit into the final layout of the book. And just from time to time seeing an illustration on the gallery wall I have had the suspicion: 'Did I choose the right one?'

Miranda and her Performing Dog

A diagrammatic example is the drawing for the cover of *Quentin Blake's ABC* with its group of rollerskaters, the alternative version of which appeared in the cover of Chris Beetles's catalogue, and you can decide for yourself if I made the right choice.

All these closely book-related drawings were joined by others produced in the studio as small explorations with no particular end in view beyond a general sense that they might appear in an exhibition one day if I liked them enough. Here, for instance, are 'magic pencil' drawings of girls with potted plants, and other energetic young women with their dogs.

But perhaps the most clear-cut demonstration of this effect has just occurred, a week or two before I write these words. As part of a general reissue of picturebooks that I published in the 1970s and 1980s, there was a call from the publishers for scans of the originals of *Jack and Nancy*. We have all of them except, somehow or other, the artwork for the cover itself, which had obviously gone astray before our present system of archiving had been put in place. However, I happened to be able to put my hand on a black-and-white version, which I suppose I had thought better of and not taken into colour at the time, and it solved the problem. So the cover illustration of *Jack and Nancy* now on sale was drawn in 1970 and coloured in 2011, and is almost, I think, indistinguishable from the first.

The Chris Beetles exhibitions have continued, I am pleased to say, as part of his annual major illustration show, but the possibilities of walls were significantly extended by two retrospective shows, one following hard on the heels of the other. The first, *Quentin Blake: Fifty Years of Illustration* (of course, it doesn't seem as long as that) took place in Somerset House in the temporary exhibition spaces of what was then the Gilbert Collection. The visitor entered between

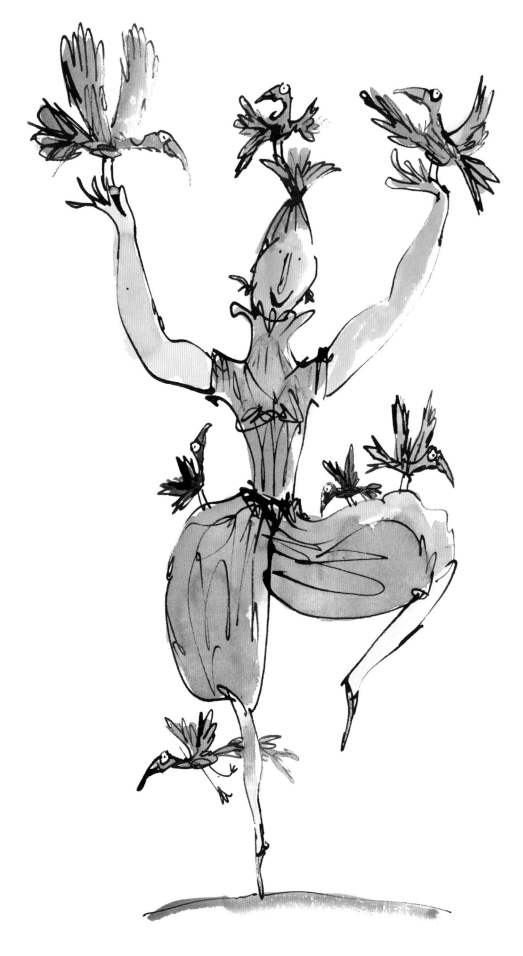

The Bird Lady

two hangings, enlargements of two facing pages of a book; and among the framed works on show was a black-and-white drawing converted into a mural by being enlarged and transferred to a white wall by the skill of a professional signwriter – a technique that came in very useful later at the Unicorn Theatre.

The exhibition had a second outing, to Aberdeen Art Gallery. The content was as before, though in an arrangement adapted to the gallery spaces. What was striking for me was the level of enthusiasm shown for the event. I confess that to go on the first day and find a red flag bearing my signature flying over the façade of the building was an encouraging start. The plan was also that for the first hour or so I should wander at will through the exhibition, after which I would be available to sign books. However, even before the doors were open the guardians of the front of house were upon us exclaiming that there were already crowds waiting to get in, with the result that I started to sign immediately and went on non-stop till lunchtime. I was taken out then for some relaxed refreshment within sight of the sea, with the reassurance that things would have quietened down by the afternoon. When we returned, however, a handful of minutes late, we found facing us a queue of young and old bearing books and reaching right round the gallery. They *applauded*. I signed for the rest of the afternoon.

The second exhibition was at Dulwich Picture Gallery and to distinguish it from the earlier one and to acknowledge the season it was called *Quentin Blake at Christmas*. I felt I was fortunate on a number of scores, Dulwich being in itself such an interesting gallery and having such an enterprising programme of exhibitions, and that I should follow on from shows of the likes of Arthur Rackham and Beatrix Potter.

2009

Magic Pencil flowers

2009

My exhibition was divided into five sections to look at different aspects of work, rather than any chronological sequence: Welcome to Birdland; Artists and Angels; Not for Publication; Cross Channel; and Christmas Garland. Two of the rooms were lofty, allowing for fifteen-foot-long banners of ascending birds (from John Yeoman's *Up With Birds*) and a collection of angels rejoicing on assorted musical instruments.

Another later exhibition at the Kelvingrove Museum in Scotland contained fewer works but also offered five opportunities for banners. They included a reading tree, a writing tree, a drawing tree and, for reasons not immediately apparent except to take full advantage of the vertical format, two banners devoted to, respectively, an acrobatic family of all ages and another family rising on personal helicopter devices. Whatever situations my characters had managed to get themselves into, at least I think I could now regard my pictures as unmistakably on the wall.

Banner of angels for Dulwich

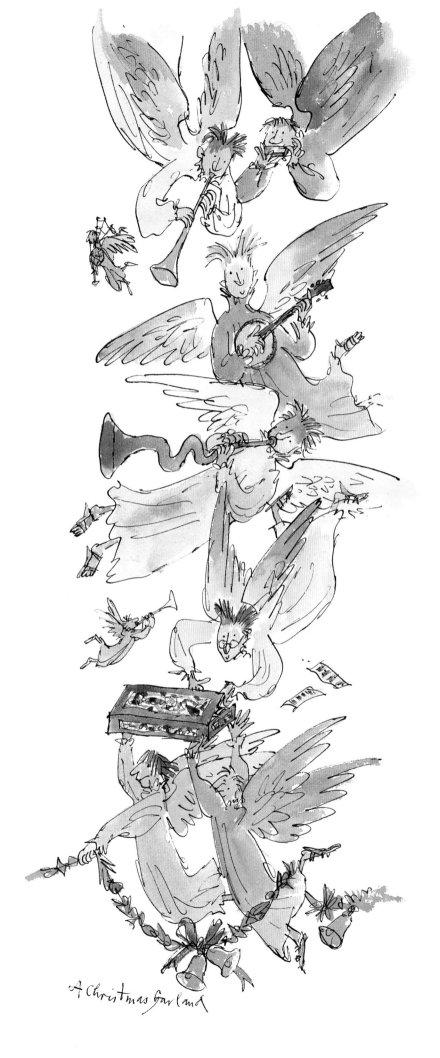

A Christmas Garland

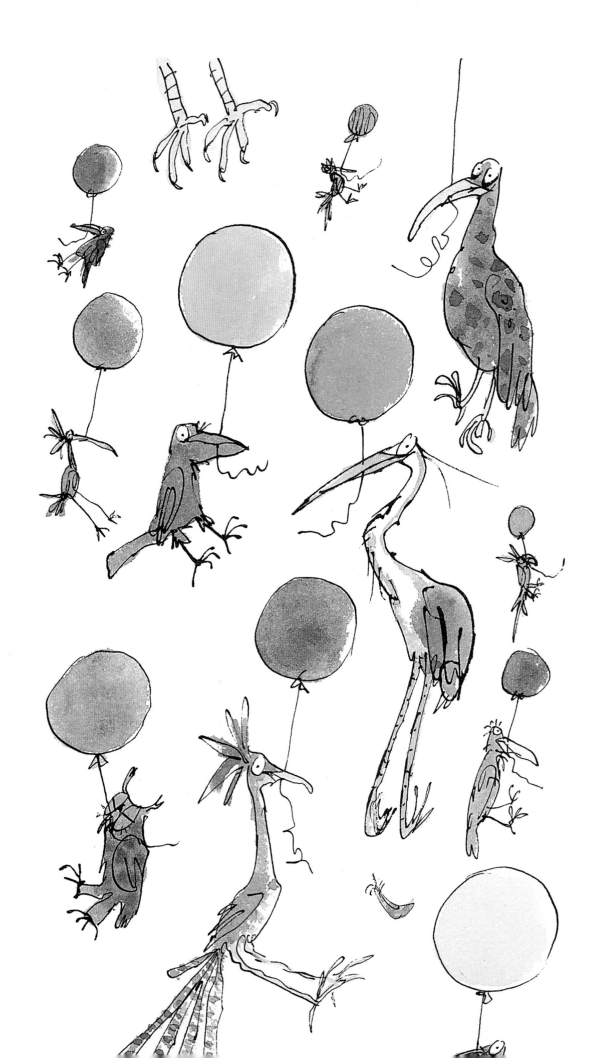

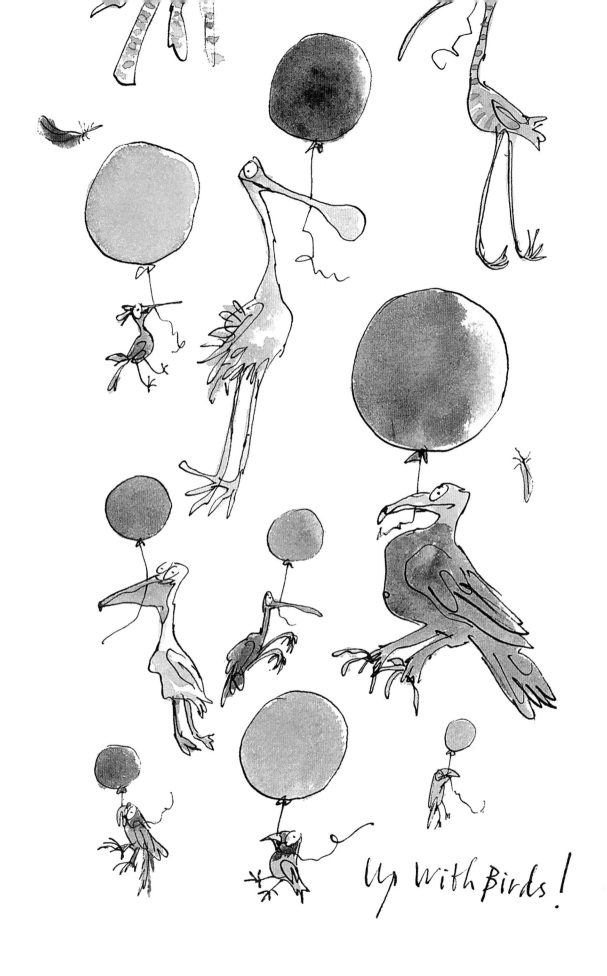

Banner of birds for Dulwich

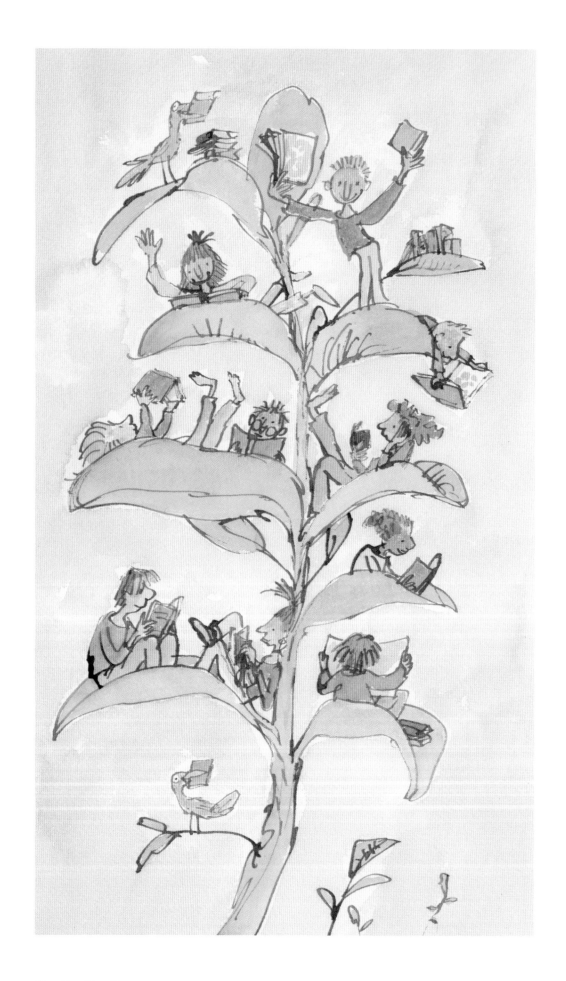

Reading Tree Banner

Drawing Tree Banner

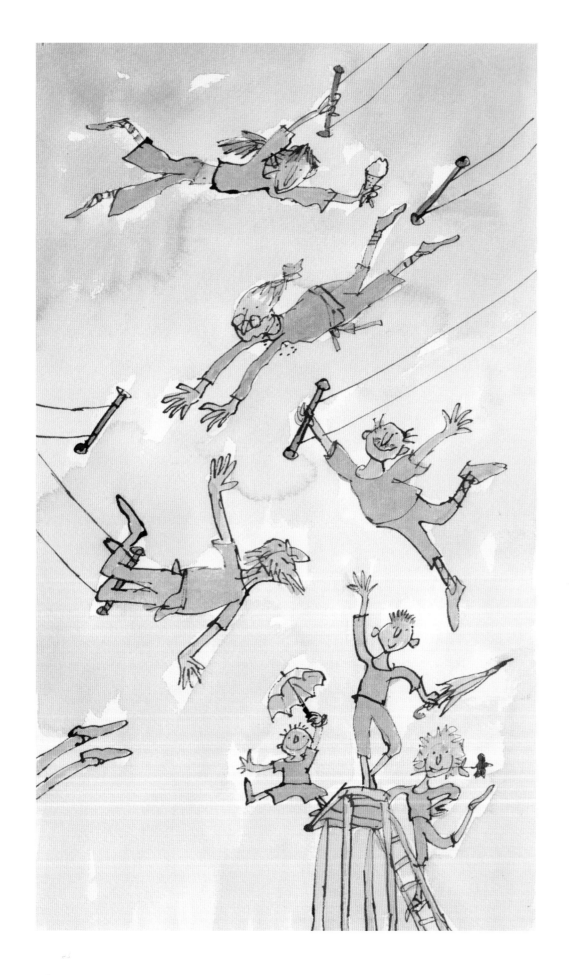

The Acrobat Family

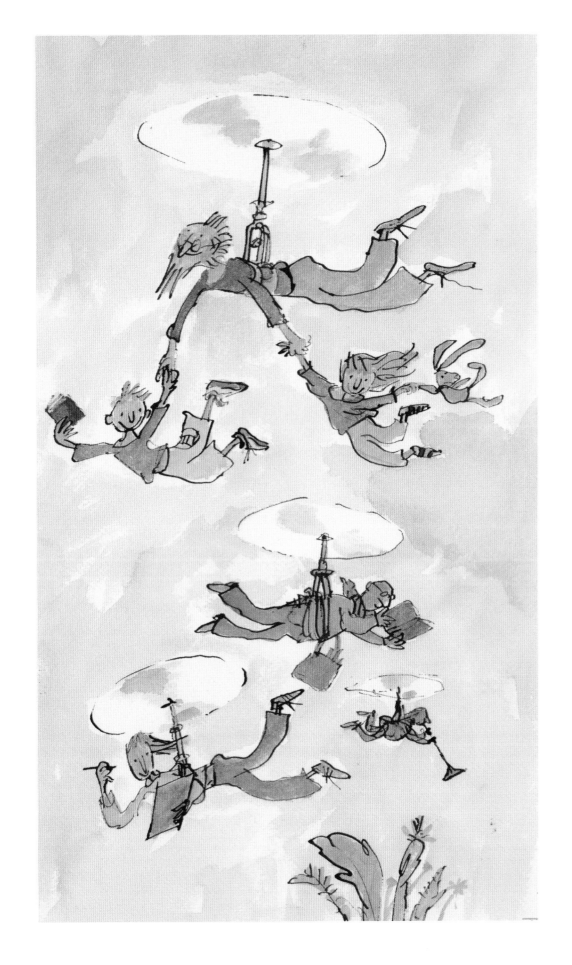

Helicopter people

A Sense of Story

Another opportunity to get pictures on the walls was offered me in 2012 by the gallery Marlborough Fine Art. The invitation was to produce some sequences of both etchings and lithographs. I had no encounter with printmaking since, on leaving university, I had become a part-time student at Chelsea School of Art. I had tried my hand at lithography with more enthusiasm than success, but I remember only one etching, a plump nude in mid-pole-vault. Fortunately this time Frankie Rossi of the Marlborough put me into the safe but nonetheless innovative hands of Michael Taylor and Simon Marsh of the Pauper Press. First there were two contrasting set of etchings. One, in black and white with tones of acquatint, was of women and birds. They were not from life or scenes from life; Jenny Uglow, whose words introduced the catalogue of the exhibition, suggested their atmosphere was of myth. The second set, multicoloured, were of insects, although insects with all kinds of human characteristics, an approach that artists have long used (and as I have with birds) to allow them to make comments on the humans around them. I liked the additional possibility of spikey silhouettes.

The lithographs found their origin in a sequence of drawings that I did a few years ago of children and dogs – many of the dogs unusually large, and doubtfully threatening or protective. In the lithographs the children have become girls who are making drawings they don't seem to be very satisfied with. I think they seem to offer some suggestion of story or metaphor which is an aspect of them I value without feeling the need to attempt any sort of definition.

Once this printmaking was embarked on I was invited also to show some sequences of drawings – drawings that needed to be in series, I felt, to explain themselves.

Insects: etchings

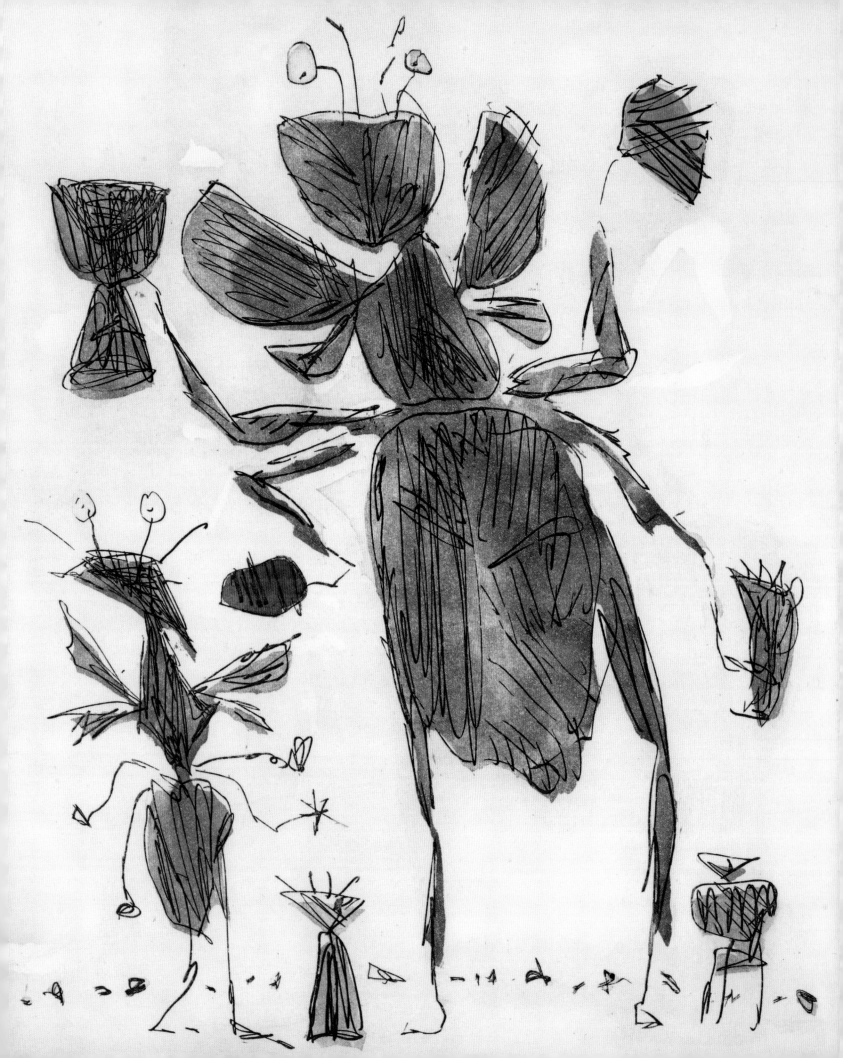

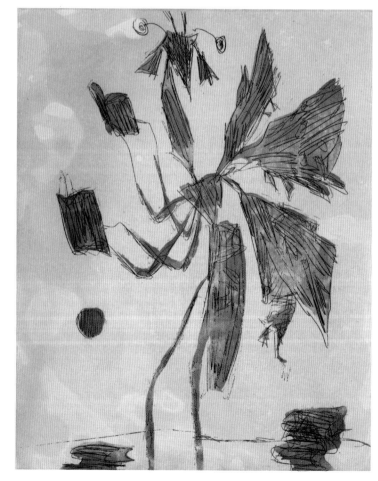

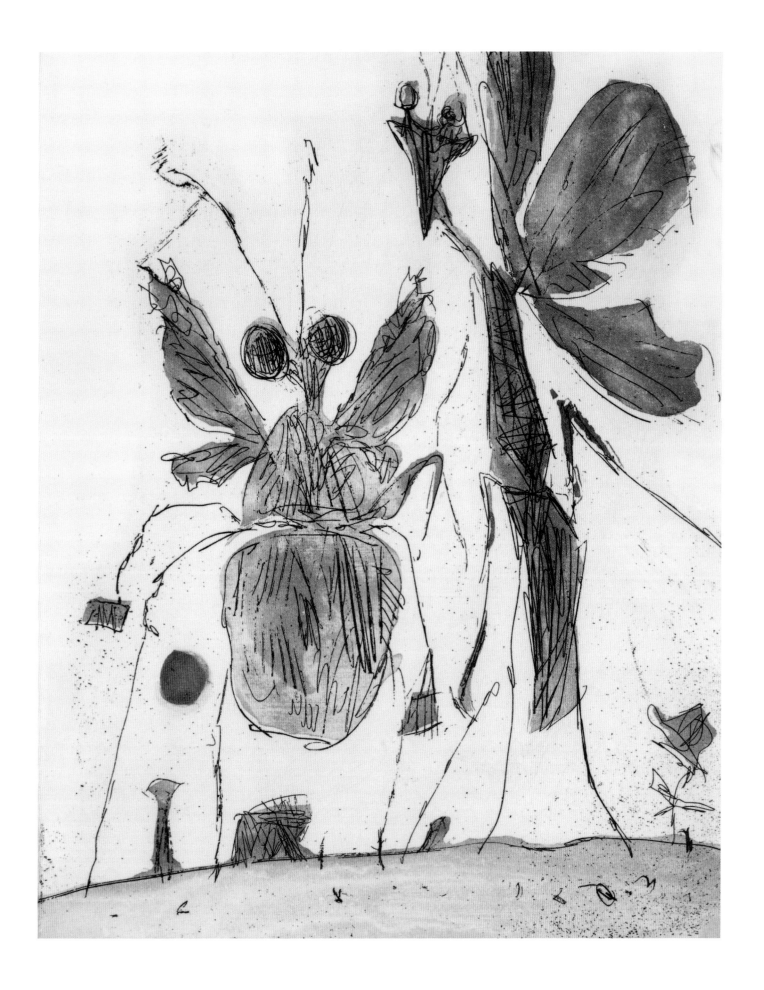

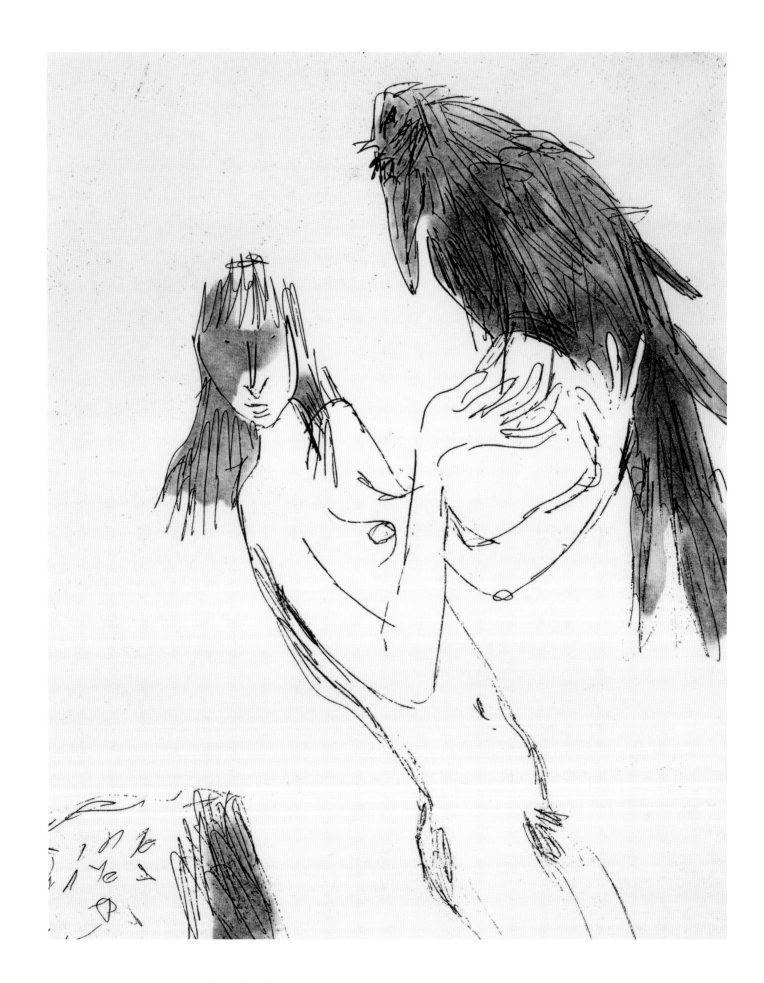

Women with Birds: etchings

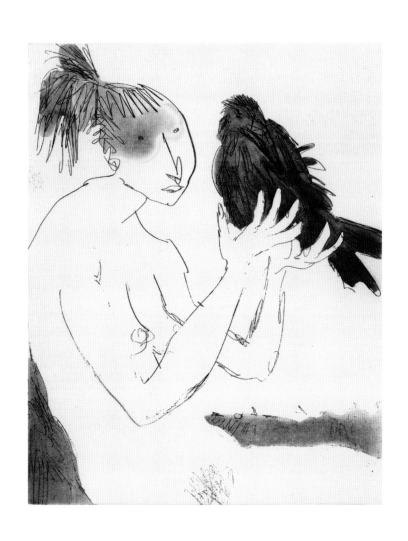

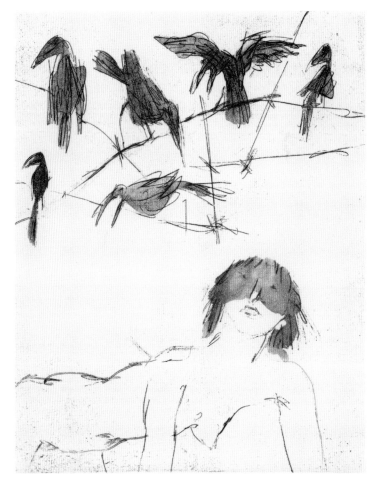

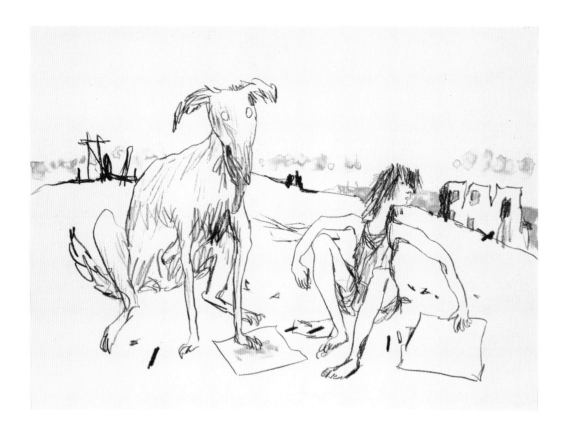

There were four of these series. Two were in the same style and technique, drawn on watercolour paper with a black chinagraph pencil. In one series a single person sits facing the spectator, and I came to think of each figure as a Character in Search of a Story: you are in a sense invited to speculate. The second series I think of as Companions, and the drawings show two seated figures. They are also looking towards the spectator and not at each other, but the relationship in the space between them is at least part of what the picture is about: mothers and children, sisters, friends, collaborators. I don't think it follows necessarily that the relationship is an easy one.

Half-a-dozen other drawings are of old and young together – scratchy pen drawings with ink running into two colours of watercolour; grey for age, gold for the young. These drawings follow on from a set that I did for hospital bedrooms – there are samples later in this book – and it did occur to me that perhaps the series described above came, in a different way, out of that hospital experience. It is not that they essentially relate to illness, but that their reactions and possible distresses are ones that I might want to keep out of pictures made to appear in those hospital situations.

The last series is of athletic women, and if they also have some kind of a story, it isn't told in the same way. They are each against an outdoor landscape; they are being very energetic (perhaps not all equally successfully) and they are not dressed at all except in colour. They rejoice, I hope, in being drawn with big Stabilo watercolour crayons. Beginning as outlines and patches of colour, they are worked into with water on a stiff brush. It's possible to decide, to some extent, how much you want the colours to mix: so that there is an element of painterliness in them, but not of a kind to slow anything down.

Girls with Dogs: lithographs

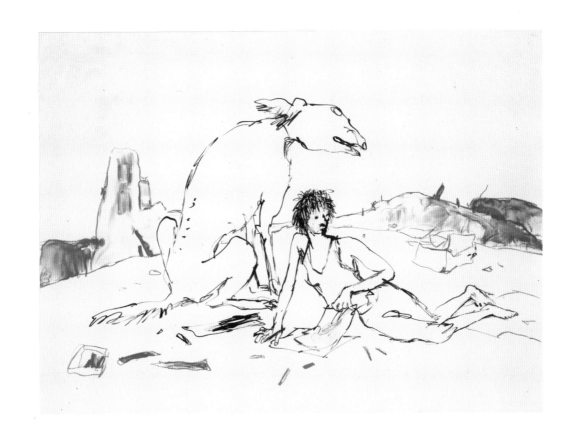

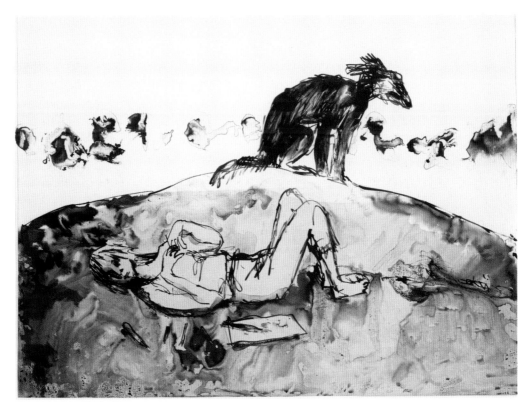

Characters in Seacrh of a Story

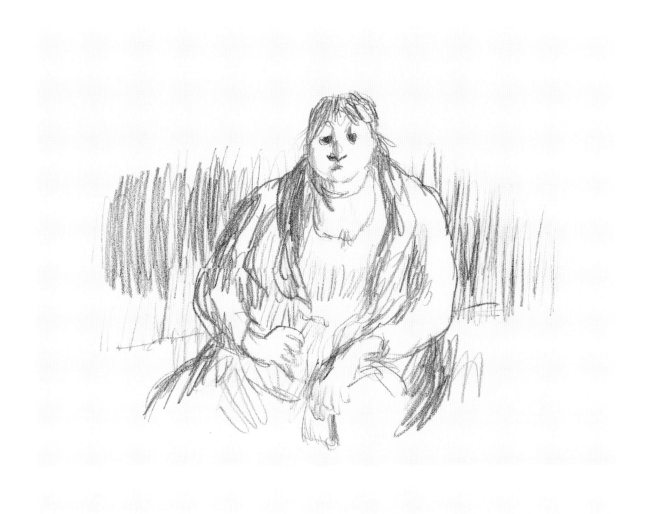

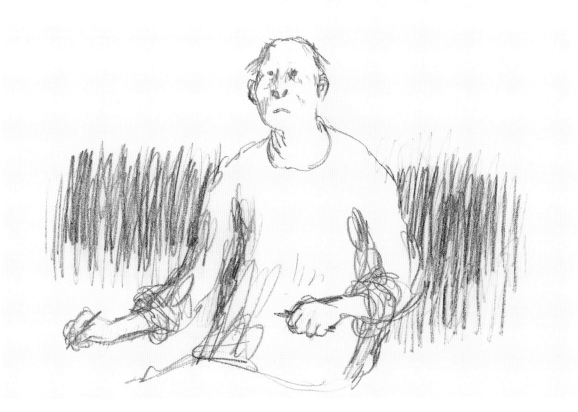

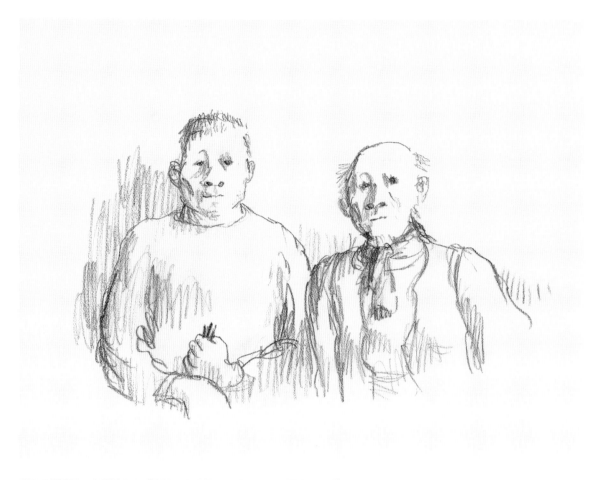

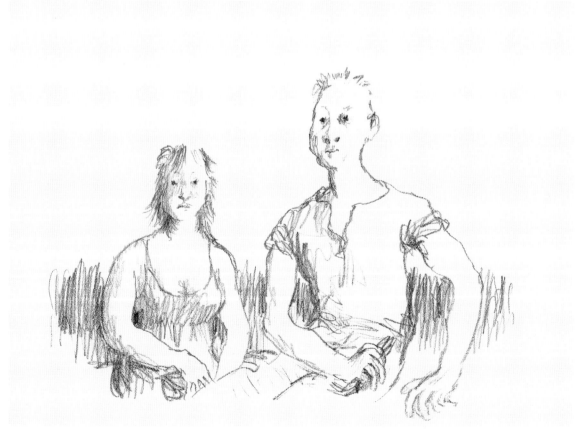

Companions

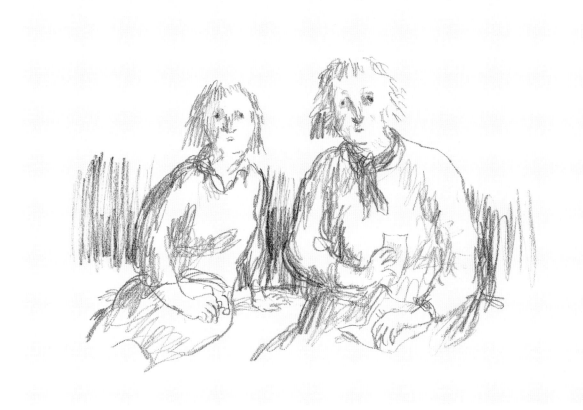

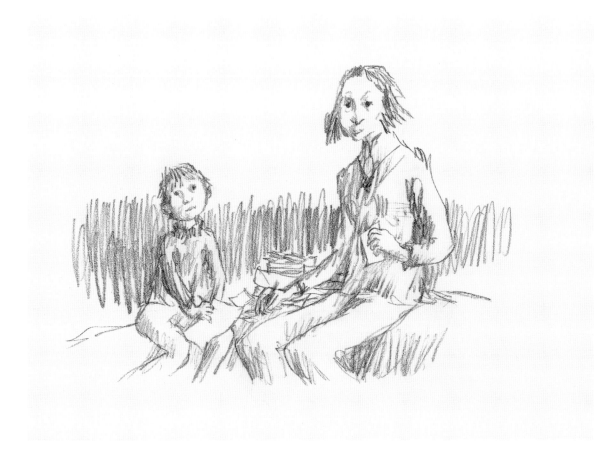

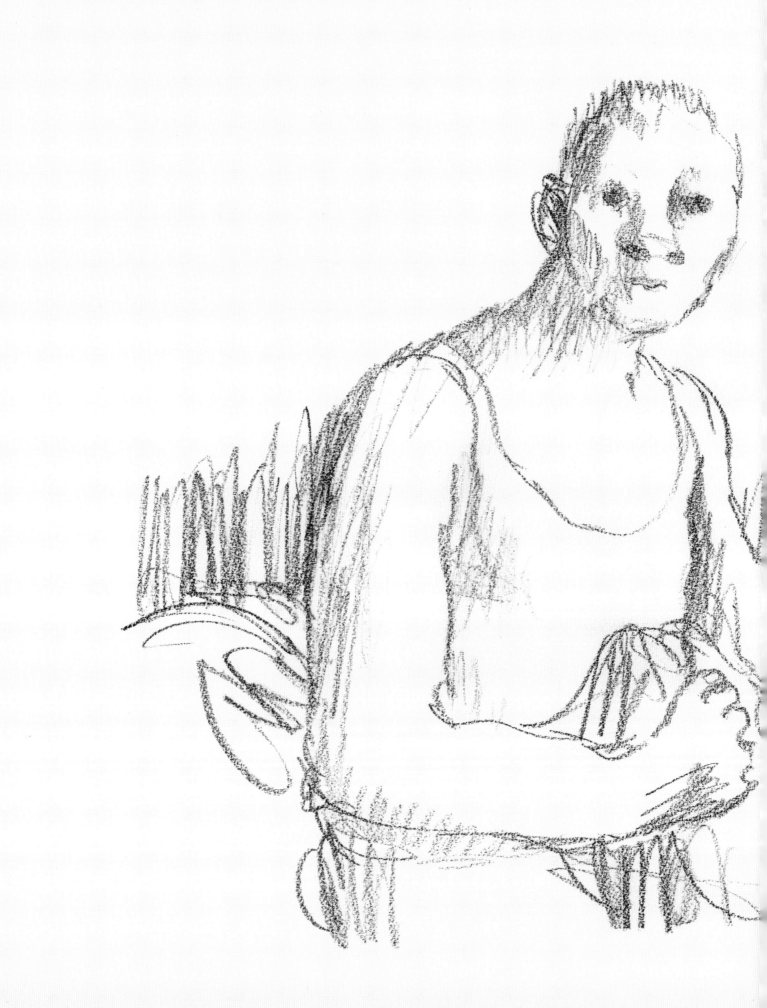

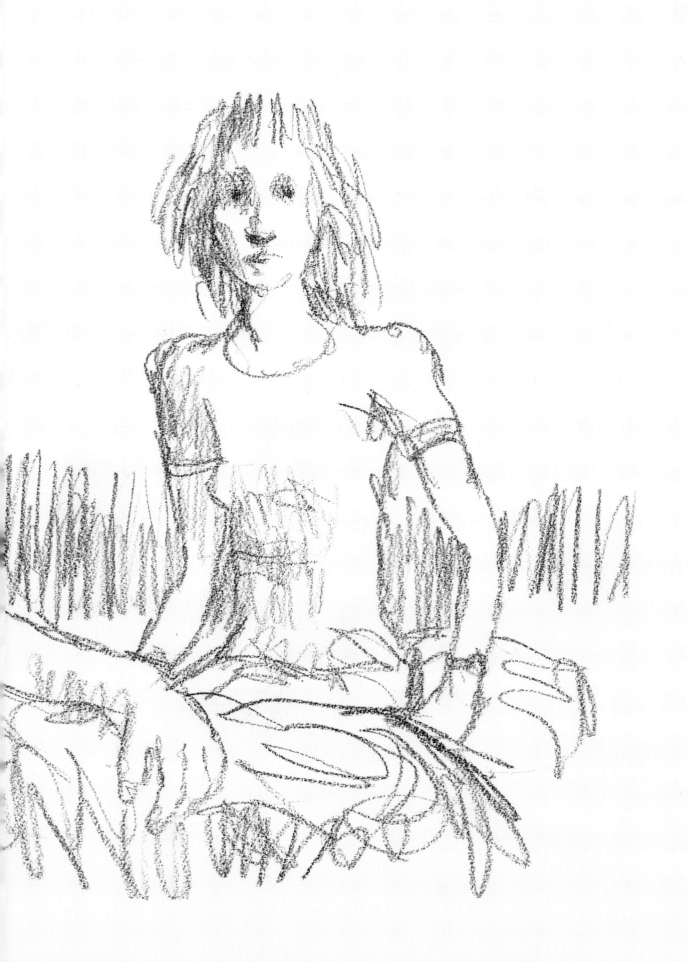

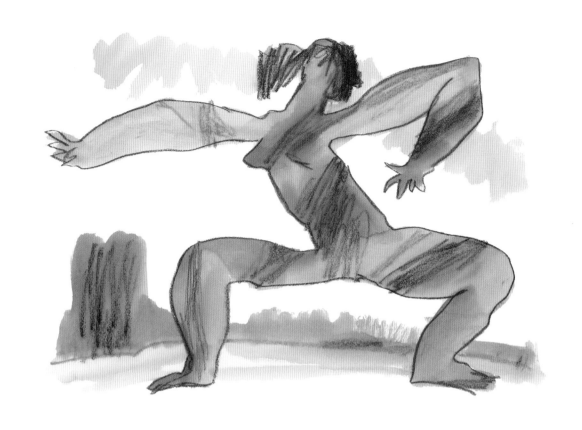

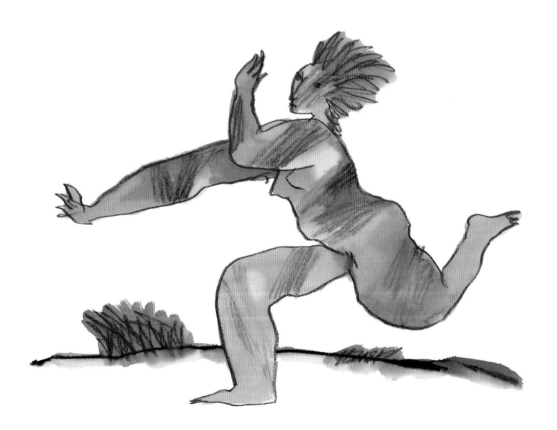

Big Healthy Girls

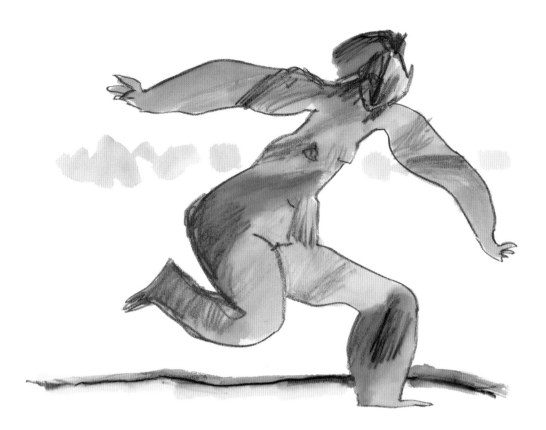

Three aspects of this Marlborough Gallery exhibition had a special appeal for me. One was quite simply that at a moment when something retrospective might have been thought to be in order, the show would consist entirely of very recent work. Another was that I was allowed to bring together at the same time three or four different techniques of depiction; and thirdly, that these techniques corresponded to, so to speak, ways of telling a story. However, in contrast to work for books, they didn't relate to an existing narrative or situation, and their stories, whatever they may be, are implied in them. Their techniques are like those you can find in illustration, but it's as though they were illustration pulled inside out. And I am not quite sure what you call that.

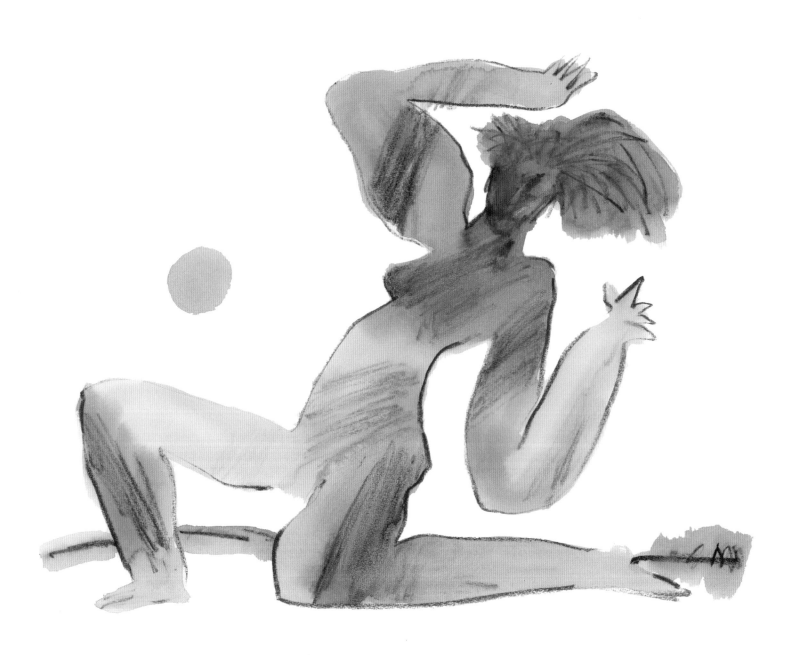

Some Kind of a Tradition

From time to time I find myself in a situation where I am asked for a definition of illustration. I find it difficult. The untidiness of its landscape, the vagueness of its borders, the way paths cross, is for me more part of the interest than part of a problem. I suppose I am better at saying what you can find in this territory than where the borders are. It may include, for instance, medical and scientific illustration; the depiction of birds and flowers in works that give information but can nevertheless (as with Audubon) be beautiful and even dramatic; the illustration that records, reports, bears witness (and which photography has not entirely displaced); and the illustration of fantasy of every kind. What one does have a sense of, I think, even so, is some kind of a tradition.

There are also difficulties of language. I can remember that when I had an exhibition some years ago at the Bibilothèque Municipale in Geneva I called it *Quentin Blake Illustrateur*. I stayed there with my friend the illustrator Philippe Dumas, who thought that was not the title I should have used – when, I suppose, I could have been 'artiste-dessinateur'. Indeed, the word 'illustrator' has often a sort of tarnish on it. When commentators call a painting 'illustration' they suggest a mere depiction of the objects or people that appear there, and that the work doesn't present characteristics that make it worth looking at in its own right. Works, however, that I think of as illustration are illustrations in ways they should be. Part of their work is to be collaborative. Perhaps this kind of problem doesn't exist in oriental art, where the notional divide between fine art and other forms of art is not so marked. In fact when artists were painting the walls of chapels or illuminating manuscripts I assume the distinction didn't exist; it came about when painters wanted to raise the tone of what they were doing, and in due course the situation arrived in which a rich man might not merely want to employ Titian to paint something for him, but might want to buy a Titian as a collectable work of genius.

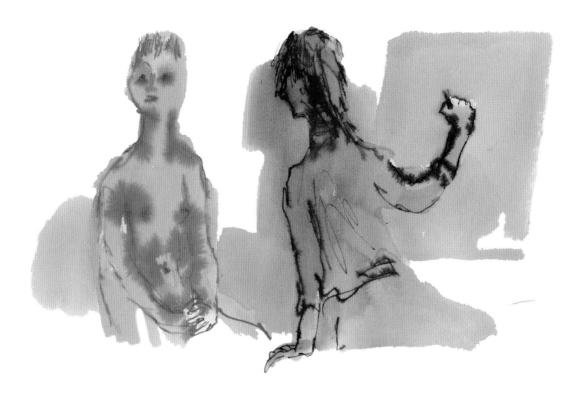

If I reach for a word I lack, one that I can be comfortable with for this activity, it isn't a problem that I alone have encountered. Baudelaire, in the mid-nineteenth century, wrote lucidly and with the same ease about graphic forms of art as he did about painting, with no sense of a gulf between them. However, the essay in which he explains the significance of Daumier, Gavarni and other such artists of his own time is called 'Quelques Caricaturistes Français'. In fact, caricature seems to have been a sort of obsession of the time with the result that Baudelaire refers to these artists as caricaturistes, though for many that was not their main activity. The breadth of reference implied in the word is emphasised, if it needs to be, when one moves on to a subsequent essay 'Quelques Caricaturistes Etrangers' which includes, not surprisingly, Hogarth and Cruikshank, but also Goya and Bruegel. I assume he refers to their engraved work and it is something of the intimacy and immediacy of these works on paper that I think we want 'illustration' to describe. There is also their aspect of narrative and invention. As Baudelaire observes, when Daumier stops doing political cartoons and turns instead to the observation of the citizens of Paris, his works enter the field of the novel.

The swiftness and flexibility that can be a characteristic of this tradition means that humour is something that illustration can do well. However, humour too seems to me not to be easy of definition and I am suspicious of discussions of humour, or 'laughter', as a separate subject. I know, in fact, that my own drawings are able to make people laugh (I have heard them in art galleries, where laughter is rather noticeable) but it always comes to me as something of a surprise. I take the view that humour is better not thought of as an end in view as much as a bi-product; something decanted out of the elements of a situation, or the way visual elements sit together. What comes to mind, for instance, is a little scene observed on a French beach a few years ago.

Old and Young

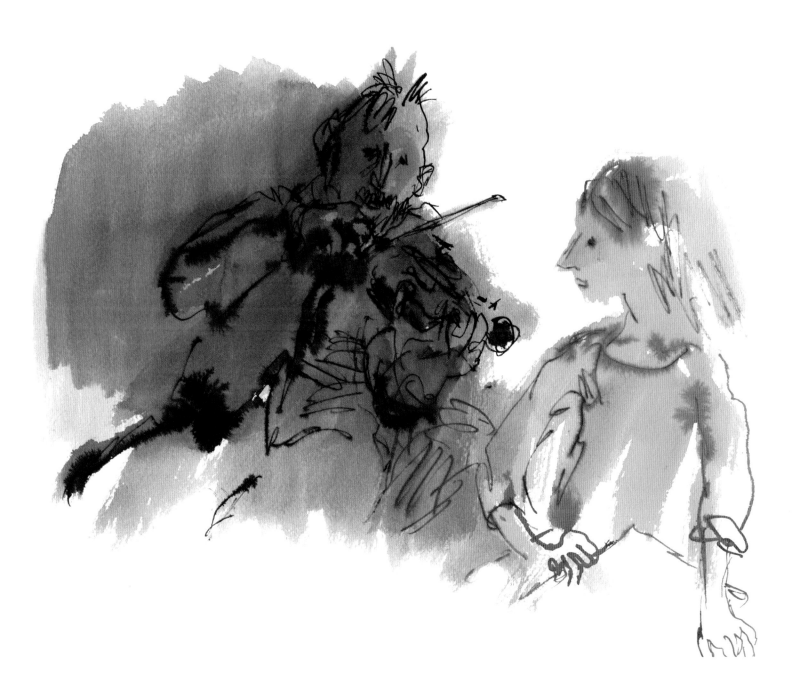

Two small boys, brothers I suppose, and just about old enough to be at school – one is burying the other in the sand, as children do, until he is all hidden except his head. Then after a short while I hear: 'Pauv' Samuel. Il est mort d'un cancer. C'est triste à dire.' They are just, once again, inventing theatre – words gather to the physical presentation. And then their sister – she is called Salomé and is perhaps two and a half – discovers that the beach-ball and her brother's head are approximately the same size, and that she can bounce one off the other. So now she has satisfactorily discovered a visual humour, a pleasure in discovering how things can relate. And you can do these things also in drawing, in illustration.

Satire benefits from the swiftness and flexibility of illustration. It's urgent, of the moment, able to respond to events. What I am perhaps less ready to accept about the attack mode, life-enhancing as it is in its own way, is that it is necessarily more demanding or by definition more serious than other kinds of humour. Non-confrontation can also have its rewards. I recently had the privilege of hearing one of our most gifted and acerbic cartoonists talk about Hogarth's *Gin Lane*, noting its elements of observation, parody, comment, diversity. The companion piece, representing the beneficent effects of a contrastingly healthy drink, is *Beer Street*, and our commentator labelled it as so boring that he did not even show it or speak of it. Subsequently, I went to refresh my memory of *Beer Street*, and I had to agree. The foaming tankards and good behaviour are near to clichés. Nevertheless it seemed to me on reflection that perhaps the task of some of us might be to show that Beer Street is – or can be – interesting. (Not, incidentally, that Hogarth himself does not do this elsewhere – look for instance at *Actresses Rehearsing in a Barn*, where the ostensible message is of derision, but the effect is of wonder.)

If this possibility concerns me it is for at least two reasons. One is that when people speak to me about books I have illustrated they often, still rather to my surprise, express gratitude, and what they most frequently mention is that that the work has given them 'joy'. The other is that with the increasing amount of work, described later in this book, that I have undertaken for hospitals and mental health centres I became more conscious that humour is not simple and separate but becomes an ingredient in a more complicated mix.

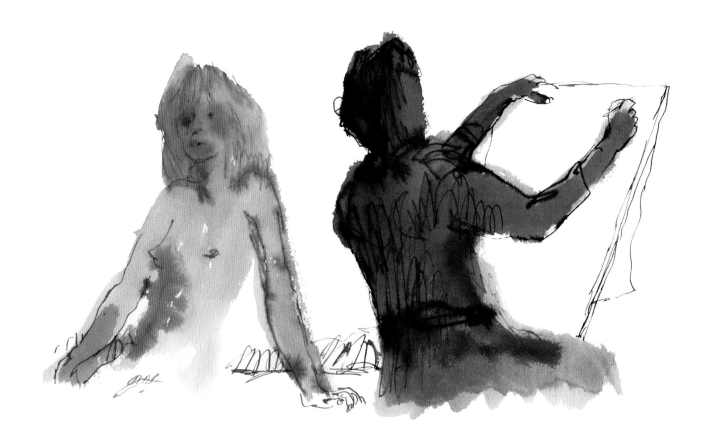

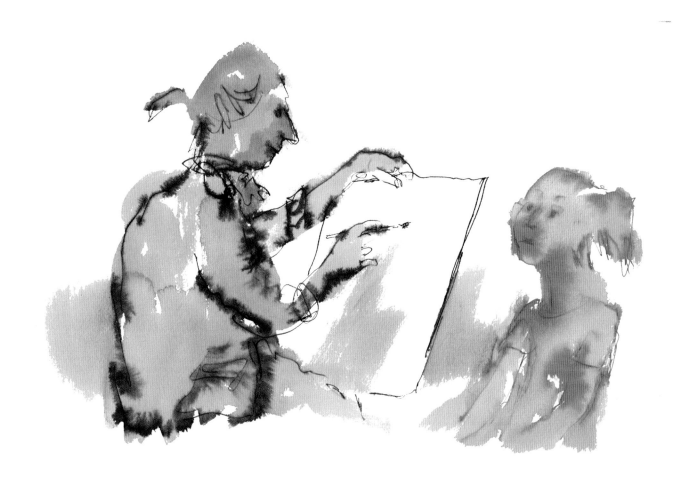

Books Still Keep Happening

Despite the long-term projects for public spaces which are the main concern of this work, books still, one way and another, keep happening. If I make a list I can see that solo picturebooks, ones that I have written and illustrated myself, are few. I can remember that whenever I delivered a finished book to Tom Maschler, my Jonathan Cape editor for thirty years and more, he had hardly received it before asking, 'What are you going to do next?' Encouraging, really, but I seldom knew and my instinctive thought was that I might never have another idea ever. (In fact, it isn't really difficult to come up with some sort of idea for a picturebook, but harder to find one that you think might stand the test of time.) My experience is that sometimes a book comes into being when two notions encounter each other. I think that at any rate that was the case with *Angel Pavement*, except that this time the elements were three. One had to do with two lifelong friends, the artists Linda Kitson and Emma Chichester Clark. We found ourselves having dinner in a restaurant on the banks of the River Seudre in South-West France, and Emma was encouraging me to do a book about angels. This prompted me to do a few impromptu drawings, not intended for any book, in which both my companions featured angelically with wings. And it's as angels that they appear in this book, though reverted to childhood. The next element was a pencil. In 2002 I had helped curate an exhibition of contemporary children's book illustration for the British Council. We called it *Magic Pencil*, and as a little souvenir on sale at the show we got hold of those crayons which draw in four different colours, and we printed the words Magic Pencil on the side. This is what the sky-pictures in the book are drawn with. I have been using the pencil ever since. The third element was provided by my involvement with the Campaign for Drawing, and its annual Big Draw, and the attempt to set up a museum of illustration which, at the time of writing, has not yet moved into its anticipated home but is now called the House of Illustration. Sue Grayson Ford, the Campaign's director, has a role at the climax of the book, and the friends of Loopy and Corky, the two child angels, are the trustees of

Loopy and Corky in 'Angel Pavement' and, on the next page, drawing in the sky in 'Angel Pavement'

Loopy was very good at drawing soldiers in
uniform and people with toothache.

Corky was very good at drawing dogs
and birds with lovely tails.

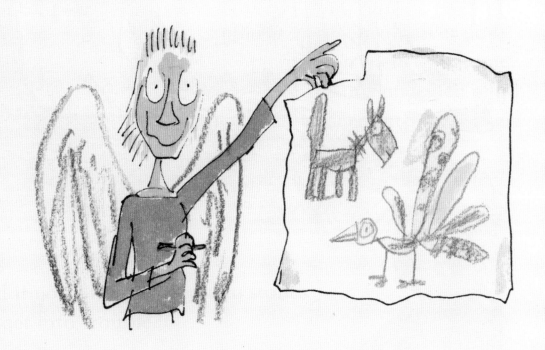

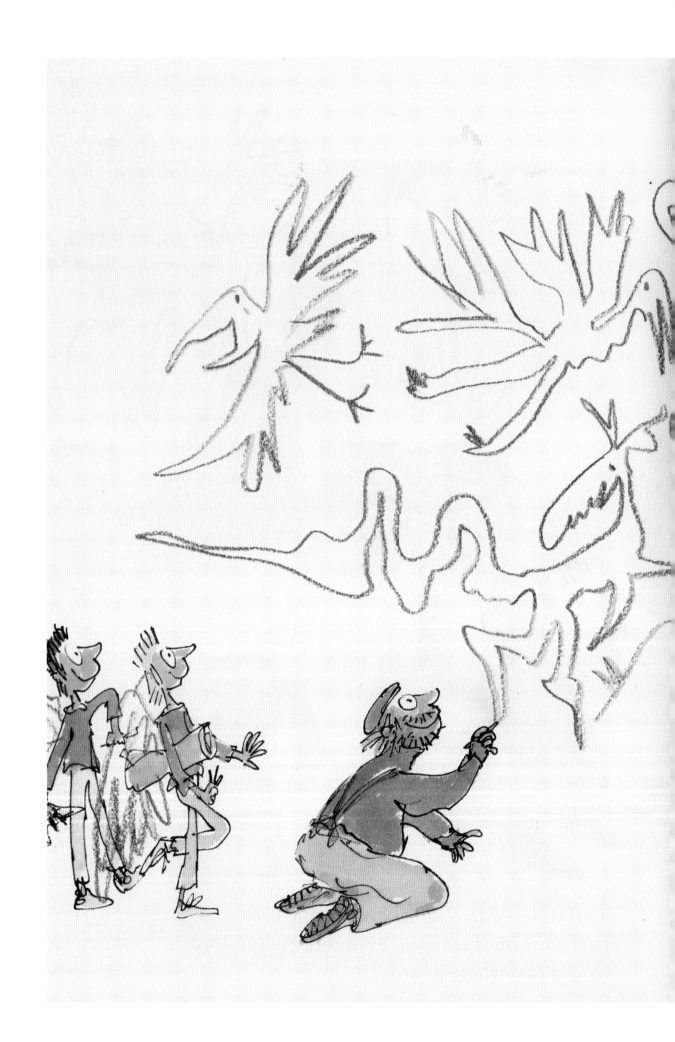

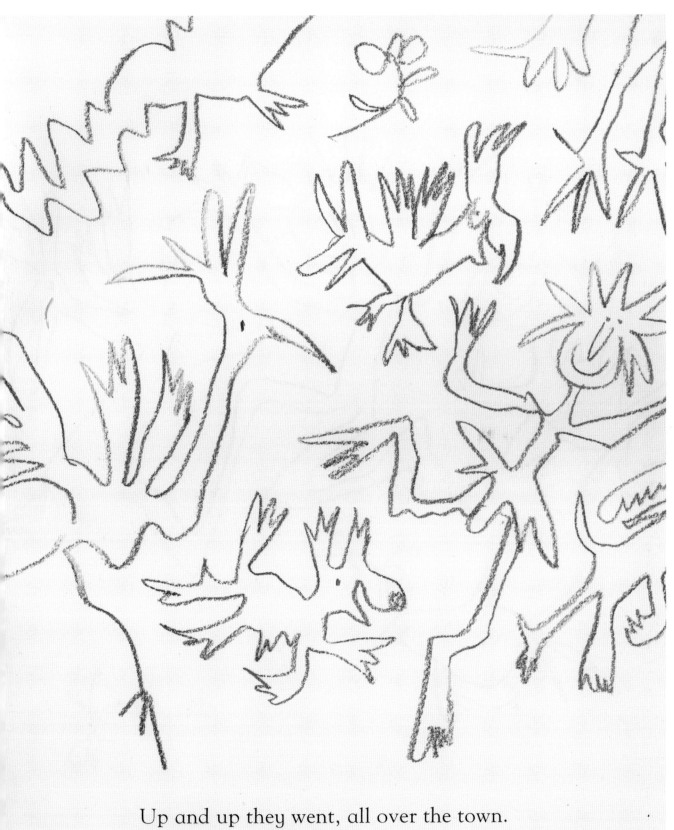

Up and up they went, all over the town.
It was extraordinary.
 But then, when you start drawing you can
never be quite sure what is going to happen
next, can you?

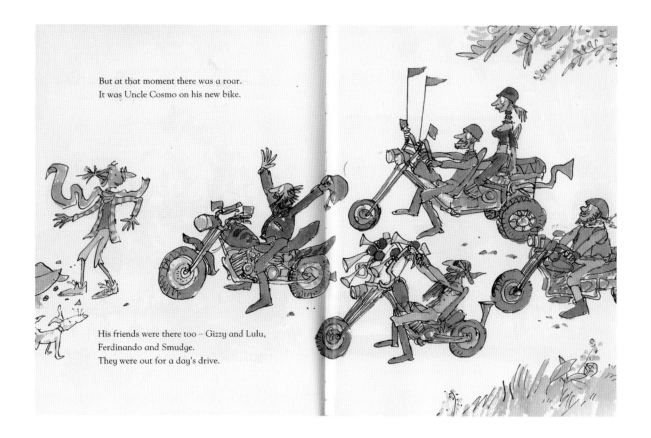

But at that moment there was a roar.
It was Uncle Cosmo on his new bike.

His friends were there too – Gizzy and Lulu,
Ferdinando and Smudge.
They were out for a day's drive.

the House of Illustration at the time, they too reduced to childhood. The book is a celebration of drawing and ends with the, I think, important words:

> 'When you start drawing you can never be quite sure what is going to happen next, can you?'

For this book I couldn't resist borrowing the name, *Angel Pavement*, from a J.B. Priestly novel of the 1930s, as it is appropriate and sounds odd; though in French the book is simply called *Le Grand Dessin* and perhaps to have called it *The Big Draw* might have improved its chances in the bookshops.

Neither of my other two books of this period can quite claim to be entirely new. Mrs Armitage, who had been seen with her faithful dog, Breakspear, in *Mrs Armitage on Wheels* and *Mrs Armitage and the Big Wave*, had another outing. *Mrs Armitage, Queen of the Road* is another visual sequence joke, but this time losing things (hubcaps, bumpers, the roof) rather than accumulating, and less is discovered to be more – more funky, anyway, as our heroine encounters her Uncle Cosmo and his friends as harmless versions of Hell's Angels.

Angelica Sprocket's Pockets is another set of visual jokes, rather than a story with any moral dimension. Although its heroine is a new character, the roots of the story go back some way – perhaps thirty years and more – to a contribution to Puffin Post, in which a Mr Joe had pockets which contained the answers to various problems. Later he became a complete set of roughs of a story about a young man called, with a rather confusing nod in the direction of Dickens, Herbert Pocket. A few years ago I found him lurking in the bottom of a plan-chest draw and reworked him. He changed sex and became more intense and, to me at least, more interesting;

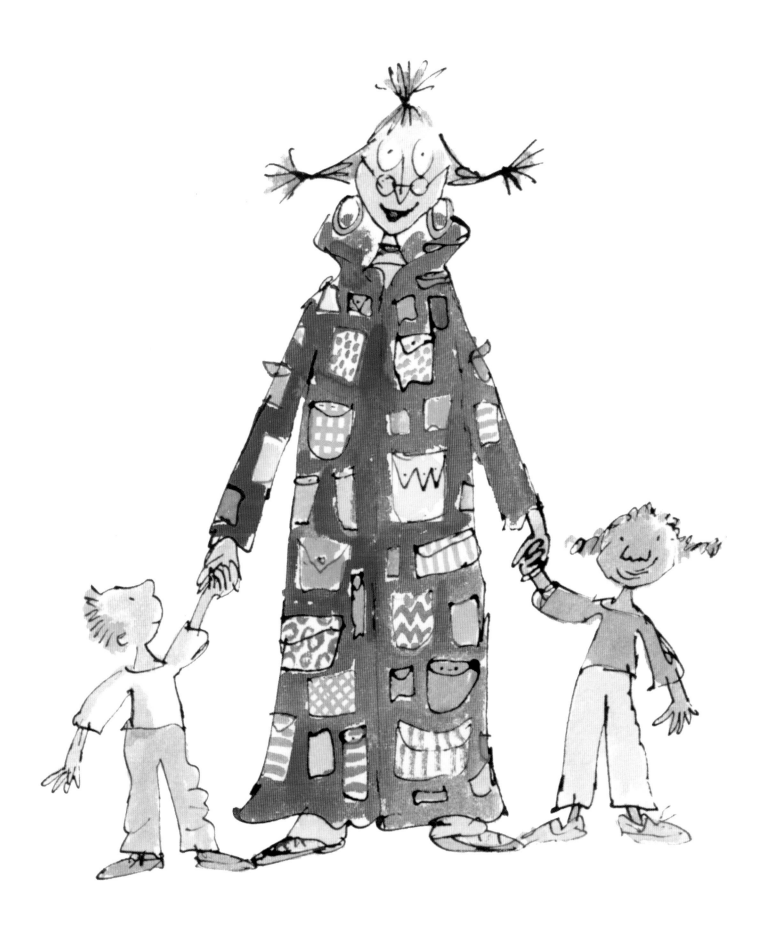

Angelica Sprocket

There's a pocket for
saucepans and frying pans and buckets

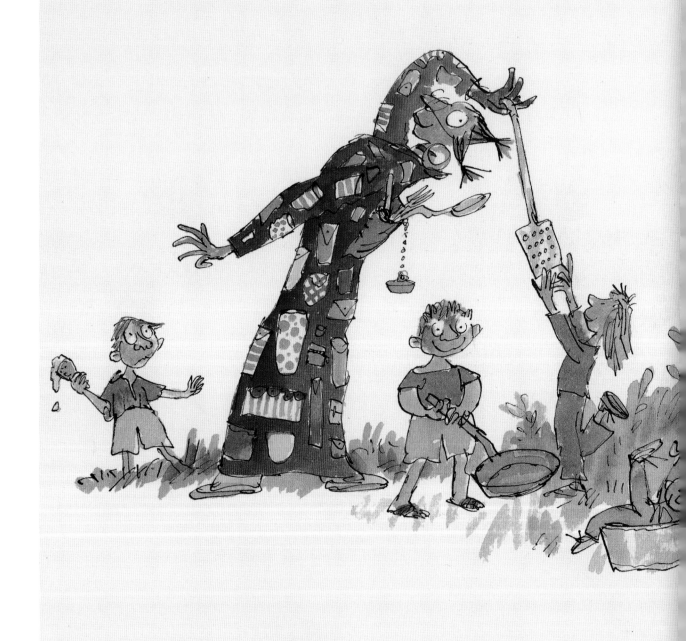

'Angelica Sprocket's Pockets'

and spoons and forks and cheesegraters and

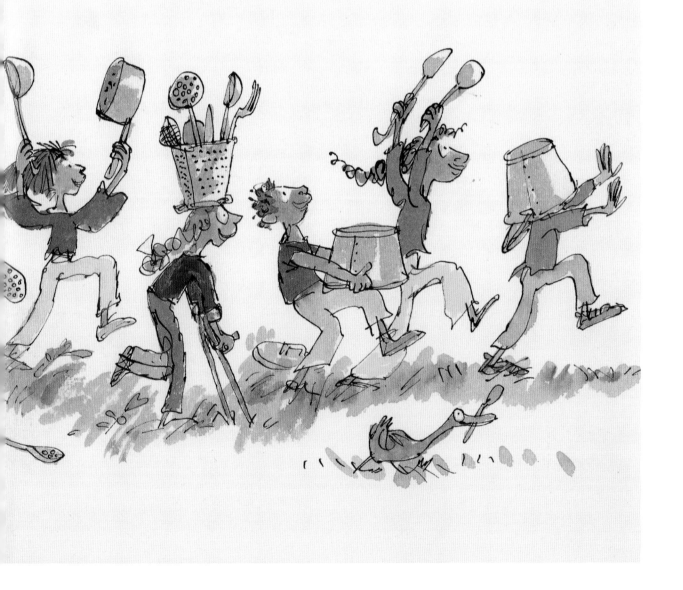

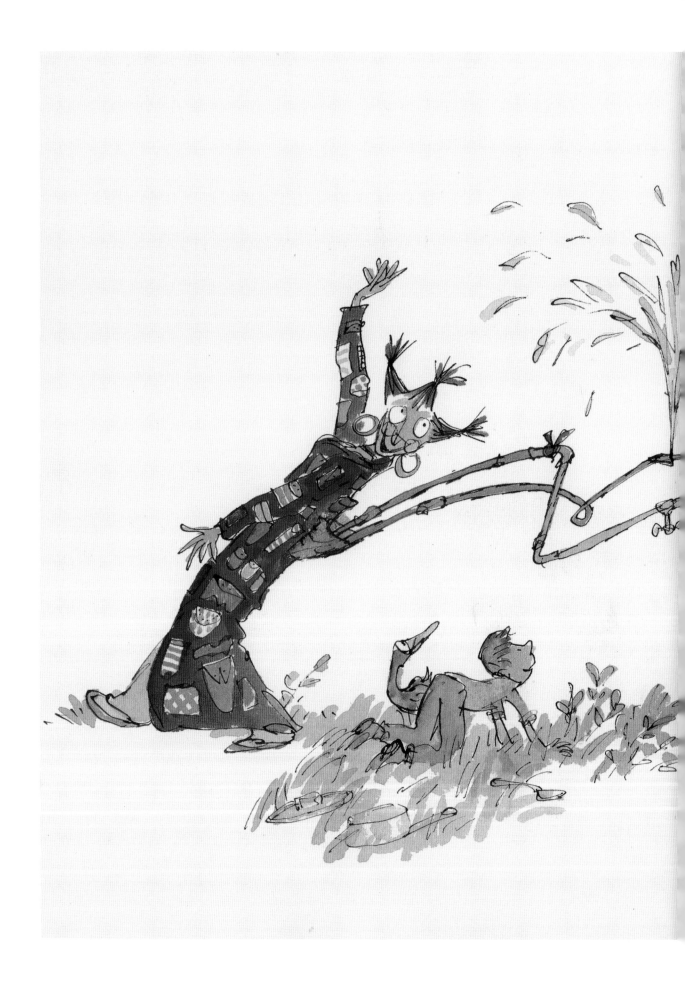

the kitchen SINK.

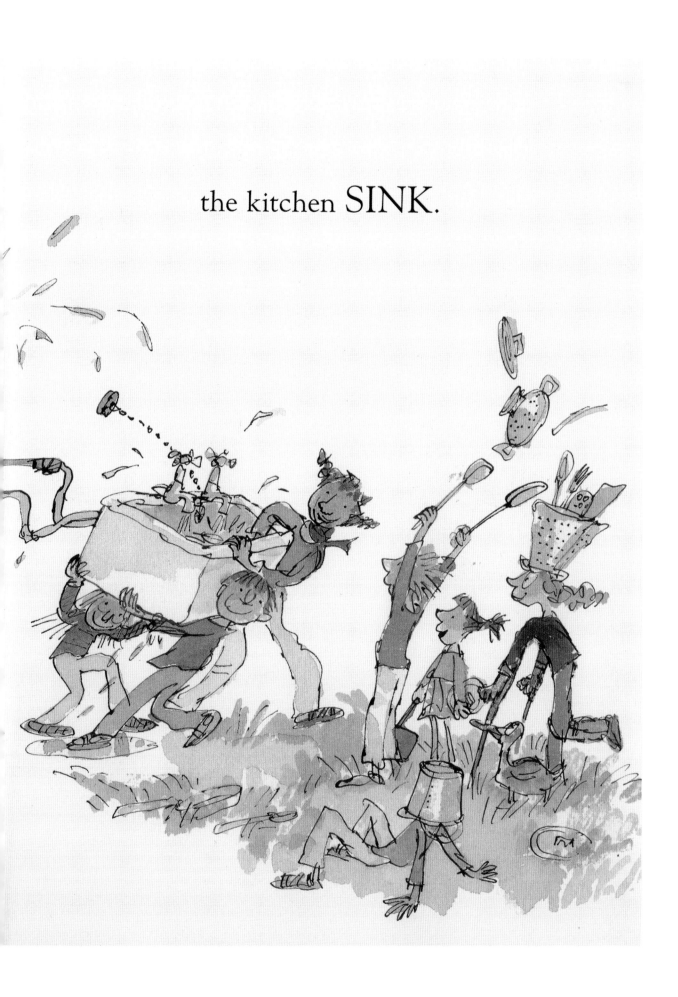

I hope perhaps even ever so slightly enigmatic, since though she is broadly speaking benevolent Angelica never shows any expression of sentiment.

There was also the question of what to do about the pockets. It would have been possible for me to make a reference drawing which showed the pattern and position of each of the pockets; I did that once for a team of ten assorted cockatoos. Instead, I made sure that they were different in size and pattern and disposition on every page. I don't know if this is something that the average reader even notices, but I liked it because to me it suggested unusually magical powers.

Though I can only record these three new titles here, the first dozen years of the twenty-first century seem to have been a time for reappearances and renewals. Early stories such as *Patrick* and *Mr Magnolia* appeared refreshed in new paperbacks from Jonathan Cape, their original publisher, adorned with gold medallions announcing thirty-year anniversaries and suchlike.

There were two similar sets of revisiting of books by my oldest friend and collaborator, John Yeoman. The intrepid Klaus Flugge, director of the Andersen Press and one of the few remaining independent children's book publishers, started to bring out the picturebooks that we had done years before, now with text reset and covers re-thought and re-lettered, *Sixes and Sevens*, one of my favourites, appeared – reappeared – in 2011, and as I noticed, just forty years after it was first seen in bookshops in 1971.

John and I had also collaborated some years ago on collections of folktales for the publishers Pavilion. Now acquired by Anova, these books were handsomely reissued in enlarged and enhanced form: a retelling of the Sinbad stories was one, followed by *Quentin Blake's Magical Tales*

Newly presented versions of John Yeoman titles

and *Quentin Blake's Amazing Animal Stories*. A book by another author even became *Quentin Blake's A Christmas Carol*, although to my relief the name of Charles Dickens was allowed to appear lower down on the cover.

These years also saw the reissue of some Michael Rosen books; two previous volumes put together as *Mustard Custard Grumblebelly and Gravy* and four shorter ones put together as *Bananas in My Ears*. However for me the most significant Michael Rosen book of this time was entirely new, *Michael Rosen's Sad Book* – though that too had a sort of strange revisiting in it. In an earlier book I had illustrated poems about Michael's small son Eddie – *Eddie and the Gerbils, Eddie and the Nappy, Eddie and the Wallpaper*. One day Eddie, now eighteen, showed symptoms of what might be influenza, was taken into hospital, and died of meningitis within little more than a few hours. It must be one of the worst things that can happen to a family, and how could anyone write about it? However, Mike Rosen did – first in a book of adult essays, and then as a script, which he sent to his publishers with the query: is this a book? I think when the words came to me from Walker Books they had still not quite decided, but indeed it was. It would be possible to create a book that dealt with bereavement to, as it were, a programme, but Michael Rosen had had the experience at first hand and had the skill and generosity to offer it to his readers.

Could it be anything but gloomy? Some people thought not, or were not sure. I'm almost embarrassed to say of something so intimately personal that I immediately wanted to do it not only because I admired what Mike Rosen had done, but as a professional task. It couldn't all be grey, and indeed the words themselves alternate feelings, of depression and of joyful and touching reminiscence, which meant a careful organisation of a sequence of pages. The words have all the appearance of being ordinary, everyday, and near to us (and in one sense so they are); it's part

From 'Quentin Blake's Magical Tales' and from 'Quentin Blake's Amazing Animal Stories'

of the strength of their appeal. But they are also visual in concept, so that when you come to draw, for instance, the words

> 'But sometimes I find myself looking at things: people at a window ... a crane and a train full of people going past.'

you discover they take on their evocative emotional significance. And the final words are a gift: 'and candles. There must be candles.' They offer you not only a candlelit scene of common feeling, but a final wordless double-page spread of one candle, Rosen, and the photo of his son, so that the book ends in reflection and silence.

One of the questions that one may expect to be asked by a member of the audience in any talk about books is to do with whether there is a book you have always wanted to illustrate. In fact, there was one such, which was Cyrano de Bergerac's *Voyages to the Moon and the Sun*, and the Folio Society did let me illustrate it, and with almost as many drawings as I chose to produce. However, my answer is usually that I am more stimulated by not knowing what the next book will be. You hope for a new atmosphere, a new personality. I know, because I have been frequently told, that my way of drawing is distinctive, recognisable: the marks are like a sort of handwriting. The interest of a new writer, or a different book by a familiar writer, is to adapt those marks to the new situation. Perhaps it's possible to make the comparison with an actor who takes on the look and gesture of a character, without losing his or her own style of performance.

This was part of what made me happy, when it was sent to me by Anne-Janine Murtagh at HarperCollins, to take on the first book by David Walliams, *The Boy in the Dress*. I had seen some of his work on television, and I hope he will forgive me if I say it made me read the first draft of the book with an element of curiosity about the task before me. Some characteristic David

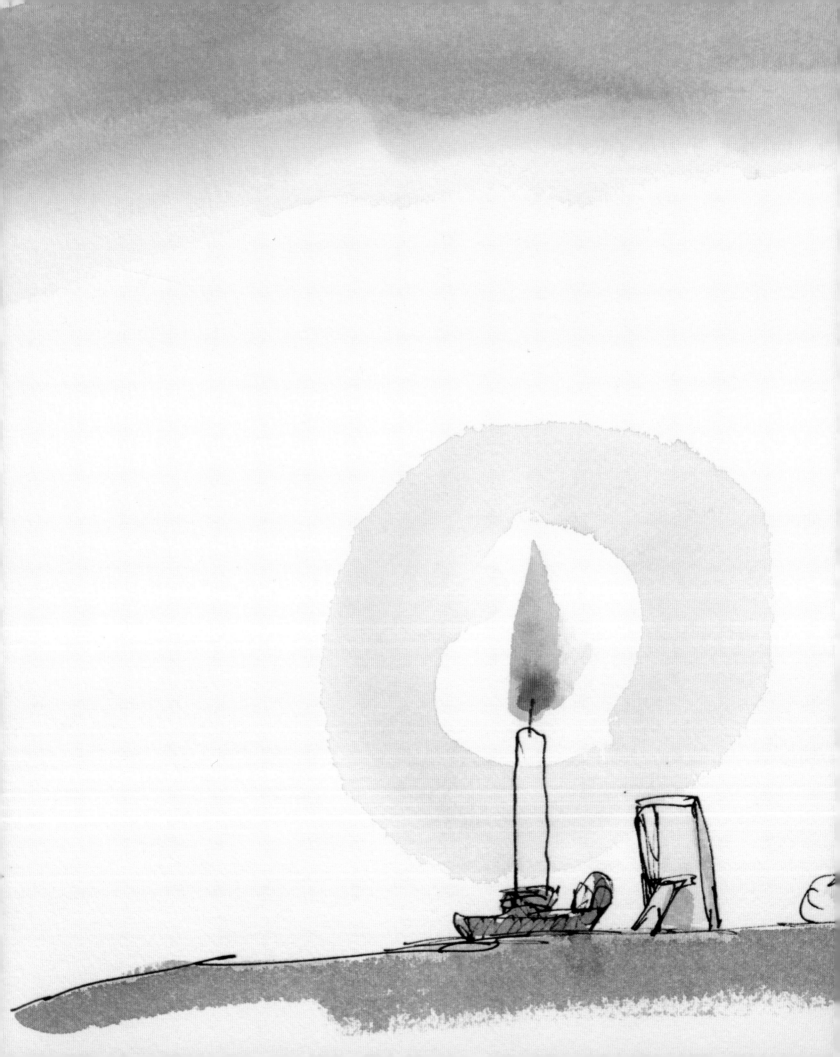

Walliams humour is there all right (if a group of schoolchildren laugh they do it in capital letters for two pages) but what most appealed was the even-handed humanity of the book. It isn't about being gay or really even about transvestism. It's about a boy (who is also a gifted footballer) finding out about his own artistic tastes, and finding out something about what it's like to be a girl. Drawing Denis and Lisa in their separate stages of development was part of the interest. I also felt at home with the cast of schoolchildren – a version of those I had grown up with at suburban grammar school many years before – and I negotiated the indulgence of eight extra pages at the ends of the book on which to draw an assorted cross-section of the school population.

I also illustrated David's second book, *Mr Stink*. An unlikely alliance between Chloe, sympathetically seen in her slightly difficult home life, and the dirty tramp who is discovered, behind the stink, to be both cultivated and considerate. I enjoyed both these books and was pleased to think that I might have helped David Walliams to get into his stride. At the same time I had the sense that he showed all the signs of a regular productivity that I would not be able to keep up with. So I arranged not even to look at the third book, and bowed myself out, happy not to have missed such an invigorating experience.

Michael Morpurgo is someone who would be even harder to keep up with; fortunately he has a brilliant collaboration with Michael Foreman (who shares his love of the West Country), as well as very successful ones with a number of other artists. My work together with Michael has been on a somewhat different footing in that, with one exception, it has been for anthologies – so, not adapting to one writer, but to several.

Lisa and Dennis, from 'The Boy in the Dress'

Endpapers for 'The Boy in the Dress'

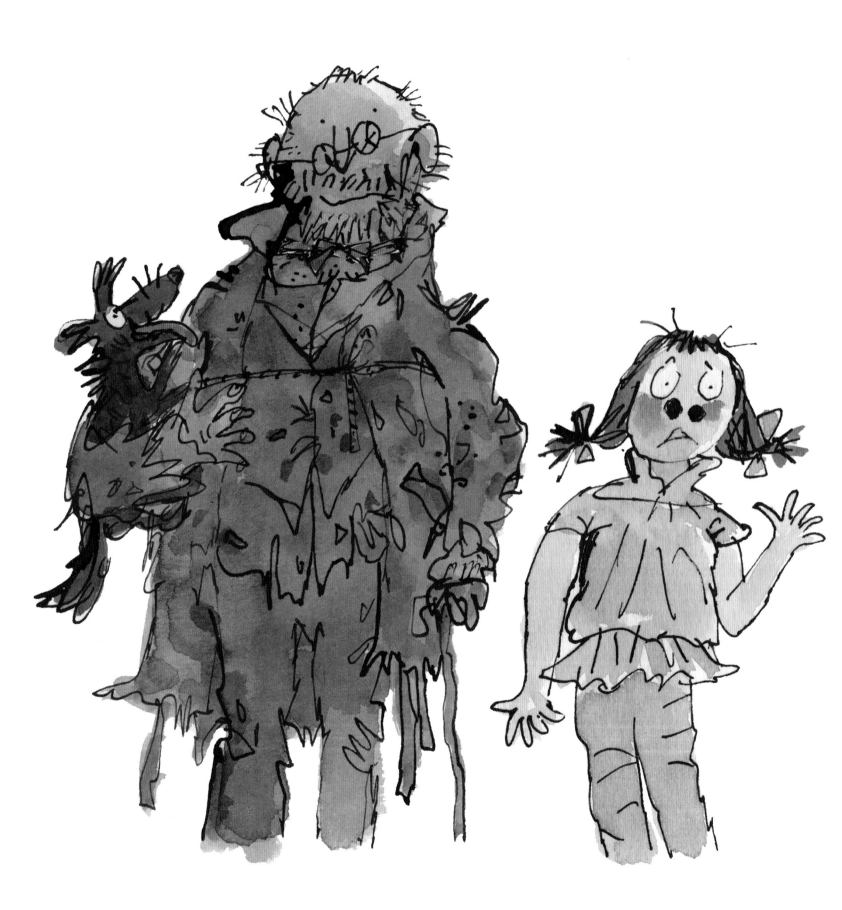

Cover illustration for 'Mr Stink'

Fig
A

Fig
B

Michael and Clare Morpurgo started twenty-five years ago – and for a long time ran – an extraordinary charity, Farms for City Children. Groups of children from city schools visit the farms the charity owns in the West of England – not to be on holiday, but to work on the farm, so that theirs is a real experience of rural life. (Children who were at first shocked to get up to clear out the pigs before breakfast might be those who, a fortnight later, would be in tears when they had to leave.) My first involvement was to help with illustrations for two anthologies of stories, *Muck and Magic* and *More Muck and Magic*, to raise funds for this enlightened scheme. Happily for me the endpapers which I drew for the first of these books have had an extended life. The little girl herding the geese and ducks became the first logo for FFCC, and she and the other characters went on to appear on greetings cards, a teatowel, oven gloves and hothands and so earned their keep.

The books after these provided a less simple task. They were both collections of verse: the first, *Because a Fire was in my Head*, a selection of 'poems to remember'; the second, *Cockcrow*, an anthology of poems of rural life – both with a fascinating range of tone and approach.

The one story of Michael Morpurgo's that I have illustrated came next. *On Angel Wings* is (characteristically for Michael) a first-person narrative; a shepherd boy's recollection of the nativity, and the event in the manger from which he would have been excluded if the angel Gabriel had not found him left behind to guard the flocks and wafted him to Bethlehem. I had to settle into doing what I could without thinking too much about the nativity-competition there has been over time from better artists. Part of the reward was that extraordinary night-flight.

Illustrations for 'Cockcrow'

The circumstances of the last book in this section I could not have foreseen. I have illustrated a number of books by Russell Hoban – the first, memorably for me, was *How Tom Beat Captain Najork and His Hired Sportsmen* in 1974 and I remember reading the manuscript for the first time and realising that I was looking at something quite out of the ordinary, while at the same time for me, tremendously sympathetic. Our last encounters were in 1999 when I illustrated the picturebook *Trouble on Thunder Mountain*, a characteristic disquisition on the relative merits of the plastic and the real, and when Russell wrote the introduction – full of his sense of drawing and narrative – to a collection of my drawings called *Woman with a Book*. A dozen years had passed as easily as they do until Jake Wilson, with whom both of us had been separately working on filmed interviews, put us in touch again. I sent Russell some copies of my recent hospital pictures in the hope that perhaps he might one day be persuaded to write something about them. What I hadn't the slightest expectation of was to receive – was it only three weeks later? It can't have been much more – the typescript on yellow paper of a completely new picturebook story. It was headed then 'Rosie and Her Magic Horse' (or maybe 'Rosie and Stickerino'?) which became, after a light revision of the text, *Rosie's Magic Horse*: a book full of imagination and things to draw. In the first words there's the idiosyncratic poetry that is characteristically Hoban:

> 'There was an ice lolly stick with ice-cold sweetness all around it, white on the inside, pink on the outside. Then the sweetness was gone and the stick fell to the ground.
> "The sweetness is gone," said the stick. "No more sweetness."'

They are words that invite the young reader to feel for their meaning, and in that effort the illustrator can help by drawing in the day-to-day reality of what they evocatively gesture at. The prospect of getting to work on a book that goes from the intimacy of the inside of a cigar-box to a flight by magic horse over cities and jungles, oceans and deserts, was irresistible. All the finished pictures for the book were completed some months before the agreed deadline. This was the result of simple enthusiasm, but in retrospect I was grateful for it. I knew that Russell wasn't in good health; but I was surprised when I was told that he had gone into hospital. Within a few weeks, alert and engaged to the last, he died. I had the consolation of knowing that he had seen all the drawings for his last text, words with no diminuition of wit, imagination and poetry.

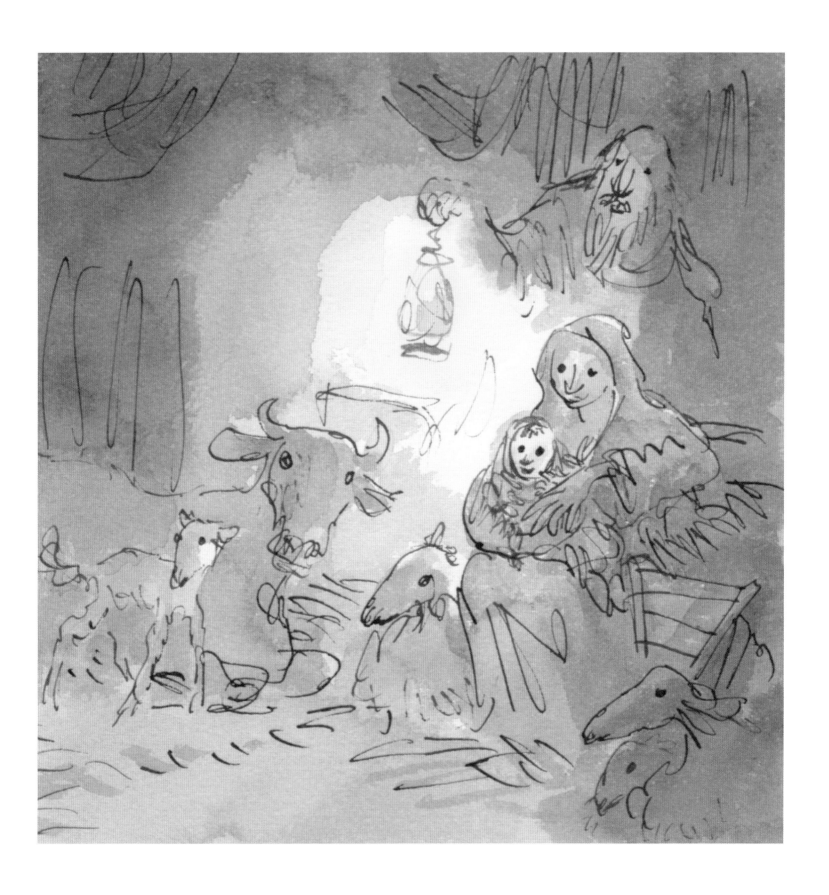

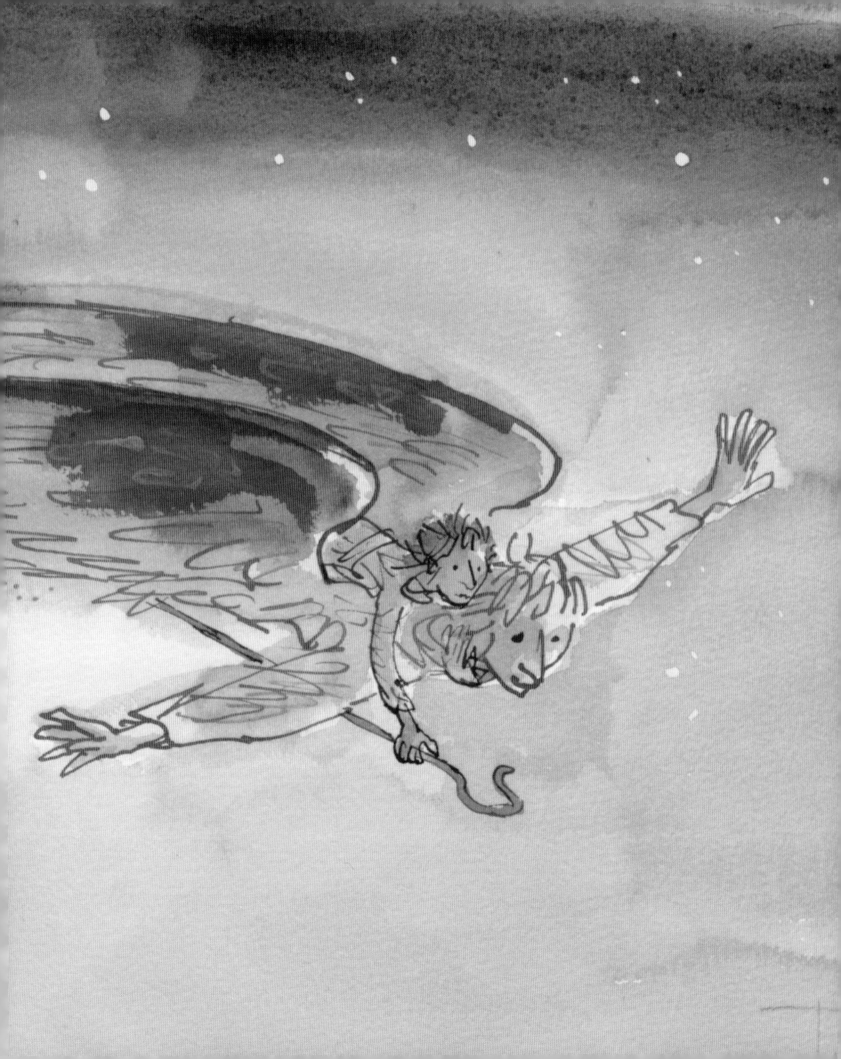

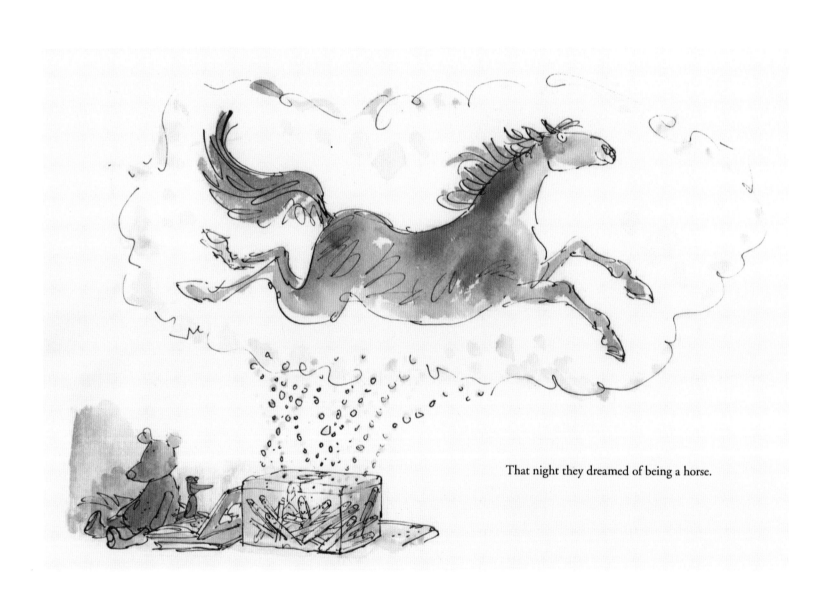

That night they dreamed of being a horse.

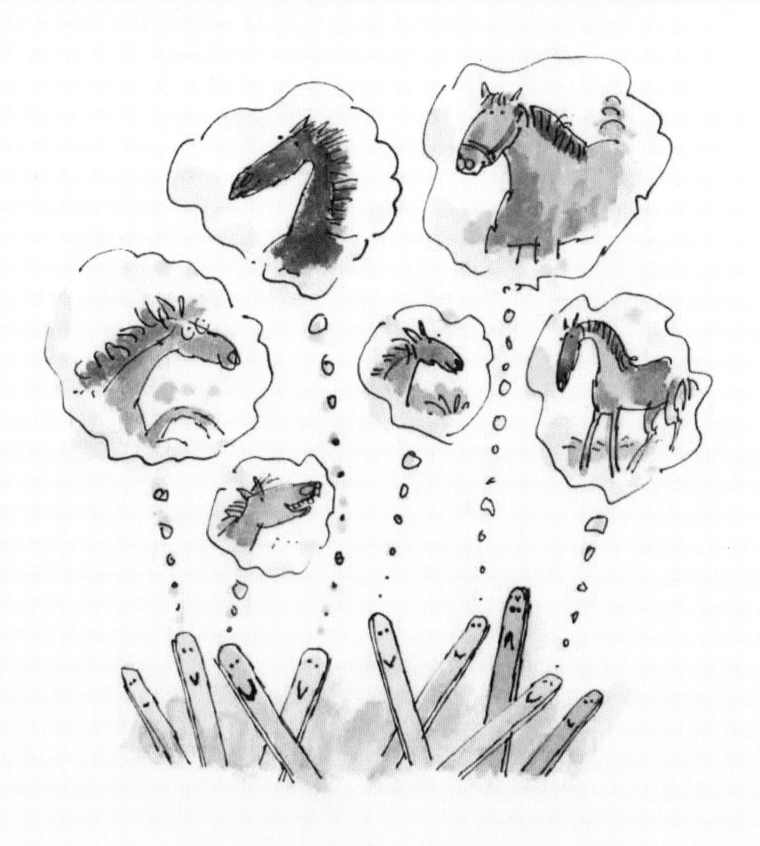

"We'd like to be a horse, too,"
said some of the other sticks.

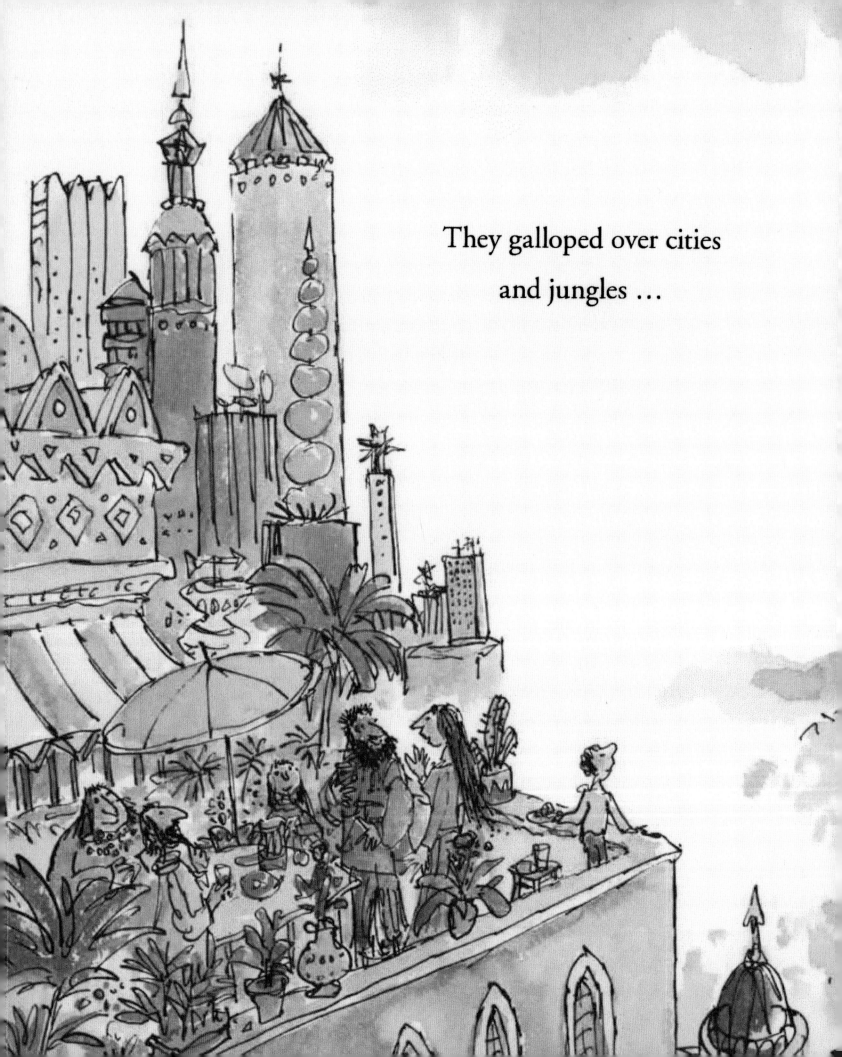

They galloped over cities
and jungles ...

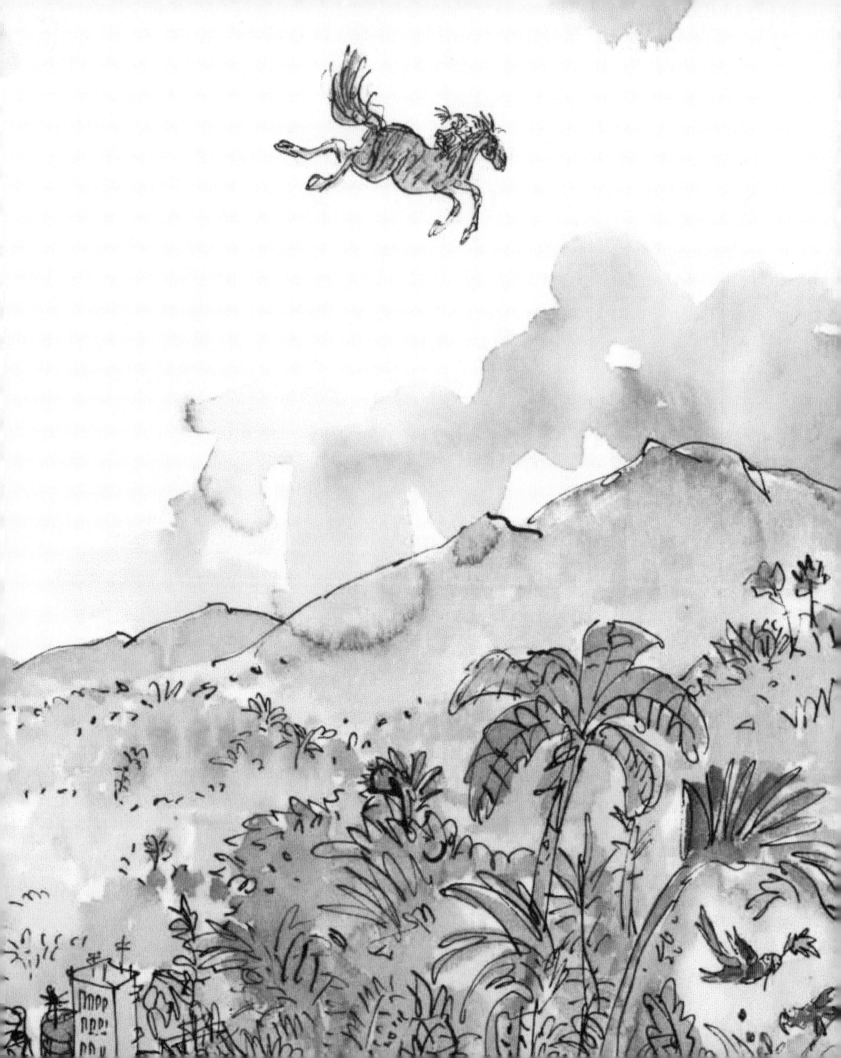

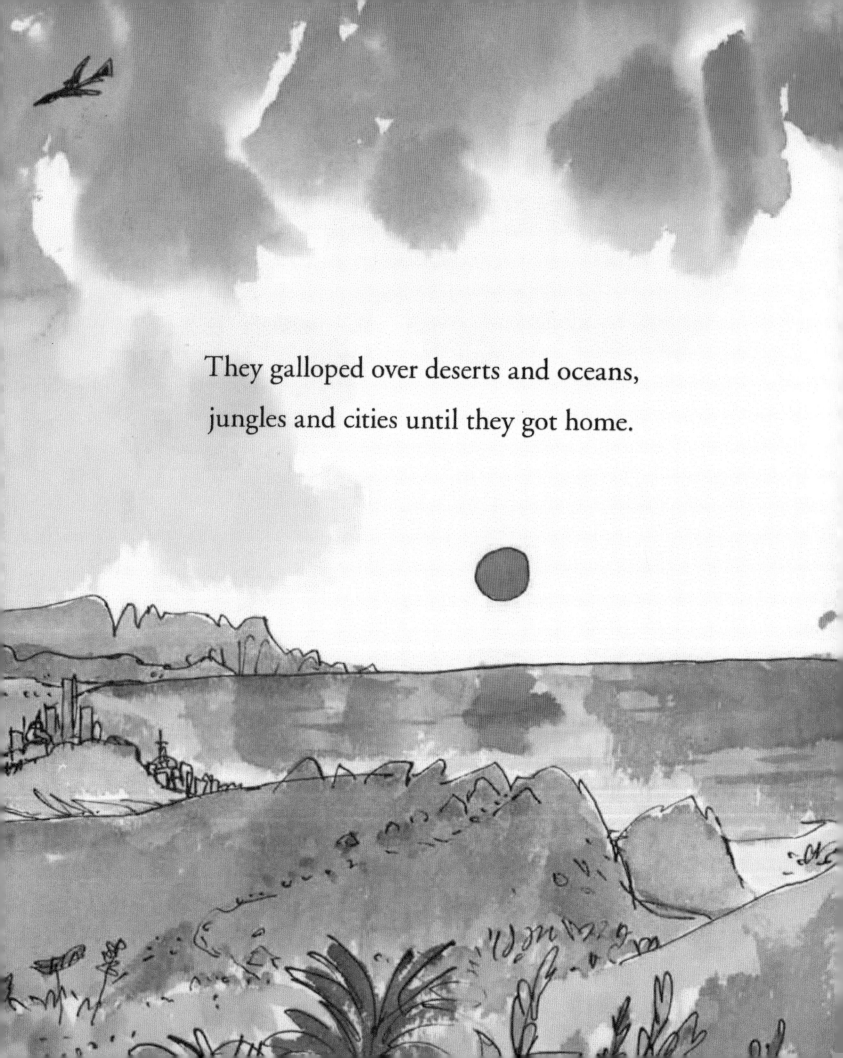

They galloped over deserts and oceans,
jungles and cities until they got home.

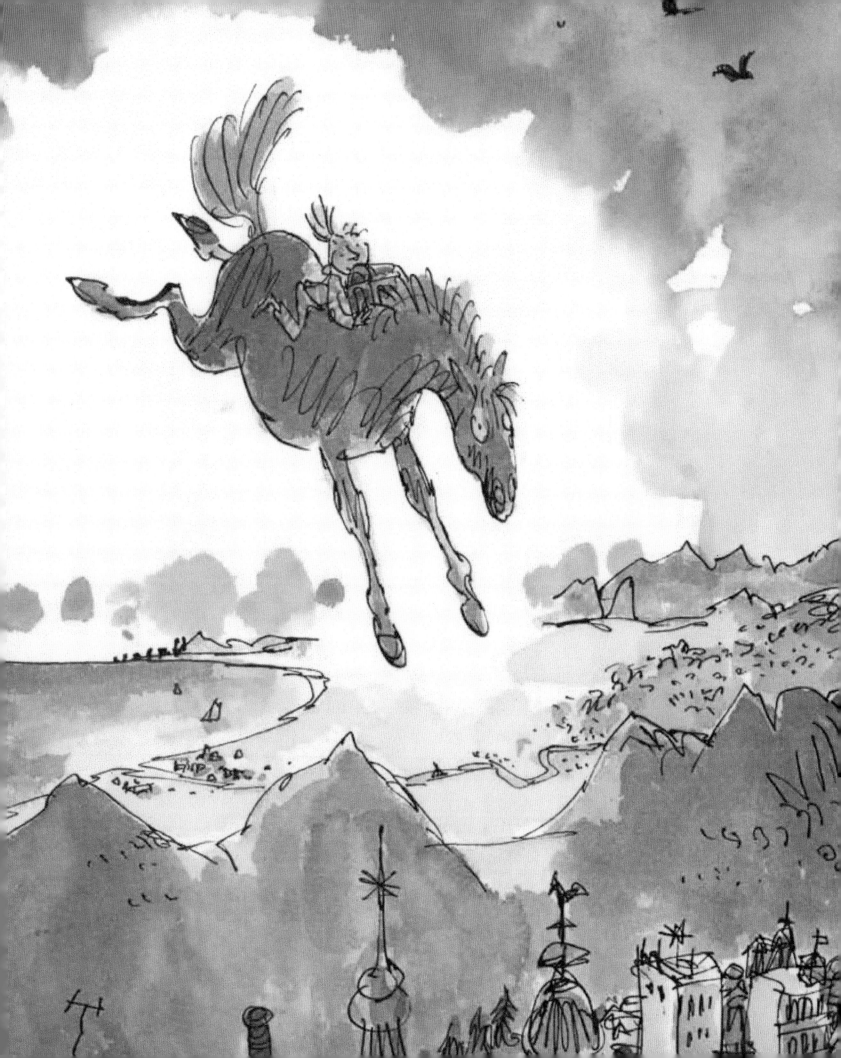

Roald Dahl Revisited

If the continuing success of the Roald Dahl books is extraordinary, it is not surprising. It is
a success that brings with it, for me as for others, continuing activity. After Roald's death in
1990 Penguin Books acquired the rights in his first six books, the ones that had appeared before
our collaboration began. I was asked to re-illustrate them to bring them into sequence with the
later books and give the whole sequence (with one exception, *The Minpins*, illustrated by Patrick
Benson) the same look; I suppose it might be thought of in marketing terms as an exercise in
branding. As a consequence for two or three years, while friends occasionally asked me if it was
strange not to have any more Roald Dahl to illustrate, I found myself more continuously and
concentratedly at work than ever – on *James and the Giant Peach*, *The Magic Finger*, *Charlie and
the Chocolate Factory*, *Charlie and the Great Glass Elevator*, and *Fantastic Mr Fox*. It was a rather
different experience from illustrating Dahl titles as they first appeared, with that unique aspect
of Gipsy House consultation; but at least I was comfortable in retaining a sense of what their
creator's preferences might be, and also – as when I was looking for approval for making the
Oompa-Loompas' hair stand on end – that I had Mrs Dahl to appeal to.

Later, while respecting the illustrations as they existed, there were other refreshments, such as
gift editions with colour skilfully added by hands not mine, but under my eye. However, when in
2010 a coloured version of *The Twits* was called for I felt it was a task that I had to take on myself.
The reason was not that a wealth of colour was called for, but if anything the reverse. The original
mood of the illustrations was metaphorically quite black, and so I was anxious that the colour
should be restrained; purples and greens would help everything and look suitably rebarbative
and poisonous. There were just one or two occasions, by contrast, where colour could flourish
appropriately, with the balloons and the Roly-Poly Bird's tail, and most dramatically when the
birds and monkeys unite their efforts to get the carpet up on to the ceiling.

The Twits in colour

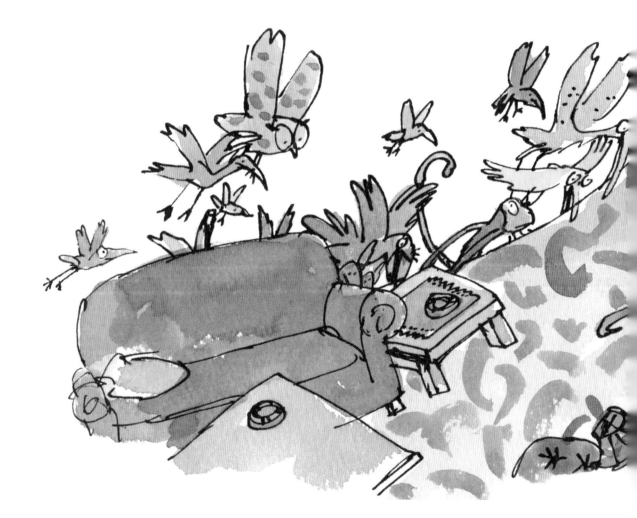

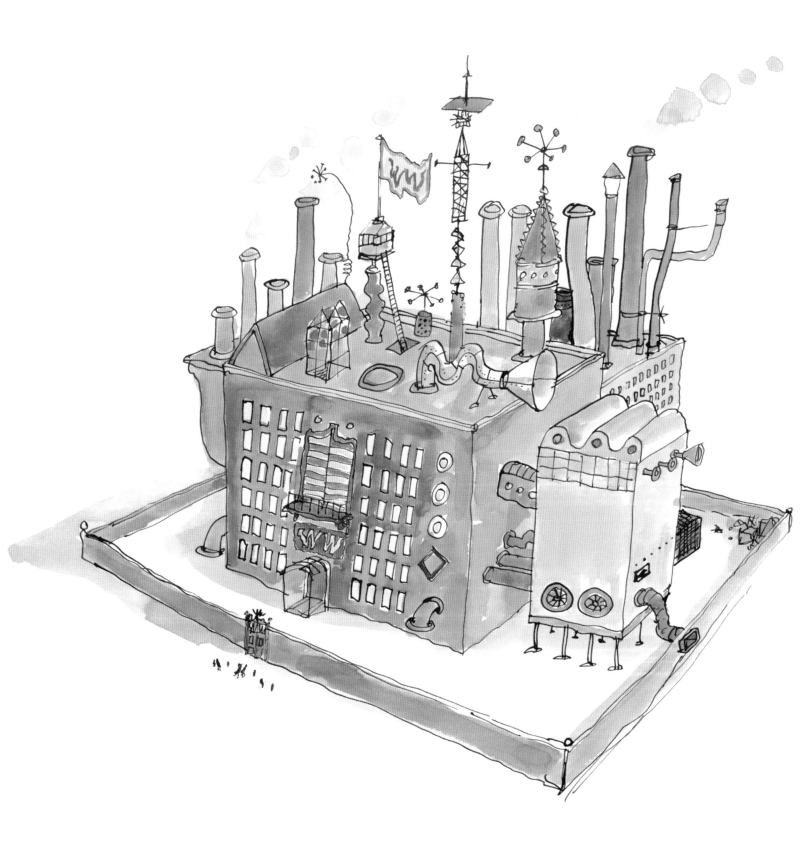

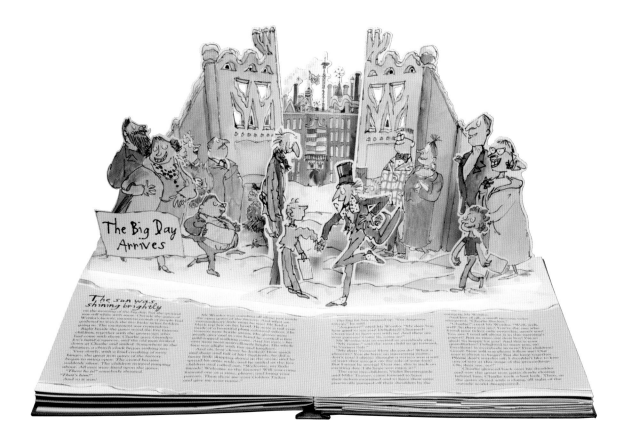

Enhancements of the books also call for other elements of hand work. One of the most unexpected of these (to me, at any rate) was a pop-up version of *Charlie and the Chocolate Factory*. Fortunately, I had some years previously carried out a complete version of Mr Willy Wonka's chocolate factory seen from two directions, and it came very conveniently to hand here. Apart from that I was involved in completing certain figures, providing arms to wave, and so on. But my efforts were insignificant compared with what must have gone into the organisation of the paper engineering and the adaptation of a substantial text to fit into a sequence of ten dramatic double-page spreads. You can now even get the chocolate factory popping-up in several languages.

Another even more dramatic version of one of the books to which I made a small contribution was the Royal Shakespeare Company musical of *Matilda* by Tim Minchin and Dennis Kelly. Called originally *Matilda: A Musical*, by the time it transferred to London it was so successful that it had become *Matilda The Musical*, and had earned publicity that no longer referred back to the original book. However, it might have been possible for me, seated in the dress circle and with the aid of a powerful telescope, to see the school badge which I designed specially for the show. Even without the help of a telescope I had the unusual experience of seeing Miss Trunchbull, almost exactly as she is in the book, terrifyingly active in three dimensions.

Roald Dahl Day is 13th September – Roald's birthday. The activities that began a few years ago to celebrate it soon spread out to fill in one way and another most of the month, and it is as part of these celebrations that I have actually found myself on stage. On several occasions the stage was of the Olivier Theatre, where, to a full house, a group of three or four actors would read extracts from Roald's works. I have vivid memories of, among others, Alex Jennings and Simon Russell Beale, and a striking Alistair McGowan performance of a section of *The Twits* translated into Scottish.

Pop-up version of Willy Wonka's Chocolate Factory

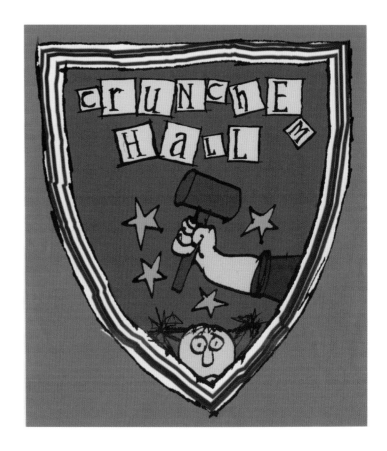

A visualizer is a useful piece of equipment which enables an audience to see what you are drawing at large – sometimes at enormous – size on a screen as you do it. It also made it possible to draw while the actors are reading. In 2011 the National Theatre performance was transformed into another event at the Royal Festival Hall where, in front of an audience of two thousand children I was able to talk and draw not only for them, but virtually live across Great Britain and to countries as far as North and South America. It also gave me the opportunity to draw some of the odd creatures mentioned by Roald in verses in the books which I did not have the chance to depict in the published versions.

The year 2012 saw the coincidence of the Queen's Diamond Jubilee and the thirtieth anniversary of the publication of *The BFG*. There is the happy coincidence that in the book the Big Friendly Giant makes an unorthodox visit to Buckingham Palace. The Royal Mail seized the opportunity by issuing a set of Roald Dahl stamps, with characters from the books representing the different denominations, as well as some extra decorative stamps to celebrate *The BFG*.

Another project in which I was involved was not to do with the enhancement of the books – or not at least in the area of visual surprises. It was rather consolidation – the establishment of a uniform edition of all the titles with new jackets incorporating original or newly adapted jackets. There is something very satisfying, it seems to me, in the knowledge that you can have such a complete set of Dahl titles standing side by side on your bookshelf.

The school badge for Matilda's school

Whangdoodle

Hornswoggler

Snozzwanger

A Whangdoodle and a Hornswoggler

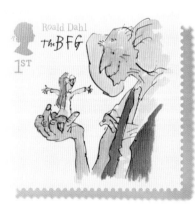

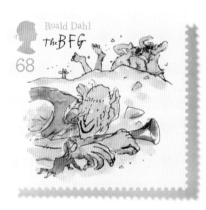

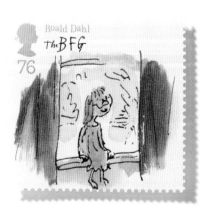

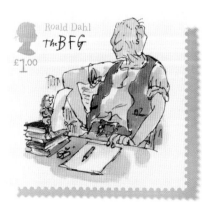

Roald Dahl stamps 2012

Covers for the uniform hardback edition of Roald Dahl's works

The prospect of this edition also gave me the opportunity to produce a small new set of Dahl drawings. When *Boy*, his book of his childhood reminiscences, came out twenty-eight years ago, I did a drawing of him as a boy as I imagined him from available photographs. There were also some drawings in the text, unattributed; I think they were intended to be 'as if by the author'. As amateur drawings they were no doubt expected to have no style, but I think a bit of my influence might have crept in. One or two references to them, consequently, assuming that they were by me, didn't make me happy without getting me to the point of doing anything about it. However in 2010 the advertisement for an American republication described the book as illustrated by me and showed one of the anonymous drawings. I thought that it might be time to, belatedly, resolve the situation, and the Dahl estate and Jonathan Cape who had first published the book graciously sanctioned my going to work – not again, but for the first time – to replace the drawings. So that, alongside its photos, *Boy* has a completely new set of drawings. I hope they may be accepted as another Dahl Day tribute.

New illustrations to 'Boy'

Drawn to Order

There is an illustrator of my acquaintance who, while working at a high level of taste and efficacy, likes to refer to himself as a 'jobbing illustrator'. I can see the appeal of the label – the implication of professional craftsmanship, the businesslike readiness to respond to whatever demand may turn up. Most of the work that an illustrator is engaged on is by definition 'drawn to order', but in my case, where I may engage over weeks or months in the production of a series of related drawings, it can be stimulating to have that rhythm interrupted, and to have to turn aside and address something that is needed now, or soonish, for some specific occasion. (There are also times, needless to say, when such interruptions are the opposite of stimulating – but I more or less know how to avoid them by now.)

Magazine commissions are perhaps the most obvious or frequent examples, so, that, for instance, in the years when Boris Johnson was editor of the *Spectator* he on two occasions asked me to provide a cover for the double Christmas edition. This was a curious little outing for me, since forty years before I used to be a frequent contributor of covers to the magazine – in those days it was for me rather like a young actor's repertory experience, with a different part to play every week. That sort of experiment was not required here, but they were enjoyable promptings. If the twins on the tightrope are not the editor himself, I think they were evidently inspired by him.

Erika Wagner on the *Times* also invited me on two occasions to supply covers for supplements which went in search of new children's book writers. A rather different sort of commission came from a publication that I previously knew nothing about. The title of *Vice* magazine doesn't quite suggest its nature but it is directed at young adults, is free (although you have to pay if you want it posted to you) and has an international readership of millions. They were happy to publish some pages of drawings of women and strange creatures that I was working on, and also invited

Cover illustration for a 'Times' supplement about new children's writers

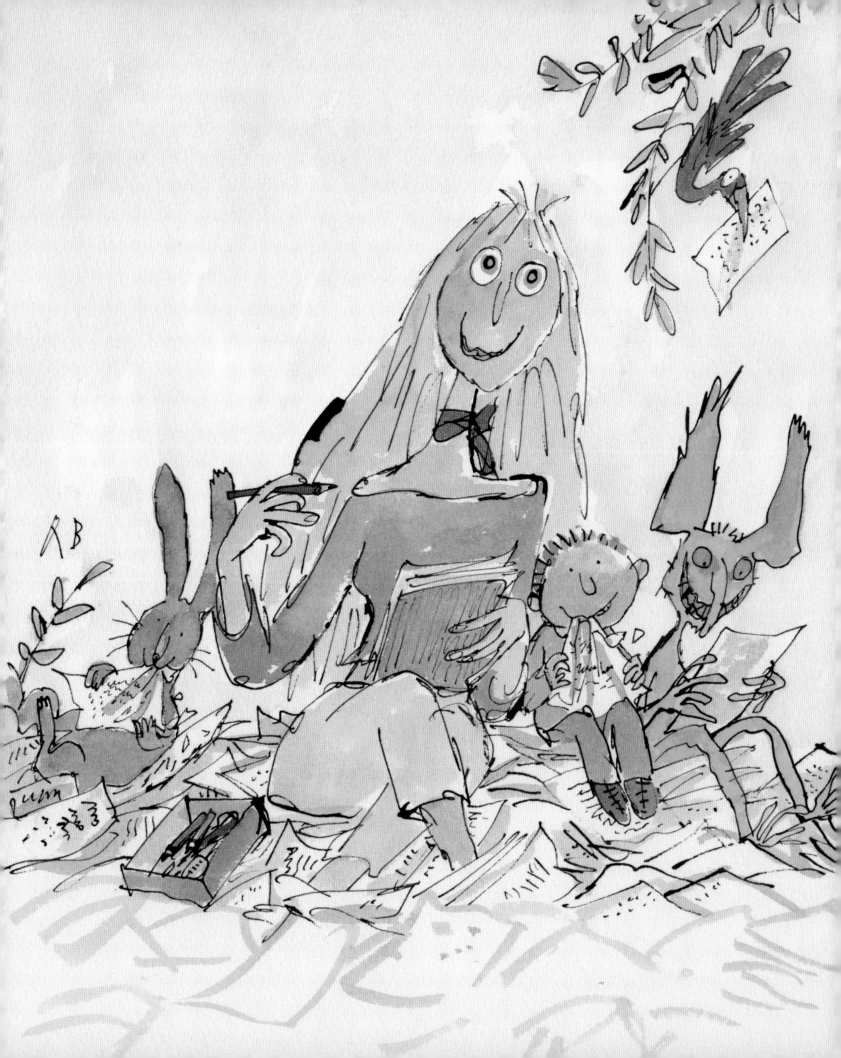

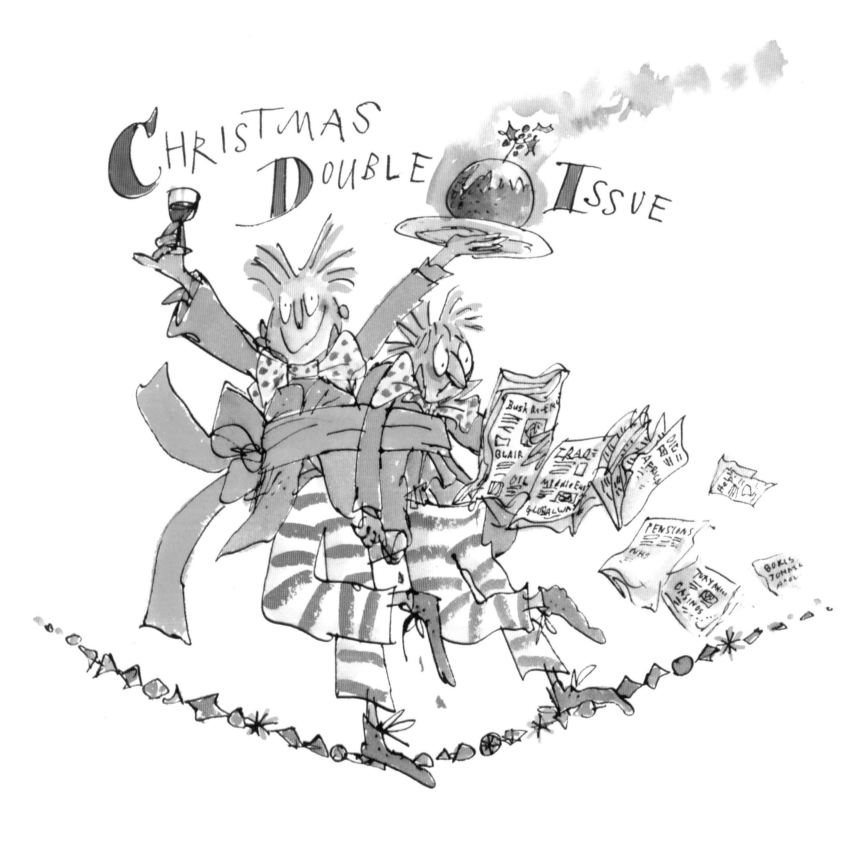

104 *Covers to special issues of the 'Spectator'*

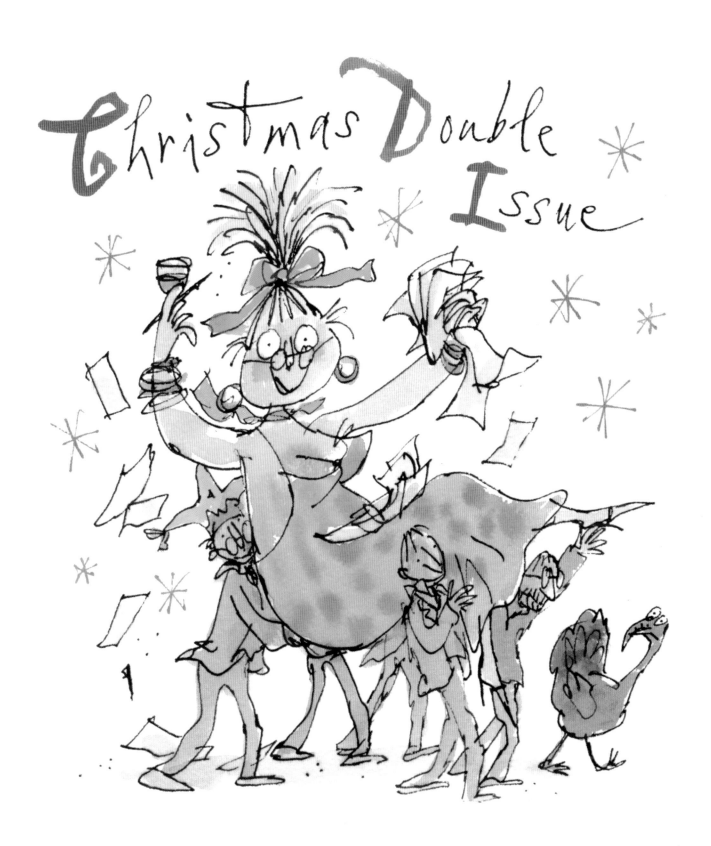

Christmas Double Issue

me to illustrate a short story. In that drawing there were also some other strange creatures who seemed to be inhabiting the painful psychology of the protagonist. The mood of the drawing might perhaps suggest it was one of a longer or more introspective series, but being asked to do it was another example of the attraction of the drawn-to-order business; that of rising to the occasion, assessing the situation, coming up with a solution. It's that rising to the occasion aspect that prompts me to include here two commissions which might otherwise be in the section devoted to books. Neither of them, however, represented an invitation to accommodate one's approach to a narrative's individual pace and mood, because both of them were in the nature of jeux d'esprit.

It was a privilege to be asked to undertake a task for John Julius Norwich who, when he is not being a distinguished scholar and historian, is a good man for a jeux d'esprit. In *The Twelve Days of Christmas* John Julius retells the song in a series of letters from Emily to the young man who is (at any rate to begin with) her Darling Edward, the sender of the gifts. The situation deteriorates as the gift become more unmanageable (who needs four calling birds?) and the artist's task is to prompt the imagination of the reader to keep up with the accumulative possibilities of disaster.

The second book, *The Illustrated Christmas Cracker*, is a whole series of invitations to rise to the occasion. Every Christmas John Julius Norwich sends his friends, in place of a Christmas card, an elegant pamphlet of cuttings, quotations, poems, extracts from letters, items of bizarre translation – a Christmas Cracker. Every ten years these are gathered together in a hardback volume, and it was into these I was to delve in search of illustratable items. There are plenty of moments of levity, offering, say, black knickers or an extremely bad-tempered hedgehog; but other moods too – a sleeping child, the shadow of a bamboo against a screen.

Four Calling Birds and A Partridge in a Pear Tree from 'The Twelve Days of Christmas'

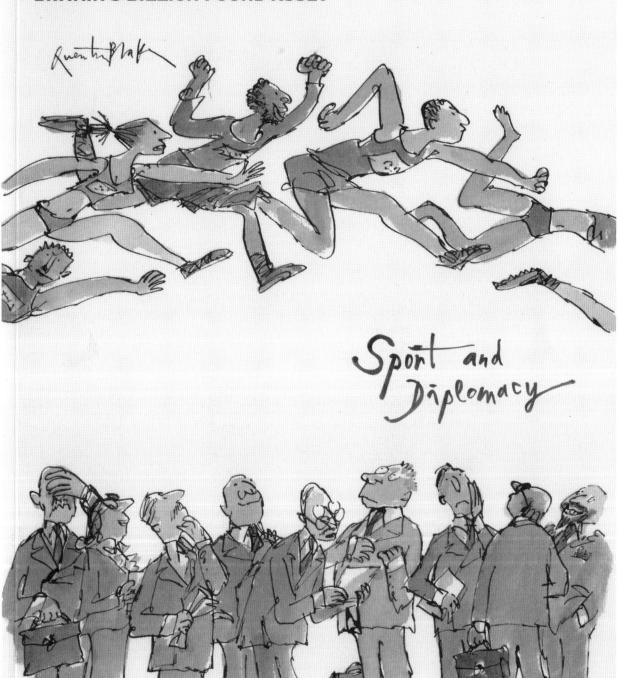

DIPLOMAT

ESTABLISHED 1947

FEBRUARY 2011 £10

- IS THE EU A GLOBAL PLAYER?
- CYBER-TERRORISM
- BRITAIN'S BILLION POUND ASSET

Sport and Diplomacy

Cover for 'Diplomat' magazine

WINNER! BRITAIN'S BEST NEW MAGAZINE

STYLIST

ISSUE 79
25 MAY 2011
STYLIST.CO.UK

The
Books
We
Never
Outgrow

Cover for 'Stylist' magazine

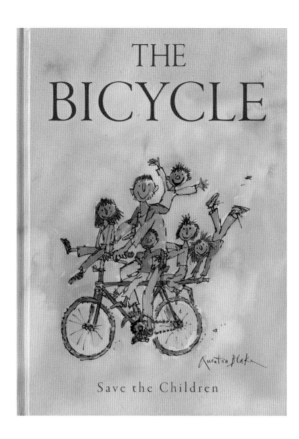

While being commissioned for covers, I had also discovered *Stylist,* a magazine of fashion which nevertheless has thoughts of its own, and *Diplomat*, which serves the international diplomatic community in London. The art editor of the latter gave me the opportunity of drawing some energetic athletes, which I can find enjoyable though I know nothing about sport.

The *Stylist* cover was for a feature about children's books and into which I was asked to introduce some of my own characters. Understandably, many of my images drawn to order relate to that area of activity, such as the cover for a book called The Bicycle edited by Colin Thompson to help children in Cambodia. I have also been called on several occasions to draw children reading – nervously, for the Dyslexia Association; enthusiastically, for the Centre for Literacy in Primary Education. I also drew them with their teachers for a pamphlet for my friend and colleague Ghislaine Kenyon. These are all drawings which have to have something of the air of being observed, although in fact they are all invented at the drawing board.

When I was starting out as an illustrator, many years ago, I was glad to be commissioned to do a certain amount of advertising – it was well paid compared to other tasks, despite the high level of wastage, by which I mean all those tasks embarked on that never got into print. In those days one could also feel oneself not so far from a time, in the 1930s and 1950s, when artists such as Savignac and André François would do advertising which was amusing, entertaining and witty. However, I gave up such work as soon as I was able to, and my response to any enquiry has been for many years that I just don't do advertising. My attitude to it is at best ambiguous, and of course there are no lack of promotions one would prefer not to have to support. In the light of that decision it is all the more gratifying to be able to help promote projects that you feel really

Cover illustration for 'The Bicycle'

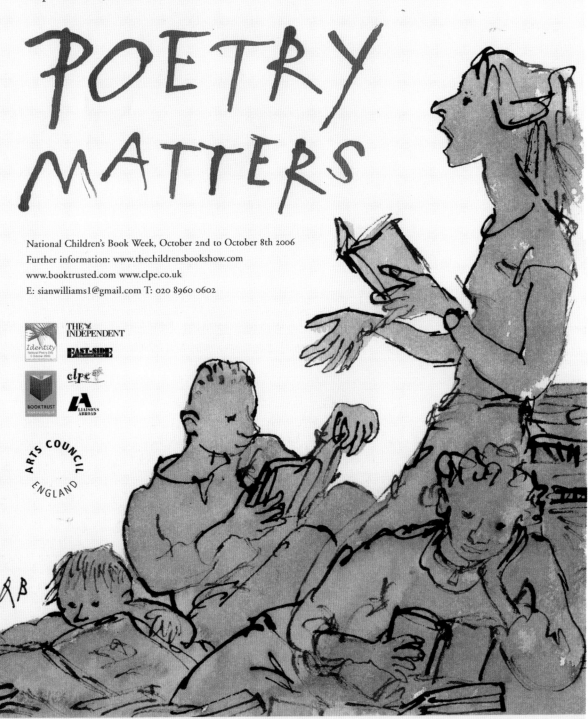

The Children's Bookshow

A National Tour of Children's Writers funded by Arts Council England
September 29th to November 15th 2006

POETRY MATTERS

National Children's Book Week, October 2nd to October 8th 2006
Further information: www.thechildrensbookshow.com
www.booktrusted.com www.clpe.co.uk
E: sianwilliams1@gmail.com T: 020 8960 0602

Illustration for a poster for 'Poetry Matters'

Illustrations for 'Artmatters' brochure for Ghislaine Kenyon

For the Centre for Literacy in Primary Education and for the Dyslexia Association

115

are valuable: to produce a poster, for instance, such as that for the series Poetry Matters; or a cover for the annual of the Bologna Children's Book Fair; or a Mammoth logo for Kids in Museums. Or, with a rather different seaside flavour, a logo for the Hastings Old Town Storytelling Festival. Drawings are also the contributions that I think I can most usefully make to a number of charities with which I have been involved on a more long-term basis. I was in at the start, for instance, of the Campaign for Drawing. This was set up in 2000 with a grant from the Guild of St George (established in his own lifetime by John Ruskin) to encourage people to draw – not only children, but people of every age. What was revelatory to me about it (if not exactly surprising) is that not a great deal of encouragement is necessary, and it is almost more a question of giving an assurance that you are allowed to draw, though an amateur, just as you are allowed to sing. The Big Draw, in October, is its main occasion and that is repeated in hundreds of sites across the country. After ten years I have become less actively involved in the Campaign's projects but not so much that I was not able to make a two-and-a-half minute journey by barge across the Regents Canal in 2011 to open the Big Draw's Big Splash, or to make a drawing for the Big Draw, Big Make at the Victoria and Albert Museum in 2012.

I have also been an Ambassador for Prince Charles's Foundation for Children and the Arts which exists to stimulate young people's awareness and participation in the arts, and drawn images for them to promote StoryQuest, MusicQuest and the Great ArtQuest, as well as other ventures.

Nearer to home, in the sense of nearer to what I do myself, is the House of Illustration, which is the charity dedicated to setting up a museum and centre for the display and study and celebration of the art of illustration. What I think I can most significantly do for the venture is eventually to give it my archive of originals. More immediately I have produced drawings to order. Some are

For Hastings Storytelling Festival

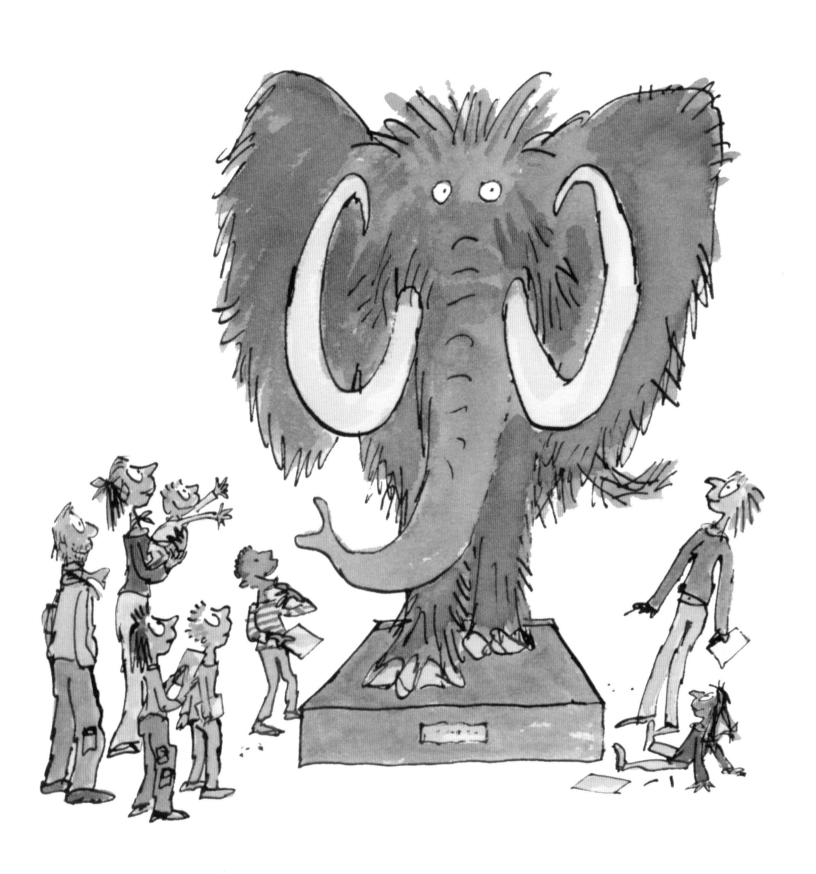

For the Kids in Museums campaign, and, on the next pages, cover for Bologna Children's Book Fair Annual and cover for a Campaign for Drawing Sketchbook

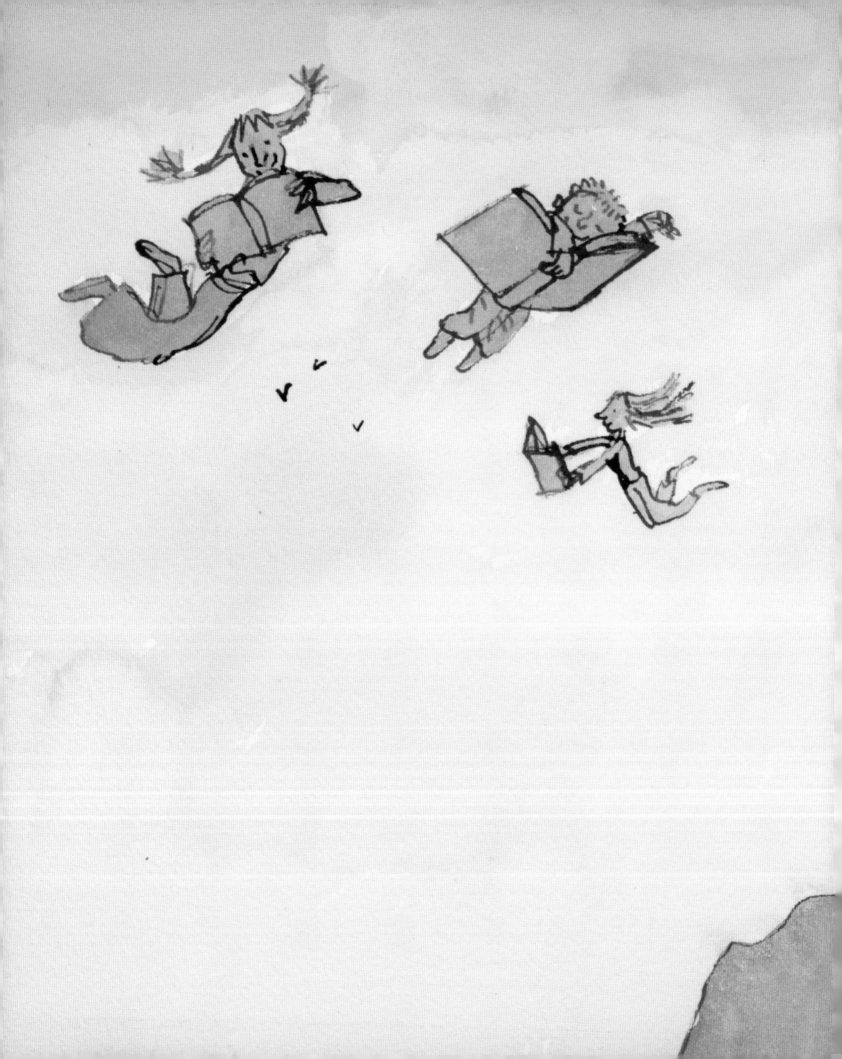

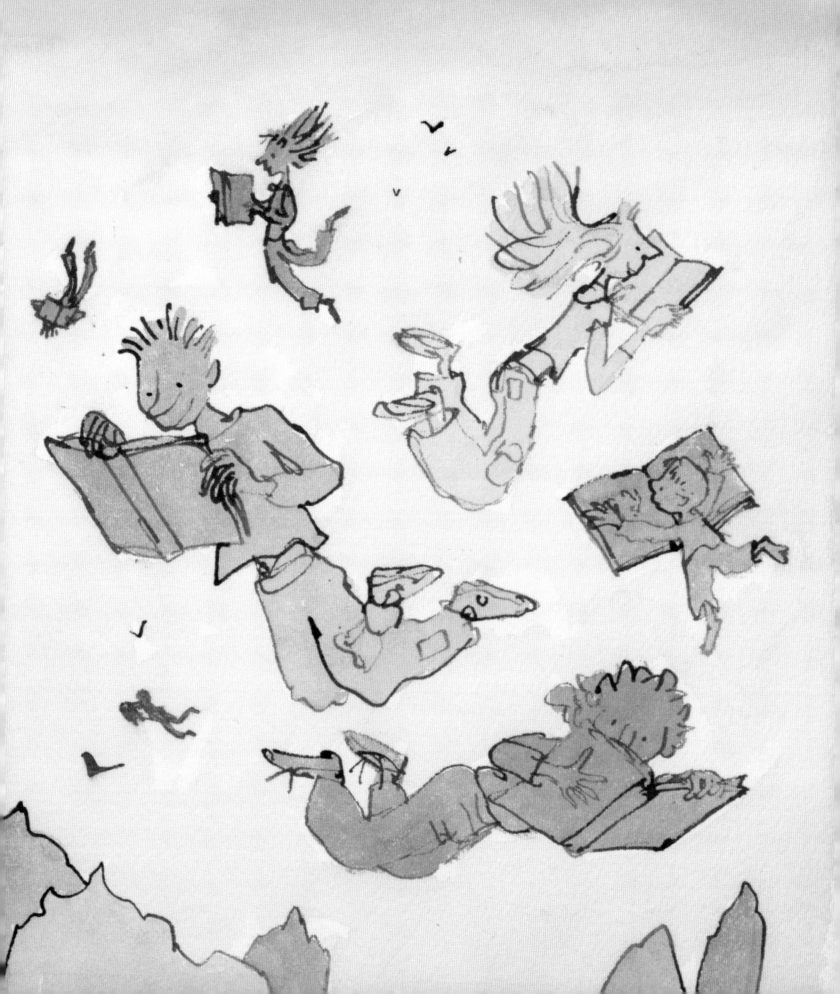

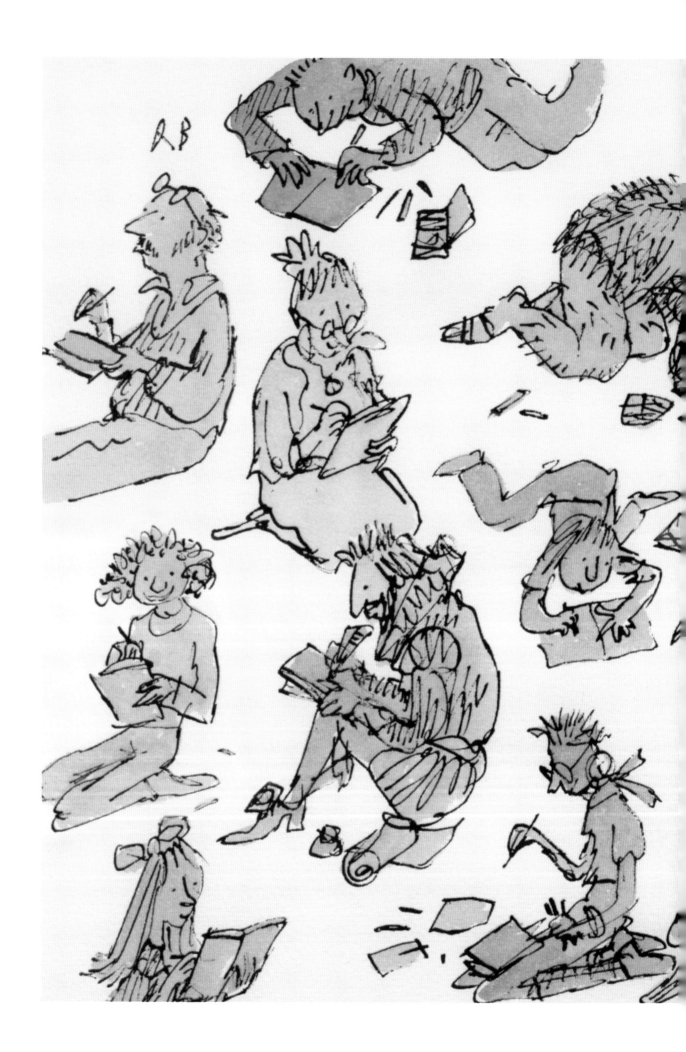

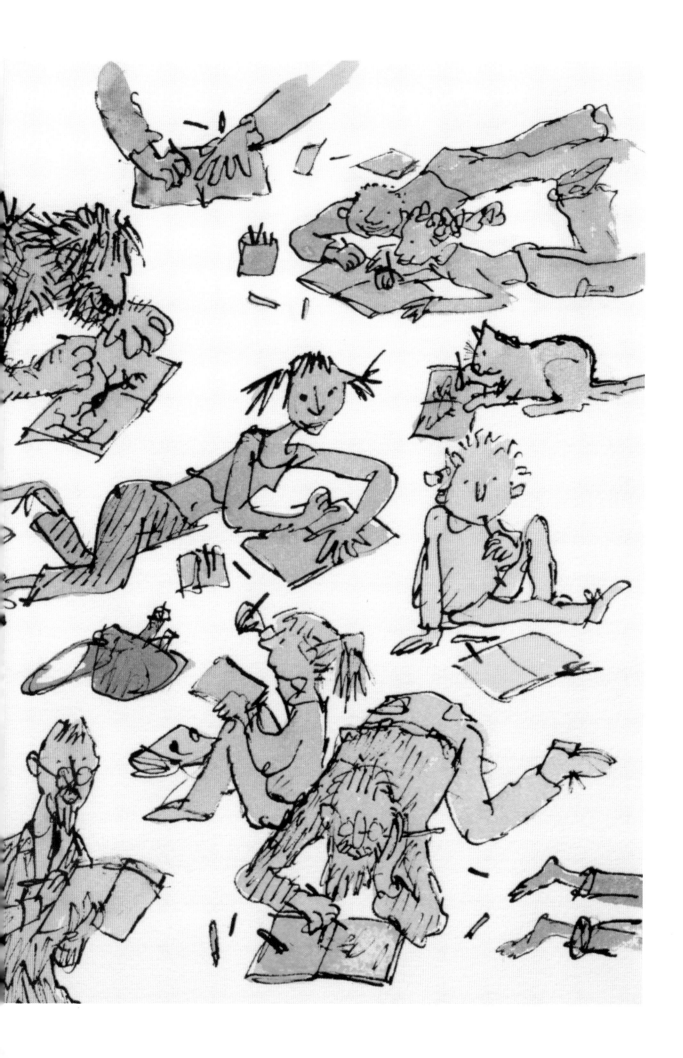

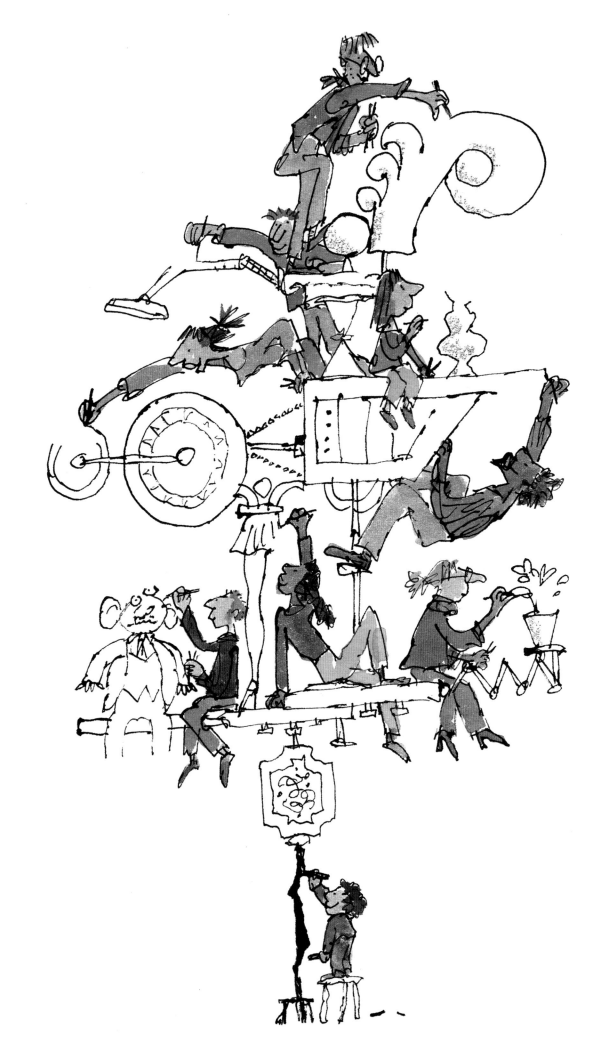

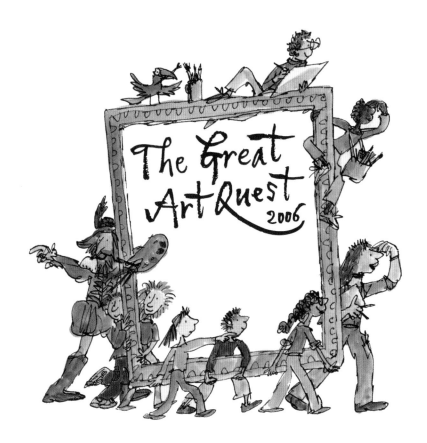

of assorted birds to encourage donors and supporters; one is an Illustration Creature with a trio of attendant handmaidens; and yet one more, was for an exhibition called *What Are You Like?* It was based on a Victorian game: artists, and other well-known people who like to draw and paint, were invited to suggest the kind of person they were by depicting their favourite place, food, weather, reading and so on, without actually portraying themselves. The participants were shown a sample of the original game: a set of drawings in a grid of squares. I was sent on ahead, as it were, to make it clear that such a straightforward answer wasn't necessarily what was called for.

Another charity of quite a different kind is Survival International. This time I know nothing of their work at first hand, but I believe passionately in what they are trying to do to minimise some of the effects of our uncaring global culture of greed and relentless growth. Once again my most useful contribution is drawing, and I am pleased that the Christmas cards that I have drawn for them are a useful source of income. I confess that Christmas cards are not an easy task at best of times and here are not made easier by the fact that the tribes will be mostly unaware of Christmas. Thank goodness for reindeer.

In recent years I have had the opportunity to renew my acquaintance with Cambridge where I was a student fifty years ago. The most noticeable evidence of that appears in a later section of this book, but I have also produced drawings for my own college, Downing. The college emblem is a griffin, and so I have invented suited griffins for a college magazine cover; an athletic griffin for a t-shirt; and a green griffin as a logo to signal the college's ecological requirements.

Logo image for Big Draw, Big Make for the Campaign for Drawing and for the Great Art Quest for the Prince's Trust for Children and the Arts

An Illustration Creature for the House of Illustration and, on the next page, an illustration for the 'What Are You Like?' exhibition

125

126

dwich
know
this is

5 Comfort : Scarves
6 Book : Alphonse Allais

7 Footwear : Trainers
8 Weather : Breezy

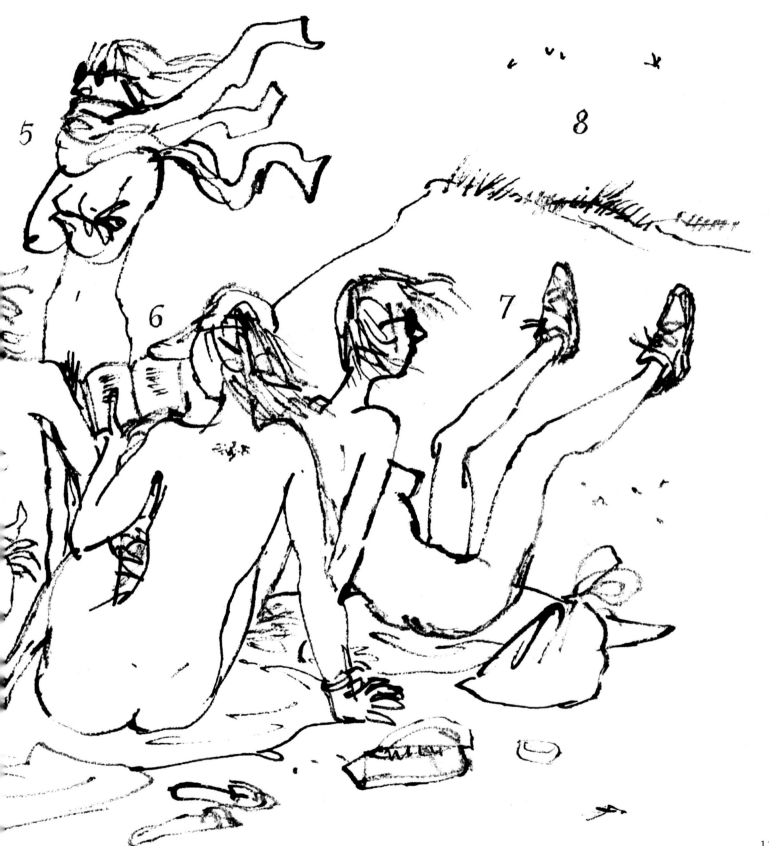

5

8

6

7

127

Christmas cards for Survival International

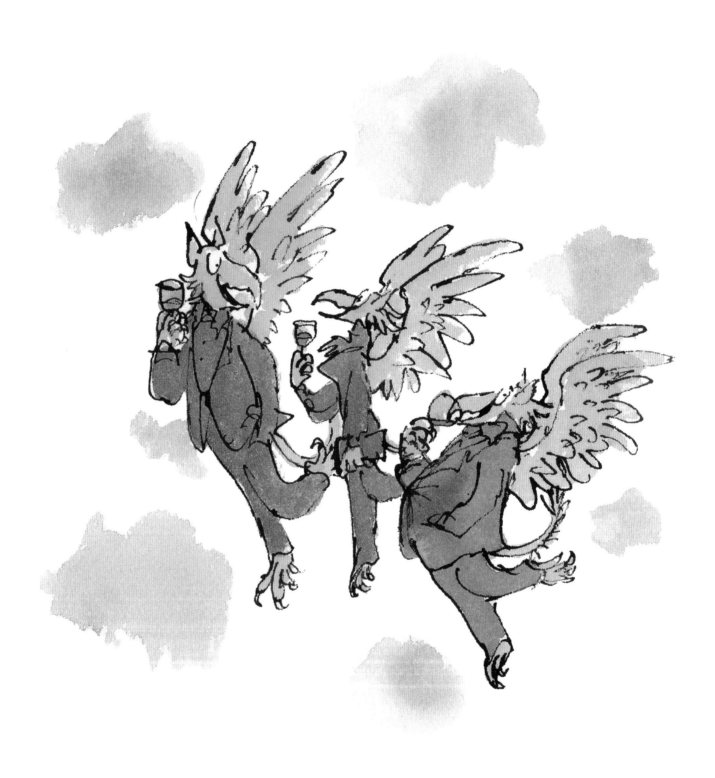

Downing Griffins celebrating and an Athletic Downing Griffin for a T-Shirt,
Logo for Downing environmental announcements

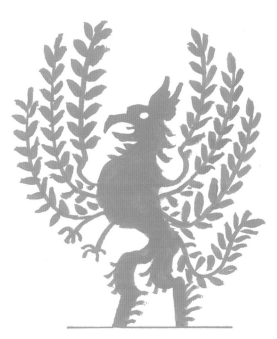

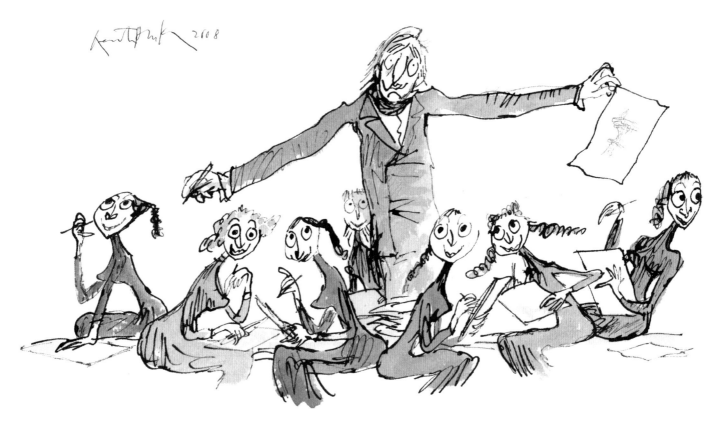

Early Days or, Mr Ruskin Inspiring the Youth of England to See.

Ruskin for Anglia Ruskin University (above) and Ruskin and Octavia Hill and the poor of London (below)

I also have links with another university in Cambridge; when a student I attended life classes at Cambridge Art school which is now part of the Cambridge Campus of Anglia Ruskin University. For a volume celebrating the 150th anniversary of the school I took the opportunity to offer a drawing of Ruskin himself, encouraging the young.

Ruskin was for a number of years a guide and mentor to the young Octavia Hill, when she worked diligently at illustrations for him. I discovered this, and what an extraordinary person she was, when I was invited to do some drawings of her for a volume celebrating her work, which included, significantly, being one of the founders of the National Trust.

The two most recent examples of drawn-to-order have both to do with design and, as it happens, fiftieth anniversaries. The first anniversary was of D&AD – the association of Designers and Art Directors – who decided to celebrate the fiftieth issue of their annual by arranging for it to have fifty different covers by fifty people they identified as noticeably 'creative'. (I am reminded irresistibly of a moment in Paris in the company of the late great Pierre Marchand, director of Gallimard Jeunesse. Attempting to show my familiarity with contemporary French I spoke of 'le top cinquante'. He gave me a reproving look: 'Nous disons le top fifty.') With an unrestrictive brief I submitted three alternative depictions of women art directors; I was pleased that they chose the nude green one. Her hair is Antwerp blue.

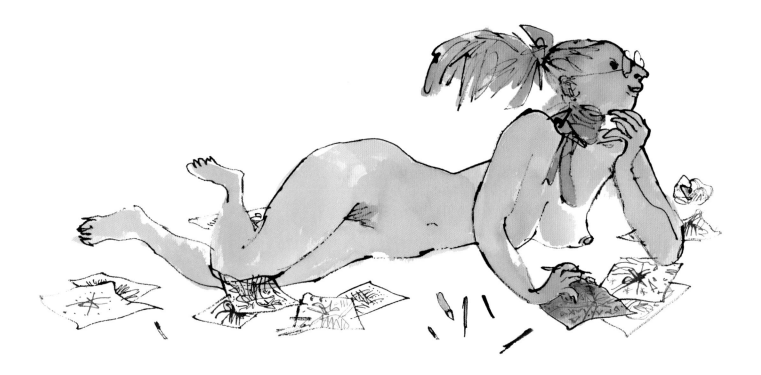

My last example was commissioned by the Design Council, and was unusual in that it was destined for a single recipient. In November 2011 I was surprised and pleased to be the winner of the Prince Philip Designers Prize. There are nine nominations from nine professional bodies, who include architects, product designers, graphic designers – the whole range of the design profession. This was the fiftieth time the award had been made, and it was to be the last. The Duke of Edinburgh has been an active chair of the judges since its inception just over fifty years ago, and no doubt he felt that at ninety he might honourably stand down.

What the winner gets is a certificate, letterpress printed by the best person to do it, Alan Kitching. As this was the last time the award was to be made the Design Council had the inspiration of giving Prince Philip a certificate of gratitude in return, uniquely for him, and asked me to work on it. The prince's name was again printed in Caslon and the rest drawn and lettered by me with a scratchy pen. How would it be received?

Though HRH was making the award for the fiftieth time and in his ninety-first year he could hardly have been more relaxed, articulate and positive, and there was obviously no diminution in his longstanding commitment to the theme. (When the announcement of the award was met with generous applause he said – 'I think we must have got it right.') To be called upon to create this certificate was of the same order of reward as being given one, and it's satisfying to be able to end this section with an image drawn rather specially to order for a single, specific (and no doubt not uncritical) eye.

A green art director for the cover of the 'Designers and Art Director's Annual 2012'

This certificate of gratitude is awarded to

Prince Philip, Duke of Edinburgh

in recognition of a triumphant 52 years of the Prince Philip Designers Prize

Certificate for the Design Council for presentation to HRH the Duke of Edinburgh

In the Shops

I mean in shops that aren't bookshops, of course. It's the destiny of some of the better-known characters in children's books to be given extensions of their lives which do not have much to do with their fictional experiences: they become merchandise or what the French call 'derived products' (produits dérivés). They go into a world of permissions, contracts and licences, where the most important person in a story may become the advocate of a brand of stationery, a stain remover or something fizzy to drink. These characters earn their author money (sometimes a lot of money) but they not only draw attention to the product but also re-advertise their book and increase the profits to be had from that as well.

My acquaintance with the business of merchandise falls very broadly into two halves. The first involves everything to do with Roald Dahl. I have at one time or another illustrated all Roald's books, with one exception, and the canon is effectively closed. We know who the characters are, we are acquainted with the accepted image of each character – this is one of the advantages which was no doubt foreseen in Penguin Books initiative to get all the books illustrated by the same person. One of Roald Dahl's many gifts as a children's book writer was his ability to invent a cast of very distinctive, idiosyncratic, often exaggerated and memorable characters. The fact that they are so universally well known, and so identifiable, makes them welcome as candidates for merchandise – indeed the only possible problem may be that there are almost too many of them. Nevertheless, the World of Roald Dahl is susceptible to all kinds of applications and the characters have been reinterpreted as everything from figurines to cake. The versions that are most attractive to me are those that are still printed, such as notebooks and calendars, where the drawings are transformed into other colours and sizes. Even T-shirts and pyjamas can be a surface for print.

Woodmansterne Cards

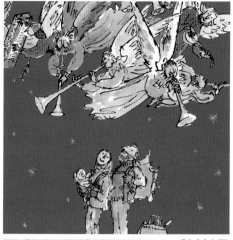

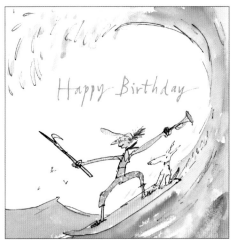

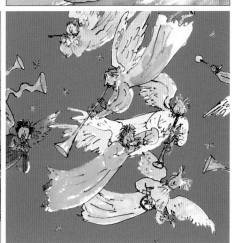

What was for me, a significant development into a different kind of merchandise venture occurred in 2001. Once or twice over time a handful or so of my published illustrations have been used as the images on greetings cards, but it was in that year that Chris Beetles was instrumental in putting the greetings card publishers Woodmansterne in touch with me. They had not tried before because apparently, 'we thought he wasn't available.' Once it was apparent that I was available Woodmansterne set about the business in serious fashion; to the extent that, in the following ten years there have been hundreds of different designs and millions of cards have been sold.

The card designs are first of all based on illustrations from books I have illustrated for younger children. Where illustrations from the original books are concerned, there is a fundamental difference from the Dahl projects and indeed from most other licensing arrangements. There, recognition of specific characters is of the essence; the character endorses the product. For the cards, the characters become generic: assorted adults of different ages and lively children. The designers at Woodmansterne have at one time and another shown remarkable ingenuity in re-applying drawings to family situations. The books as sources, however, just aren't adequate to the flow of occasions. I find myself inventing pictures to celebrate Mother's Day, exam success, your ninetieth or even hundredth birthday, or, at the height of summer, the Christmases that will arrive eighteen months later.

A drawing that was created for a page, or a double-page spread, can equally go round a cylinder, and so they have, both as mugs and lampshades. A lampshade can accept, for instance, a procession of people and creatures from John Yeoman's *Sixes and Sevens* but it's equally an opportunity to invent some eccentric new birds running in both directions.

Wild birds for a Stamp Creative lampshade

An interesting development that I had not envisaged came about in 2010 when Osborne and Little produced a range of fabrics and wallpapers based on the illustrations to several of my books under the general title of Zagazoo. It was a delight and a surprise to me to see how, in the hands of an experienced fabric designer, these images could be transmuted into patterns of quite disparate mood and application. The cockatoos are the most dramatic and are no doubt therefore the star of the show. But it was educational to me to see how a full-colour set of illustrations to my ABC became, printed in single colours, a sort of unexpected Toile de Jouey. Another design is made up of a hand-lettered alphabet and the numbers from 1 to 9. What might have been expected from its subject matter to be the most juvenile proved to be the most sophisticated – though even that varies depending on whether in black and white or a more assorted range of colours.

As I have already suggested, one of the interests of a project such as this is to see the same images printed at different scales and in different colours. There's a tantalising urge (which I am afraid won't be fulfilled) to go back and see some of my earlier books reprinted in different colourways.

Following four pages: wallpaper and fabric designs from the Osborne and Little Zagazoo collection

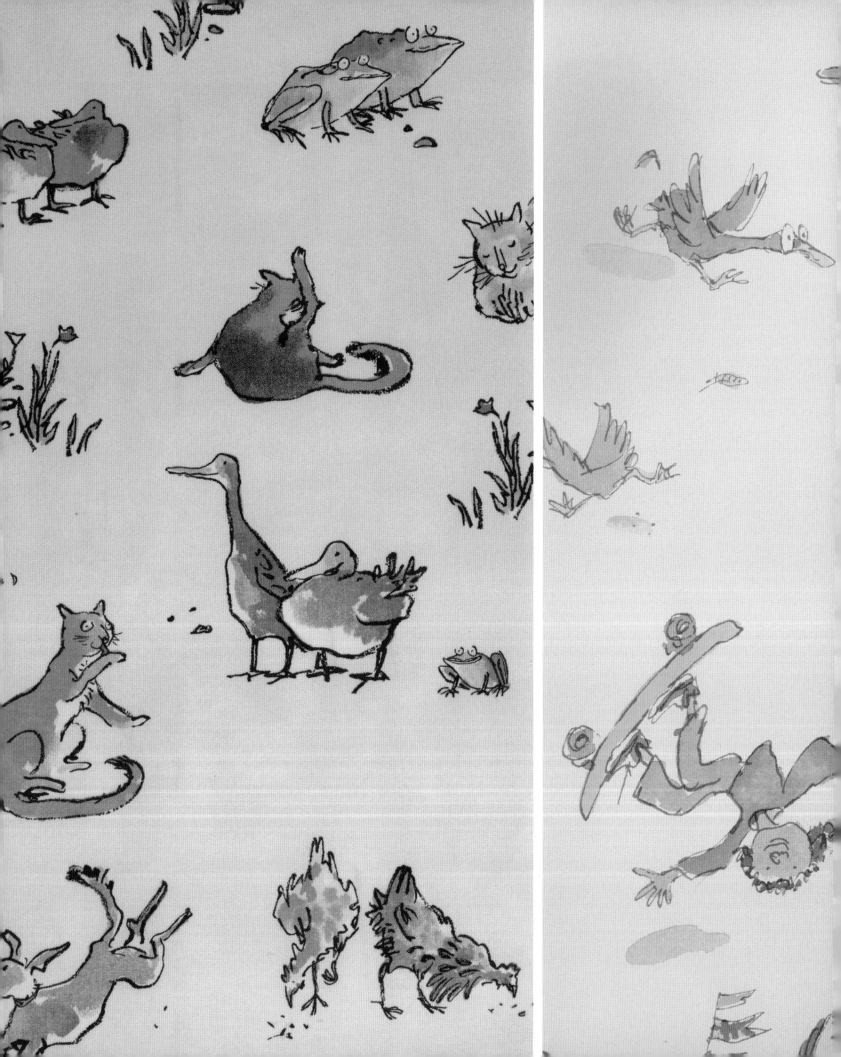

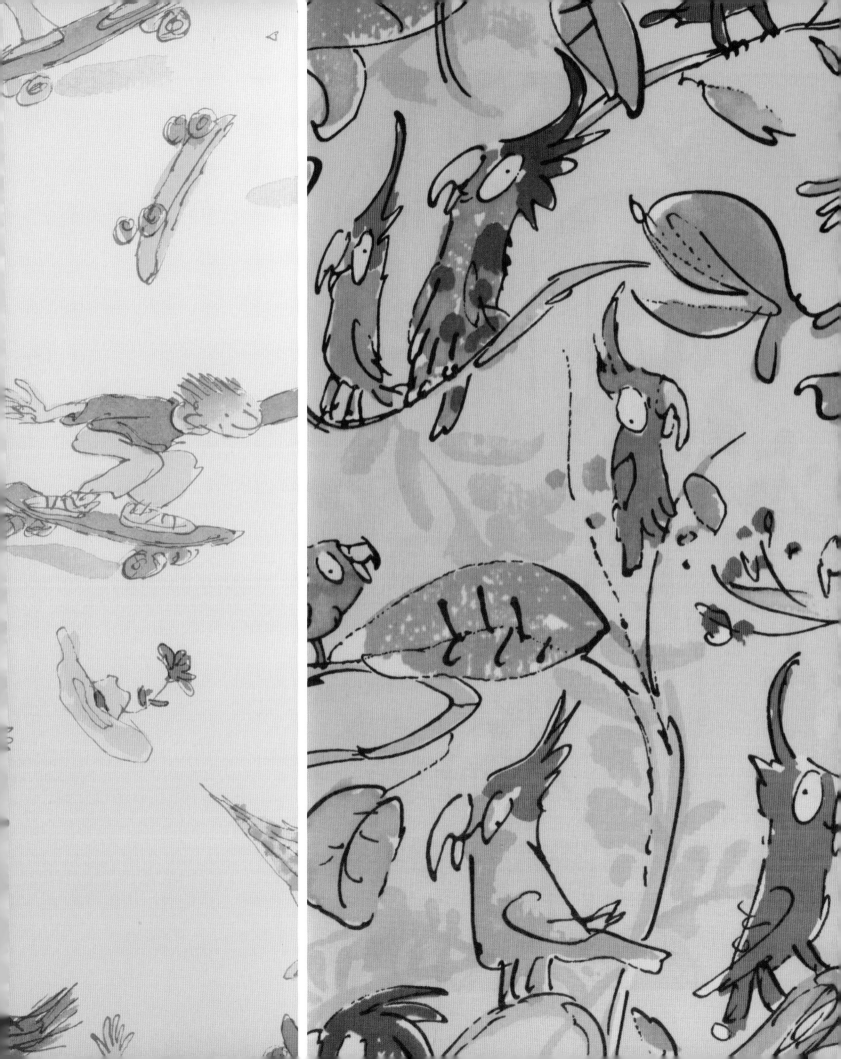

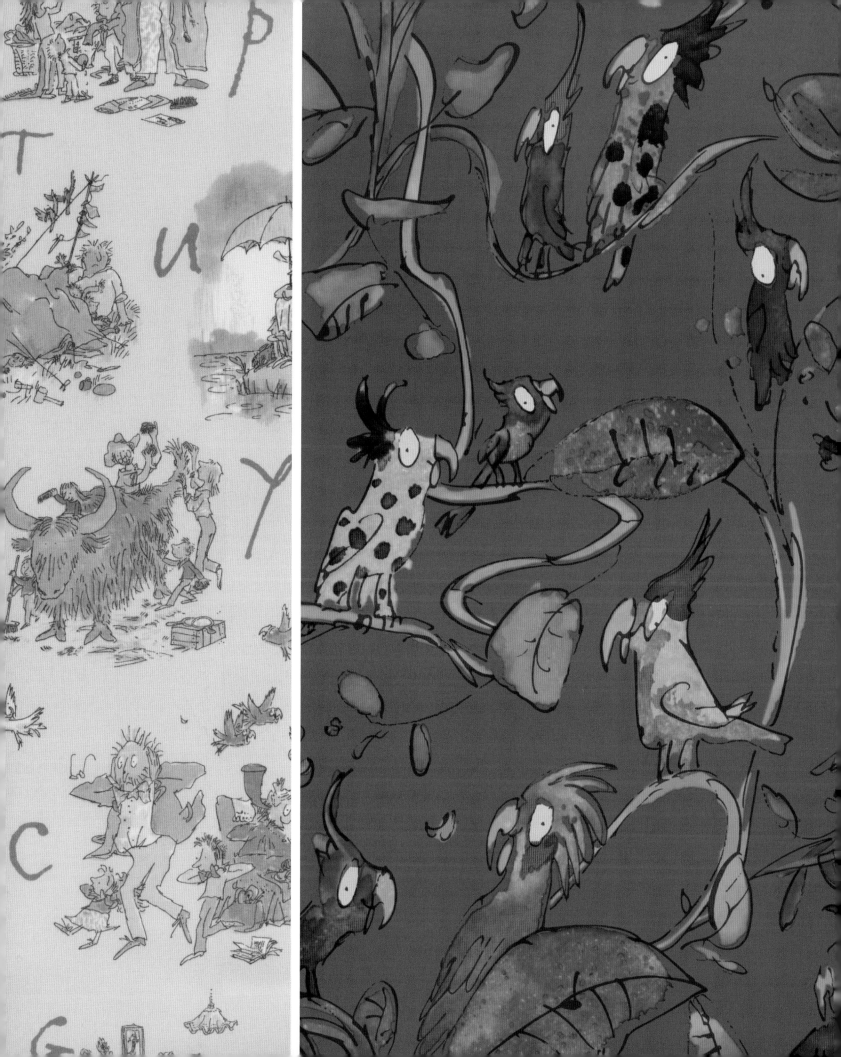

France: To and Fro

As far as France is concerned I am happy to say that I am, in terms of both books and visits, in a constant state of va et vient, Much of this activity finds its origins in my long relationship with my main French publishers, Gallimard Jeunesse. I am especially fortunate in that Christine Baker, their editorial director, lives and has an office in London. It's not a quarter of an hour's walk from where I live, which means that, although most of what Gallimard publish of my books (or those of John Yeoman and other writers) are French versions of English books, we stay in touch and France is an audience that I am aware of from the start. My most recent picturebook is called in English *Angelica Sprocket's Pockets*, and the eponymous heroine has a coat with many different pockets from which emerge increasingly unlikely items, concluding with an elephant, but all prompted by the rhymes of a chanting verse. By some inadvertence the French translator was only asked for a translation in prose, which rather took any forward movement out of the venture. However, she did have the inspiration of a French name, so that finally creating a rhyming version of *Les Merveilleuses Poches d'Angélique Brioche* became a sort of collaborative venture amongst a handful of French-speaking friends and, of course, Christine Baker herself.

Though few titles originate with Gallimard Jeunesse there are some translations from English for which I have provided illustrations and there is one specifically French title which I found engrossing to work on. I suspect that, when Christine Baker suggested that I might put together and illustrate a little collection of verse for children, she had in mind something for the quite young. However, once I had the idea in front of me I found I could not resist the temptation to start looking in anthologies of French verse in search of poems written for adults but still accessible to younger readers.

Illustration for Voltaire's 'Candide'

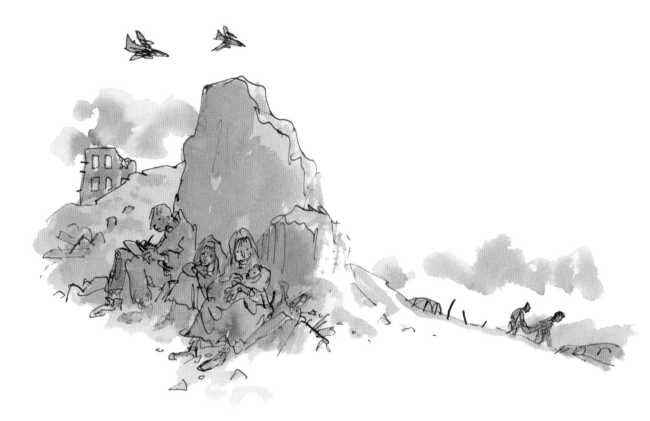

Collecting together what was in the end about thirty of them was fascinating and, perhaps needless to say, took far longer than creating the illustrations. The poems came from various periods and I made an attempt – I have no idea how successfully – to underline some continuing relevance by illustrating the poems as if they were all happening today. An emotional sonnet by Louise Labé from the sixteenth century is given to a distressed teenager; a poem about war from the same century shows devastation that might belong to any contemporary Balkan or Middle Eastern conflict. I was also able to claim in the introduction that it must be the only book of poetry where the readers spoke the language better than the person who had made the selection. In the end my French proved inadequate in providing a suitable title for the book. However, when I went to Christine Baker with the problem she said: 'In Paris we always call it *Promenade de Quentin Blake au Pays de la Poésie Française*' and so those are the words that appear on the cover.

Another book that began in France was a direct commission from the children's book publisher Circonflexe, to a text by André Bouchard called *La Tête Ailleurs*. André Bouchard is a writer who generally illustrates his own books, and he is full of visual ideas. 'La tête ailleurs' means colloquially that your mind is on something else, but in this case Daddy has literally mislaid his head so that the two children make him a replacement of papier mâché, which conveniently does everything that it is told. I drew all the illustrations with a quill, the scratchiness of which seemed to me to correspond somehow to the craziness of the idea. *Promenade* was effectively untranslatable, but it wasn't hard to get this book into English as *Daddy Lost His Head*.

Illustrations for 'Promenade de Quentin Blake au Pays de la Poésie Française'

Pour faire une tête de papa, c'est fastoche ! Surtout s'il ne ressemble pas
à une vedette de cinéma. Prenez les journaux de votre père et faites-en une
boule bien tassée de la taille de sa tête. Ensuite, peignez-la de la couleur
de sa peau. Dès que la peinture est sèche, dessinez la bouche et les yeux
sans oublier les cils !

Taillez le nez dans une patate (toutefois si votre papa a un nez plus gros
qu'une pomme de terre, un chou-fleur fera l'affaire).

Pour la couleur, reprenez celle qui a servi pour la peau en y ajoutant
un peu de rouge. Pour ceux et celles dont les papas ont encore des cheveux :
un peu de laine, un peu de colle et le tour est joué.

La tête de papa était enfin prête ! Elle était même plus réussie que l'originale !
Même que maman s'écria : « Bravo, mes chéris ! Vous l'avez retrouvée ! »

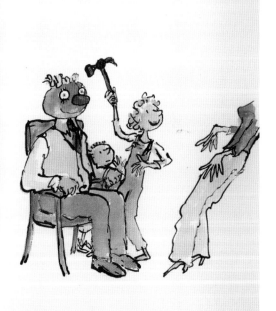

Mais, quand on a tapé dessus avec un marteau pour lui montrer
que ce n'était que du papier, maman s'est évanouie...

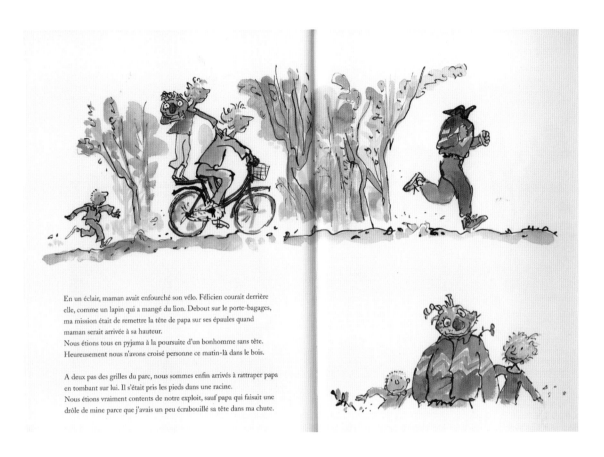

En un éclair, maman avait enfourché son vélo. Félicien courait derrière
elle, comme un lapin qui a mangé du lion. Debout sur le porte-bagages,
ma mission était de remettre la tête de papa sur ses épaules quand
maman serait arrivée à sa hauteur.
Nous étions tous en pyjama à la poursuite d'un bonhomme sans tête.
Heureusement nous n'avons croisé personne ce matin-là dans le bois.

A deux pas des grilles du parc, nous sommes enfin arrivés à rattraper papa
en tombant sur lui. Il s'était pris les pieds dans une racine.
Nous étions vraiment contents de notre exploit, sauf papa qui faisait une
drôle de mine parce que j'avais un peu écrabouillé sa tête dans ma chute.

The cover of *Promenade* shows a drawing of a badly shaven character who is meant to be me, reading a French book, and my bicycle (it was a promenade en vélo) leaning against a tree in what I know is a bit of typically flat landscape of South-West France. One of the aspects of the French editions and co-editions is that they come about against a backdrop of visits and activities in France. There is scarcely a self-respecting town of any size that doesn't have some kind of Salon du Livre or Salon du Livre de Jeunesse, and over time I have visited many: Arles, Avignon, Nantes, Limoges, Orléans, Metz, Geneva and met there many French illustrators who have remained friends. Perhaps the special attraction is also of not being a tourist, of entering places to which you would not normally be invited; to cross the playground, the cours de récré, with its two or three big trees, and meet new people who may have different habits and assumptions, but share your interests.

Nearer home – I mean my home in France – educational projects have in various ways provided many of my most memorable and enjoyable days. I am within half-an-hour's drive of Rochefort, that impressive seventeenth century 'new town.' There, the library has the good fortune to be established in the now restored ropeworks – the Corderie Royale – a single-storied period building some 365 metres long on the banks of the Charente. Fifteen or so years ago the librarian, Marie-Hélène Montéagudo, found that I was in the neighbourhood, and we undertook some activities with classes from local schools. I shan't forget a June evening when in the sunshine of the Corderie grounds there was a parade of Clowns, thrown into the air by children not much bigger than they were, cardboard versions of Cockatoos, the Enormous Crocodile and Daisy Artichoke, a version of the House that Jack Built, and the arrival, in a boat on wheels, of the jeunes mariés (who don't appear in *La Maison Que Jack a Bâtie*) accompanied by a fleet of children in beflagged bicycles.

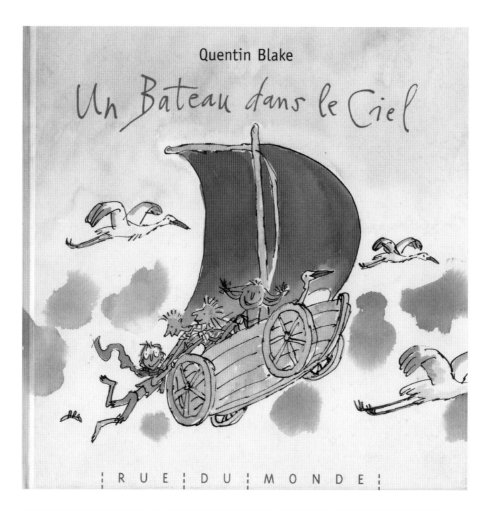

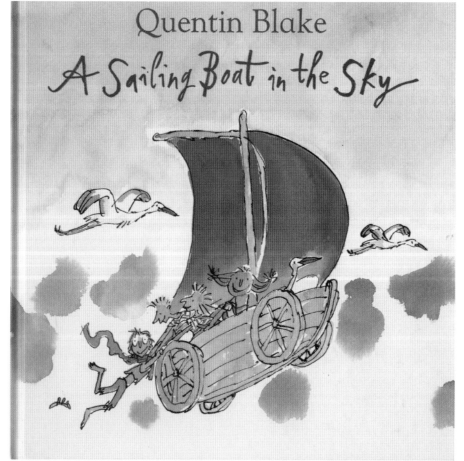

It was in Rochefort library on one such occasion that I met Geneviève Roy and her partner Pascal Bordignon, two enterprising educationalists, and at their instigation set about the project that bore fruit as the picture book about problems such as war, racism and pollution which eventually became *Un Bateau Dans le Ciel*. The story started with a handful of rough drawings in which I suggested two children and a sailing boat which had wheels but could also fly. After that ideas flooded in from 1800 francophone schoolchildren in the south-west of France, but also in England, Sweden, Luxemburg and Singapore; and there were two grand meetings in Rochefort and La Rochelle where children sang and recited and acted.

Then I sat in my studio in France and mixing the ingredients from the children's suggestions I cooked the story and edited and did the forty pages of illustrations. The text was edited and polished by the poet Alain Serres, who published the book at his own imprint of Rue du Monde, astonishingly, before the year was out. Later on there were editions in English and several other languages.

There were subsequently other ventures though (perhaps, thank goodness) none of this order. I have a memory of getting up on a sunny morning at an inn in the shadow of the Chateau d'Oiron and going out and seeing the fields gleaming with poppies and cornflowers. This must have been the occasion of the Prix Littéraire Quentin Blake, organised by Geneviève Roy in all the schools around Thouars in the Deux-Sèvres. It wouldn't, of course, have been called that in an English-speaking country, and the additional charm of it for me was that I had to win, as nobody else's books were in question: the children made their choices of their favourites of my books, at different age levels. The real essence and purpose of the exercise however was the enormous amount of writing, pictures, posters and performance that they brought to the occasion. I don't remember in fact if there was a prize, but I was allowed to carry away a jigsaw puzzle of Clown made by some of the younger pupils, which has altogether twelve pieces and of which I think Dubuffet would not have been ashamed.

In some recent years many of these outings have been replaced by activities associated with the exhibition at the Petit Palais and work in hospitals in Paris and Angers which are dealt with in other sections of this book. I was reminded of them, however, when the municipal library of the city of Angers, in anticipation of the work I was preparing for their hospital, put on a show of my work – Quentin Blake pour tous les âges. I was invited to what was called une visite loufoque of the exhibition (a barmy visit?) and I assumed that the young library readers had been organised into some kind of event; so I was quite surprised to be welcomed by the half-dozen staff of the junior library dressed as various of the characters from my books. They sang and had cross-talk and accompanied me to the different areas of the exhibition on different levels of the library (Mrs Armitage's bike had to go up the stairs) where every ritual was filmed including, out of respect for my Englishness, the Presentation of The Tea-bags. I took one and wore it with pride.

Another prompting for two-way traffic across the channel has been my association with Daniel Pennac. Pennac is an enormously successful French writer with an array of inventive, humorous and bizarre novels to his name. However, he also spent twenty years as a teacher, and in 1997 he wrote a book called *Comme un roman*. It is about encouraging young people to read, and equally about how not to discourage them. It was as successful as all his other books, and it concludes with a list of what he proposes as the ten rights of the reader. Being commissioned

by Gallimard Jeunesse to illustrate a poster of these Droits du lecteur was my first encounter with Pennac, and I subsequently met him at book festivals in France and in England. His book has been twice translated into English: the first time under the title *Like a Novel*, although it is difficult to find an equivalent in English for the expression, which suggests with ease and enthusiasm, so that you might read a book about biblical texts or urban sewage systems comme un roman if you were so disposed. In more recent years it was translated once again, by Sarah Ardizzone, this time as *The Rights of the Reader*, and on the strength of my poster, which they had also adopted, Walker Books invited me to illustrate it. As someone who had trained as a teacher of literature fifty years ago I also, slightly tremulously, took on the task of writing a foreword to the book. It seemed to me that Pennac's reaction to the rather desiccated intellectual approach taken in the French educational system was nowadays appropriate to the non-intellectual but equally bloodless take on literacy and literature in Britain, where we seem to lack a sense of the importance of feeling and motivation. Later I was also invited to provide a jacket – with a picture of the teenage Daniel Pennac as I imagined him – and a foreword for *School Blues*, a translation of *Chagrin d'Ecole*, Pennac's account, complementary to the previous book, of his adolescent difficulties in relating to the educational system, and of the teachers who did succeed in bringing out his latent abilities – as any French reader will now know, to some effect.

The set of drawings of people as birds, published in England as *The Life of Birds* has also had its history of cross-channel coming and going. In France it became *Nous les Oiseaux*, and indeed some of the inspiration was French: the schoolteacher and the children with their cartables on their backs evidently so, but also in my mind, for instance, the writer at his desk. There was at one time the prospect of an exhibition in Paris which unfortunately vanished, and I determined to publish the drawings myself. I would have done so if I had not happened to show them to

Covers to 'The Rights of the Reader' and 'School Blues'

Les dix **droits** du **lecteur**
par **Daniel Pennac**
illustrations de **Quentin Blake**

1. Le droit de ne pas lire

2. Le droit de sauter des pages

3. Le droit de ne pas finir un livre

4. Le droit de relire

5. Le droit de lire n'importe quoi

6. Le droit au bovarysme

7. Le droit de lire n'importe où

8. Le droit de grappiller

9. Le droit de lire à voix haute

10. Le droit de nous taire

Ces 10 droits se résument en 1 seul devoir —

NE VOUS MOQUEZ JAMAIS de ceux qui ne lisent pas, si vous voulez qu'ils lisent un jour.

GALLIMARD JEUNESSE

Poster of 'Les Droits du Lecteur' (The Rights of the Reader)

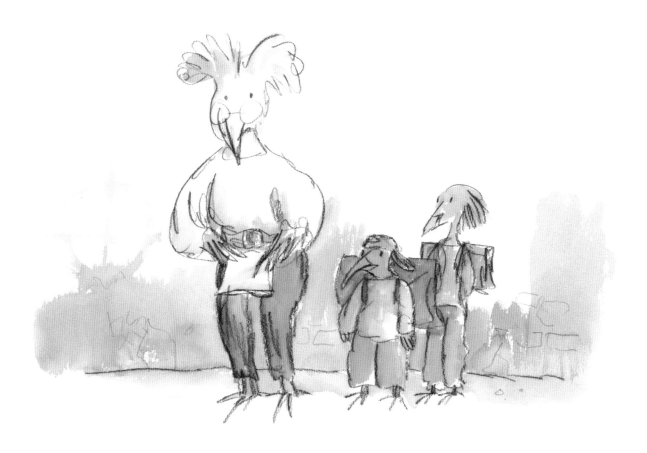

Tom Maschler who prompted Patrick Janson Smith to bring them out at Doubleday. After that my good fortune increased still further when Peter Campbell designed the book, and wrote an introduction for it.

Once they had become a book the birds crossed the channel again, at the behest of Gallimard (Gallimard for adults, that is). It was thought that it might help the book if there could also be a French name on the cover. Without having much hope of his having time to think about it I approached Daniel Pennac to see if he might write an introduction. Daniel invited me to take the drawings to show him at his home in Paris. I remember it well, as he not only evidently responded positively to the pictures but, as he turned from one to the next, could not resist the urge to start writing titles for them, at times almost breaking into dialogue. For the fretful writer, for instance: 'Question de vocabulaire ... non, non ... le mot juste!' Even more eloquent evidence of Pennac's response came in the introduction that he eventually wrote. 'The drawings which we are offered in this book,' he says, 'are not illustrations. They aren't born of reading, or observation, but of a vision. Each of them is a separate work. You could write a short story, not to speak of a novel, on most of them. Take the weeping bird, for instance, who is reading the letter and wailing with distress ...' What Pennac writes helps me realise that these birds allow me to depict more easily certain types, certain situations of distress, which I would find harder to undertake as it were 'from life'.

Schoolteacher and pupils from 'Nous Les Oiseaux'

Once in existence these birds have stayed with me. After the book was published the birds had some outings as prints, where they became social groups reading, visiting, painting. More importantly they came back to my rescue in 2011 when I had to find some way of reflecting the range of artistic activities that take place in the Barbican, so that you will find that they reappear in the section called Big Illustration.

Of the books I have been commissioned to illustrate for the Folio Society over the past thirty or so years, three have been French classics, and each, in different ways, has come about at my own suggestion. I had discovered Cyrano de Bergerac's *Voyages to the Sun and the Moon* in a French paperback and I could see that it was bursting with things that asked to be drawn. Hugo's *The Hunchback of Notre Dame* was chosen almost inadvertently. I hadn't actually read it at that time, and I was grasping for a work in period costume. Gesturing almost at random at the Hugo I lit on something that appealed to the Folio Society, and in due course, when I had finally made its acquaintance, to me. The route to Voltaire's *Candide*, which the Society published with my illustrations in 2011, was also quite roundabout. A year before, the House of Illustration had organised an evening in the Senior Common Room of the Royal College of Art, and I was asked to think of something to which I could produce spontaneous illustrations while it was read by the actor Peter Capaldi. An article that I had just read in the *Times Literary Supplement* put *Candide* into my mind, and I seized on Chapter One. The Baron of Thunder-ten-tronckh and his family were sitting targets for instant characterisation.

Illustrations for Voltaire's 'Candide'

159

It was only later in a conversation with Joe Whitlock Blundell of the Folio Society that he put forward the idea that the book might be a suitable title in an existing series of de luxe limited editions. The relentless catalogue of disasters afflicting this best of all possible worlds offered plentiful subject matter. I hoped that the style that I brought to it – not one that would have been possible at the time of the book's original publication – did something to match Voltaire's rapid and devastating caricature. At any rate, the thousand copies in their leather binding and slipcase were almost immediately dispersed, and the venture also had, for me, an interesting sequel. The Folio Society normally and naturally claim exclusivity in the illustrations they commission, but on this occasion they generously allowed another very different edition – though one that shared their name. In the spring of 2012 Folio, the paperback imprint of Gallimard, published a clutch of titles to celebrate the imprint's fortieth anniversary, and included among them Candide with my illustrations. There was something very gratifying to me to have these French-inspired drawings being returned to a French audience with Voltaire's own words.

On 8th November 2011 I once again arrived on Eurostar at the Gare du Nord. This time the visit was not directly about a book, but about a medal. Joann Sfar, whom I have got to know in recent years, is immensely prolific, a star of the French bande dessineé, author of a series of written and drawn personal journals, and most recently animator of his own books and director of a live-action film about Serge Gainsbourg. But most of all he is a fluent, brilliant and spontaneous draughtsman, and an enthusiasm for that kind of drawing is one that we share. As a result of his achievements the French Minister of Culture had it in mind to award him the honour of Chevalier de l'Ordre des Arts et des Lettres. The ceremony of pinning on the medal has the requirement that it is carried out by someone who has such a medal already, and it was the thought of Christine Baker that for Joann it might feel less formal, less like joining the establishment, if I took on the task, as one dessinateur to another. And, though it was in one of these elegant rooms looking on to the interior garden of the Gallimard where many literary events must have taken place, informal it was. I read my short speech (with the French corrected beforehand), and managed to fix the two spikes of the medal on to Joann's T-shirt without drawing blood. As an extra to the proceedings I had brought a drawing, which I claimed was by an unknown seventeenth century artist, called *Chevalier jouant au banjo*; in fact the face and the banjo I had copied from Joann Sfar's drawings of himself in his journal. I hope for all of us it was a memorable evening. It certainly was for me; to be invited across the channel to give a French medal to a Frenchman is almost as good as being given a medal yourself. Or perhaps as good.

Vive le va-et-vient.

The drawing for Johann Sfar

Chevalier jouant au banjo...
(9x^me siècle)

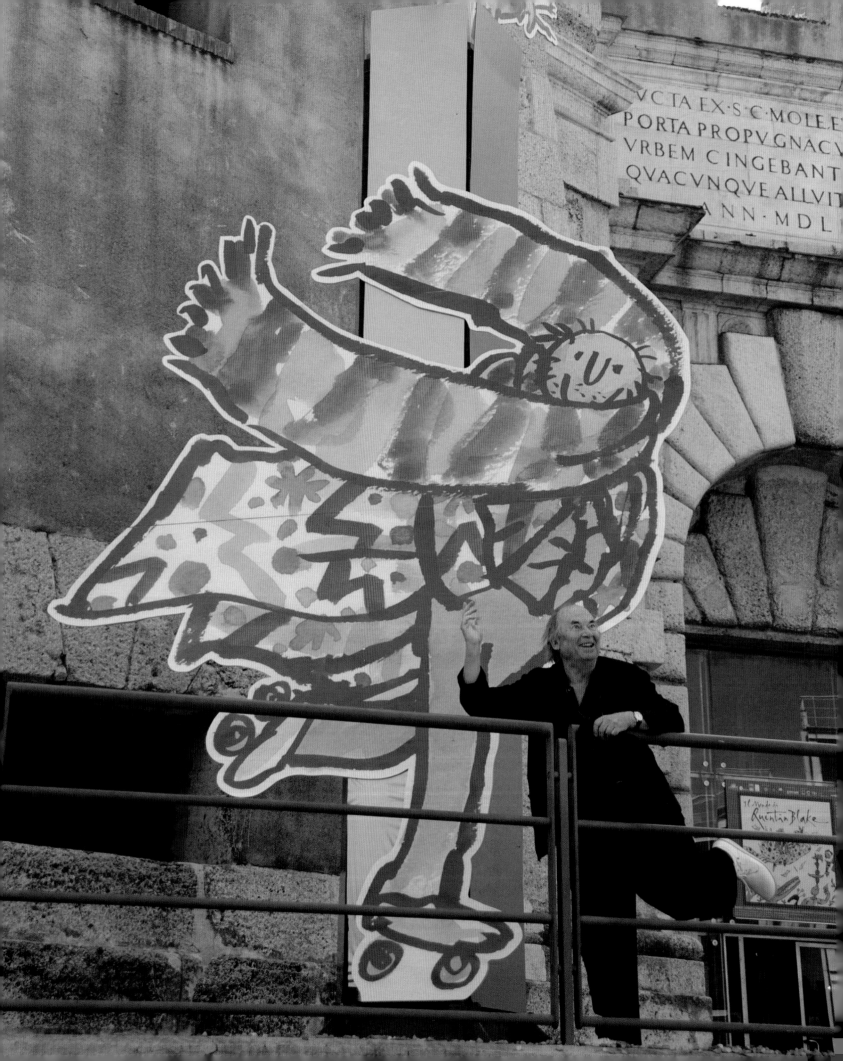

Il Mondo di Quintino

If I were ever fortunate enough to be offered some kind of a magical wish the first thing I would go for would be to have the Italian language descend on me, complete, overnight. (While I am about it I might also try for some extra years of active life in which to get to those parts of Italy that I have so far failed to visit). At least like most illustrators of children's books I have been able to take advantage, from time to time, of the fact that the main children's book fair – the one where the world's publishers sell books to each other – takes place in Bologna, a city one is happy to visit. I have been there on fewer occasions recently, but that has been more than compensated for by Genoa, where I showed my work in 2009.

That any of this happened at all is thanks to Rossana Pitelli, the art adviser of the Italian Cultural Institute in London. She had in view for the Institute an exhibition of the artist Emmanuele Luzzati when she, like my Rochefort librarian, became aware that I was a neighbour, and came forward with the idea that it should be shared between us. We established the title 'Theatres of the Imagination', which expresses the link between us. My theatre is of course on the page; Luzzati's was real, because as well as a brilliant illustrator he was a set and costume designer, especially for Mozart, of an international reputation. I was proud to have my works hanging alongside his in Belgrave Square.

Sadly Luzzati died before the exhibition took place. He was born in Genoa and lived there, in the same house, for the whole of his life, and it was on the seafront at Genoa that a few years ago the city authorities found a new use for a small fifteenth-century fortress at the Porta Siberia: it became the Museo Luzzati and holds the collection of his works. A preliminary visit to the museum was obviously necessary. With other projects and distractions my thoughts and preparations were proving to be worse than ineffectual, when I was rescued. Claudia Zeff is

the Deputy Chair of the House of Illustration. I had worked with her and knew her well, and it was at this moment I received a postcard from her saying that she would be pleased to help with any exhibition if I ever needed it. It arrived coincidentally but at exactly the right moment, and my reply was, in effect 'Yes, please. Now. Genoa.' We were able to take our flight to Genoa in a calm and organised fashion, and Claudia became one of the curators of the exhibition, and the Museo Luzzati's link with the House of Illustration. And ever since she has been a major support in the inception and organisation of my projects, the Marlborough exhibition and this book among them.

The Luzzati building is in its nature full of character, but it has stone walls not designed for the showing of pictures, so that most of the framed works hang on substantial moveable screens. We chose as far as possible from works that were known in Italy. All the Dahl titles are available there, as are some of John Yeoman's titles – *The Wild Washerwomen* had become *La Rivolta delle Lavandaie* and *Mouse Trouble, Topolini Sempre in Festa*. And curiously, my illustrations for John Masefield's *The Box of Delights* and *The Midnight Folk* were originally commissioned by the Italian publisher Mondadori.

The walls themselves were, however, excellent for hanging banners; I already had a number of those from previous exhibitions, and created others, as well as cut-out figures and passenger-carrying birds to hang from the ceiling. I was also invited to create a set of six prints – for the four smaller ones I used a tightrope theme that waved to the commedia dell'arte characters of Angelo which I had also been sure to include in the show.

Cover illustration for 'The Midnight Folk'

Il Mondo di Quentin Blake started in the summer of 2009 and ran for six months. Half way through the run a comprehensive catalogue was published, imaginatively designed by Luigi Berio, the designer who had also worked on the design of the exhibition. The catalogue had three specially written introductions, and there was a bonus for me in that one was by Bianca Pitzorno, whose books I have been illustrating for over twenty years. The introduction had the title 'Quintino' ... which is (I now know) what I am called by Bianca and the editors at Mondadori. She recalls that an early encounter with my drawings was when she undertook to write an Italian version of Sylvia Plath's *The Bed Book*, which I had already illustrated and which became *A Letto Bambini!* As a reward? a surprise? at any rate a sequel, Margherita Forestan of Mondadori got me to illustrate Bianca's next book, *La Casa sull'Albero* (The Treehouse). The two main characters were based on Bianca Pitzorno herself and a girl called Aglaia and I had to work from photographs. Bianca describes her surprise at being shown the drawings and recognising herself and Aglaia portrayed in my 'pointed and spiky style' ('nello stile aguzzo e puntato di Quintino').

I went on to illustrate several more of Bianca's books, and as I don't read or speak Italian, by a method which must be unusual for any illustrator. I worked from a summary and a list of suggested subjects, and when I had done a set of rough drawings I put them with a text before one of my Italian-speaking friends, to make sure that I hadn't made any crass mistakes. There was also, I discovered, an advantage to the author, in that I wasn't unhappy to take instruction, where Italian artists, Bianca observed, might be overly determined to express their artistic independence.

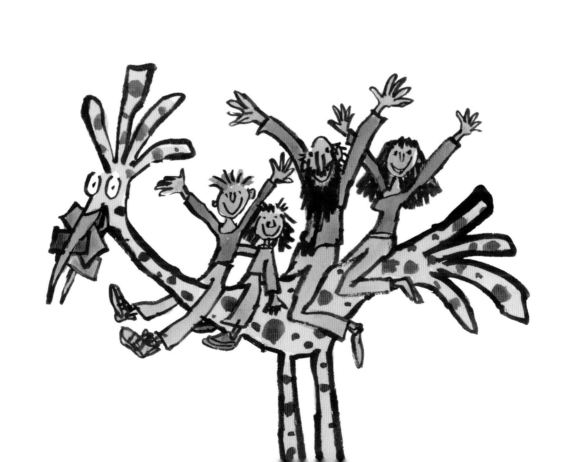

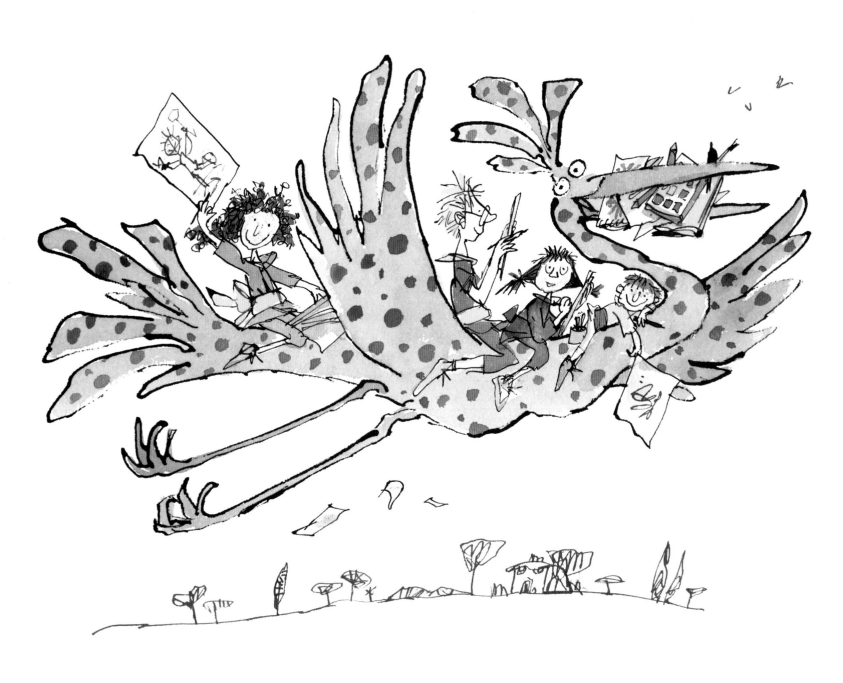

Bird prints for the Museo Luzzati

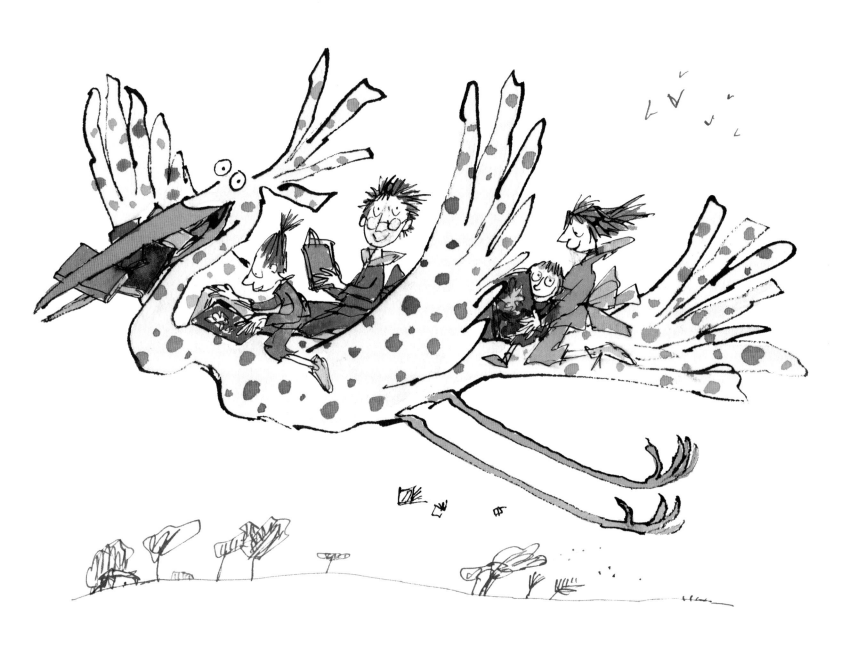

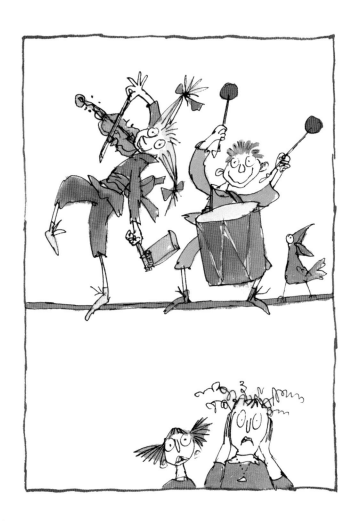
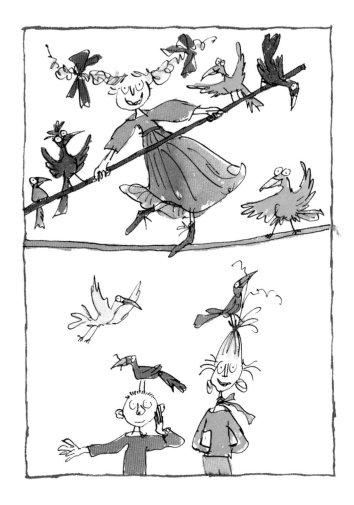

Commedia dell'arte prints for the Museo Luzzati

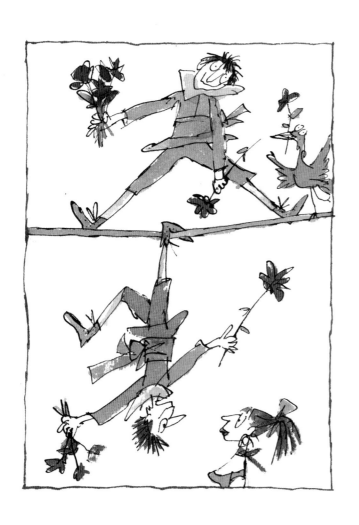

I managed to work on several of Bianca's books with this method. For *Re Mida ha le orecchie d'asino* (King Midas Has Ass's ears) I had the use of an old film tape of a Pitzorno family holiday in Sardinia in the 1950s. There must also have been something of a rapport and sympathy, because I was delighted to see Bianca acknowledging that she 'found with a lot of emotion and affection, a precise summer of my childhood, with the same sailing boats, beach umbrellas, my mother's halter top, the fig tree in the backyard, the small coffee shop with the pergola of grape vines… as I had lived and experienced it'. Another of my favourites was *Polissena del Porcello* (Polissena and the Pig) with a great deal of period dressing-up of both humans and animals. I had a banner made of its cover illustration specially for the Genoa exhibition.

The most recent of Bianca books that I have illustrated are those about a pathetic little match-girl called Lavinia. That at any rate is what she is to begin with, until she is visited by a strikingly updated fairy godmother, who makes her a present of a magic ring. The ring's distinctive property is not quite the sort that we have become accustomed to; when twisted by Lavinia on her finger, whatever she is looking at turns to shit. Bianca says her readers called it 'la saga della cacca' – 'the saga of poo'. I am not sure whether or not such a theme could be an attraction but I have nothing in English by Bianca, so I hope some English publisher may take up the opportunity. The drawings are all done and ready to be printed.

It may seem to be slightly strange that our catalogue should appear halfway through the run of the exhibition, but in the event it had its advantages. It gave us the pretext, notably, for another celebratory occasion to launch the book (if the first had been for the city and its tourists, this was for the reassembly of schools at the beginning of the scholastic year – a different audience).

It also gave me the opportunity to revisit Genoa. This time as well as a gathering in the museum there was an event at the major bookshop (name) where I was able to make impromptu drawings as a well-known actor read from the Italian version of Roald Dahl's *Revolting Rhymes*. Afterwards I signed copies of the catalogue and other books. During the signing there was one, for me, memorable moment: an attractive dark-haired young woman was crouched beside the table so that her face was almost at the level of the book I was writing in, when I noticed that tears were running down her cheeks. I encouraged her not to be embarrassed and we continued. Later she wrote to me to explain, and I will try to overcome any embarrassment in mentioning it here, as perhaps it can stand for other moments that I encounter more frequently now when grandparents or thirty-year-old mothers are revisiting their own well-thumbed books with their own young children. What my Italian young woman wrote to me was that, when she was seven, the children in her class were given a book each, randomly, by their teacher. She discovered that hers was *Matilda* – and she knew immediately that it was *her* book, and had kept it ever since. When she knew that the illustrator of the book was coming to her city she was ready to resist the instinct to come to the bookshop because, apparently, if you meet people whose work you admire 'they are always a disappointment, especially artists'. However her mother had persuaded her to make the attempt. I think I must have come out better than expected.

Illustrations to stories about Lavinia, by Bianca Pitzorno

Illustrations to 'Tornatras' by Bianca Pitzorno

Although this section has an Italian title, and is mainly about Genoa, it will also have to make room for another city that has an important meaning for me: Berlin. Berlin has a number of schools which are known as Europe schools and which are bilingual: English-German, French-German and so on. In 2003 the school so far known as the Staatlichen Europaschule No.13 decided it would be nicer not to merely go by a number but to have a name. I think a several names were seen as possibilities but when it came to a vote the result went to the one candidate who was alive and, happily for me, the school became the Quentin Blake Europe School. My first visit was for Naming Day, when a tree was planted and hundreds of balloons were released in the presence of the British Ambassador and a lady with a bicycle who bore a striking resemblance to Mrs Armitage. I provided the school with its logo, now visible to visitors as they arrive.

On my subsequent (too infrequent) visits my beyond-the-page drawings have mostly been produced impromptu for the benefit of the assembled school, though the school preserves and displays them. But what has been most rewarding, as often in this kind of situation, is that the occasion of your visit is the wonderful pretext for a surge of their drawing, painting, writing and performance. I don't think I have ever seen so many hand-drawn cockatoos together at one time.

The Quentin Blake Europe School logo

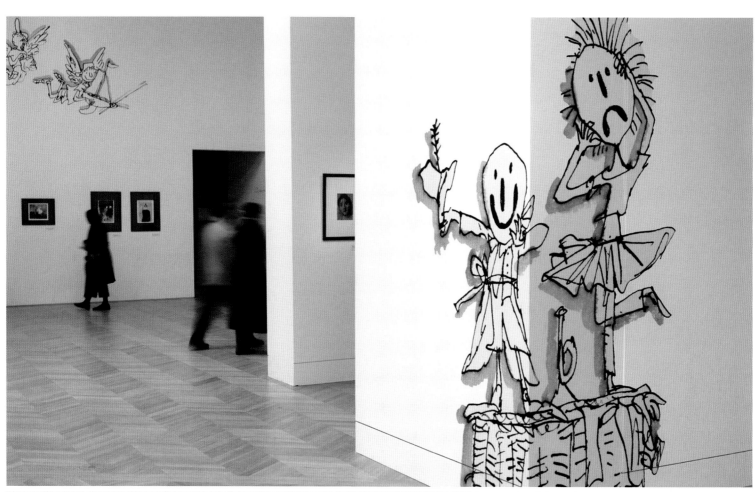
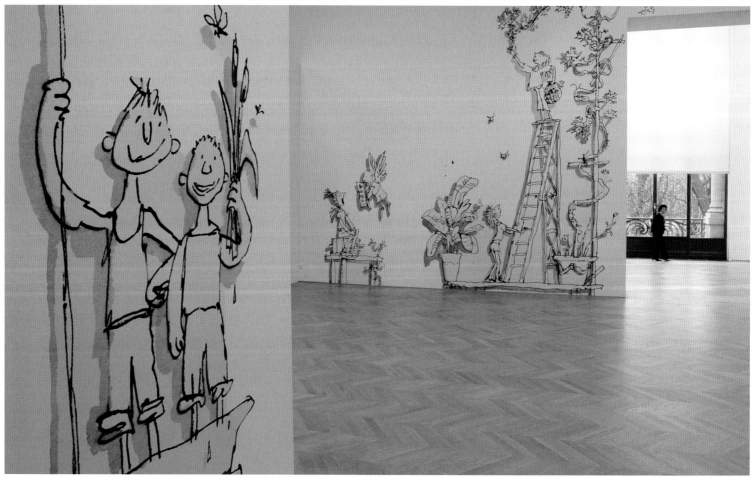

Big Illustration

One way of telling the story of illustration is by way of the technology of reproduction. I tried to do this in the catalogue of an exhibition that I curated in collaboration with the Arts Council, called *In All Directions*. Its ostensible subject was travel and transport but in its examples it demonstrated etching, wood engraving, lithography and so on, through to the four-colour half-tone printing of more recent years. Now we have the omnipresent computer and computer-controlled reproduction techniques. Many contemporary artists and illustrators embrace the opportunities these offer, inventing new ways of collage, exploiting or subverting the possibilities of existing software programmes, revisiting new versions of the art of printmaking. For many artists there are no longer even any originals. One of the questions that I am sometimes asked is how new technology affects me and whether I make use of it. The answer is hardly at all except in one very significant respect. I want to go on drawing with those old-fashioned implements with which you can literally feel the shapes and forms you are committing to paper – metal nibs, brushes, reed pens, quills. But today these drawings can be reproduced at any size. It's a change of technical possibility which offers a change of outlook.

My first step in that direction was one that I was hardly aware of at the time. When I was engaged on my two years as the first Children's Laureate I had the idea that I would like to organise an exhibition where the works were hung in alphabetical order, which would get rid of any sense of implicit hierarchy between the old masters, modern paintings and illustrations that I wanted to include in it. The National Gallery responded with enthusiasm and miraculously had a space at the heart of the gallery available within the year. I worked with Ghislaine Kenyon who was on the staff of the National Gallery at the time, and we selected pictures which had an implied – but not too evident – story. The show became *Tell Me A Picture*. It was Michael Wilson, director of exhibitions at the gallery, who suggested I draw on the walls. 'Are you allowed to do

that?' 'We want it to look as little like the National Gallery as possible.' It was a new experience for me to be organising, not the sequence of pages of a book, but the handsome interior spaces of the Sunley Room. As well as the drawings in the gallery there were drawings in the entrance area and around the shop – a big coloured picture of a canvas being held up before an audience of children of different periods of history and even, irresistibly, a drawing of two children with a bucket of red paint perched above the main entrance. In due course everything was in place, and I can remember saying to my friend and collaborator John Yeoman, 'Now we have to wait and see if anyone comes'. He said: 'I shouldn't worry about that. Are they any good at crowd control?' And indeed there were queues at the opening, and a quarter of a million adults and children came to see the show in its four-month run. To begin with I suspect that the guardians were a little alarmed by the fact that the pictures were hung lower than is usual, but I don't think they suffered from the attention of sticky fingers; and what the guardians were also, I think, rather taken by was the amount that everyone was talking to each other. In fact there was only an appearance of my having drawn on the walls: the cast of characters who guided you round the exhibition were printed on transparent acetate and stuck to the walls. They could be put in place quickly and easily stripped off when the exhibition closed.

I could not have anticipated that I could have the same double opportunity of curating and drawing again – but in 2005 Ghislaine Kenyon and I found ourselves engaged on a similar task for the re-opening of the Petit Palais, the Musée des Beaux Arts of the city of Paris. This time the theme was of women as they appeared in the paintings of the reserve collection of the museum. Delving into the reserves of the Petit Palais was not an easy task, and Ghislaine and I became almost fortnightly commuters to Paris for about a year, faithful clients of both Eurostar and the Hotel Lutétia. Initially we had some doubts about what we might find – or fail to find – in the

Children from 'Tell Me A Picture'

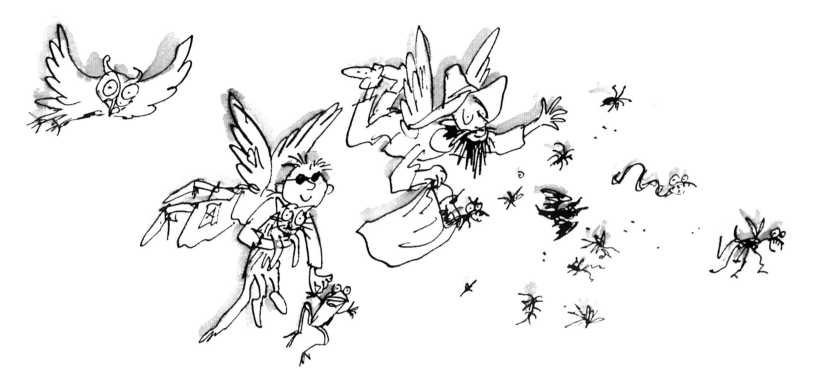

reserves. However, there was a Degas and a Mary Cassatt; lithographs by Vuillard, Steinlen and Toulouse-Lautrec; and other paintings that became more interesting as we got to know them – by Maurice Denis, by Jacques-Emil Blanche, by Georges Jeanneret.

There was no commentary, the 'interpretation' that museums so like to offer, but the pictures were arranged together in groups of two or three of similar subject, so that they silently commented on each other. (Gilles Chazal, the Director of the gallery, called these 'confrontations suggestives'). In the National Gallery the young people introducing the exhibition clambered about on a sort of flimsy scaffolding. In Paris the walls were much more lofty – but in this building of 1900 there were plenty of angels and winged spirits about the place, so I took contemporary children and gave them wings to make them into cherubs ('angelots') who could fly high above the paintings and accompany you around the exhibition. As in the National Gallery, the drawings are in black and white and they are backed with a light cast shadow which emphasizes this flimsiness. It's important that they shouldn't compete with the paintings – they are evidently small drawings enlarged. You see them from a distance and then move in to concentrate on the complexity of the painted works.

An artist at the vernissage explained it to himself, and to me, as a sort of installation; and indeed I was pleased to think that there could be an interplay between the drawings and the site. At one point in the exhibition, for instance it was possible to see at the same time plants drawn on the walls; the formal Italian gardens of a Maurice Denis tryptich, and looking in one direction the trees of the banks of the Seine and in the other the interior garden of the museum with its exotic plants and gilded statues.

Angelots from the walls of the Petit Palais Exhibition

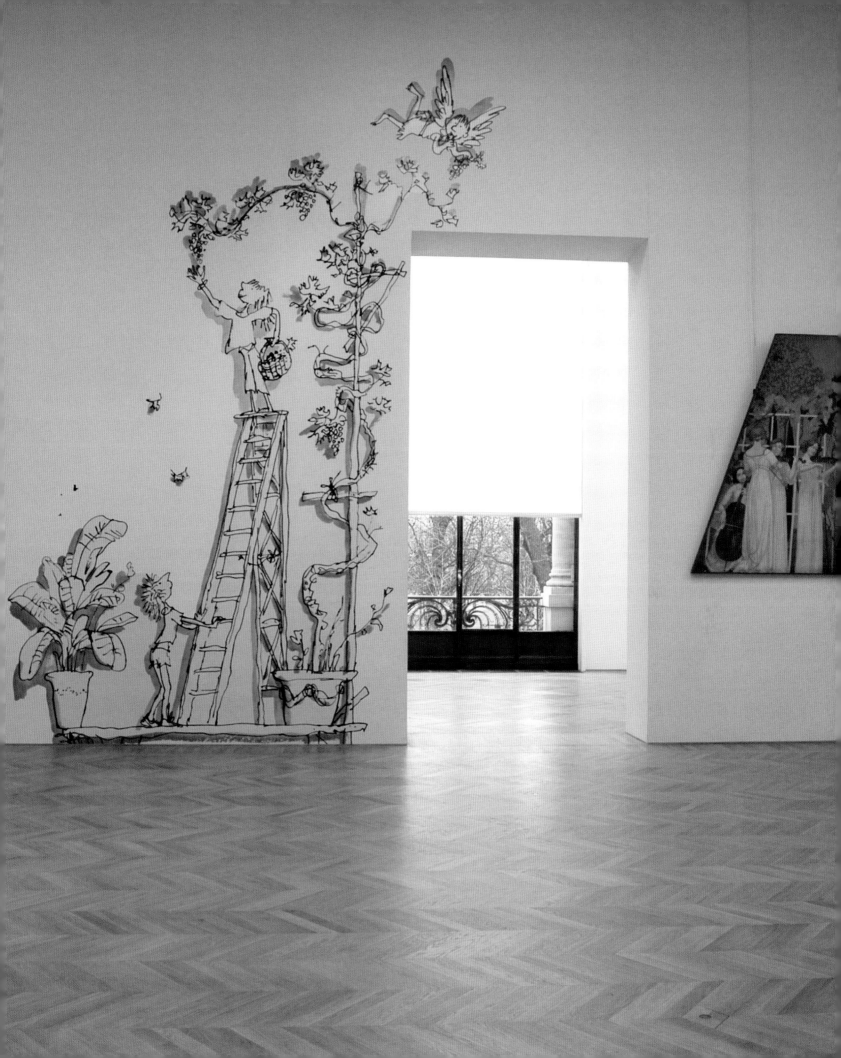

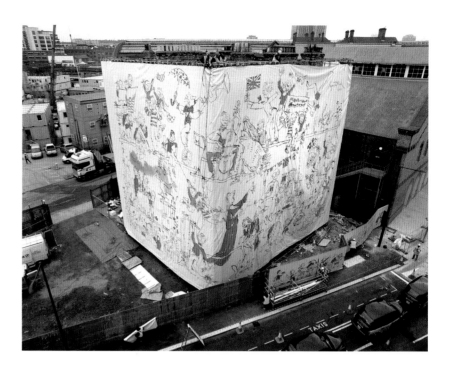

Thinking of a suitable French title for all this was rather beyond me, and after various unsuccessful attempts we were rescued by Aude Mouchonnet, the Director's assistant on the project, who proposed *Quentin Blake and Les Demoiselles des Bords de Seine*; appropriate as the Courbet painting *Les Demoiselles des Bords de La Seine* hangs in the gallery's permanent collection. One aspect of the project which was particularly inspiring – and it was inspiring enough already to be given such large and beautiful spaces to work in – was the unswerving support of Gilles Chazal. It was announced unequivocally in a committee meeting in preparation for the exhibition, in response to some tentative enquiry: 'Carte blanche à Quentin Blake'; and that was exactly what he meant.

One distinctive memory remains from what must have been pretty well the last day of the hanging. I had found a chair from which I would get a view of the work in progress, and I was approached by one of the blazered gardiens. He established that I was indeed M. Quentin Blake: 'J'aime bien ce que vous faites', he said – 'C'est plein de poésie et de tendresse.'

I was completely taken with this adventure of being off the page, and other projects made possible by printing at size seemed to follow as a sequence of happy coincidences. The most striking followed soon at St Pancras – not indoors, but outdoors. We were already talking to Argent, the property developers for the great King's Cross renewal, about the House of Illustration, so that when they felt they ought to do something about the rather dreary presence of the Stanley Building, as yet not refurbished, opposite the royal re-opening of St Pancras station, they came to us to see if there was something we could do to brighten it up. I talked to the designer Lexi Burgess and he went back with the answer 'We can only wrap it'; and so we did – at least on the two St Pancras-facing sides. Once again I was keen to keep the sense that

Wrapping the Stanley Building at St Pancras, and, on the right, from the original drawing

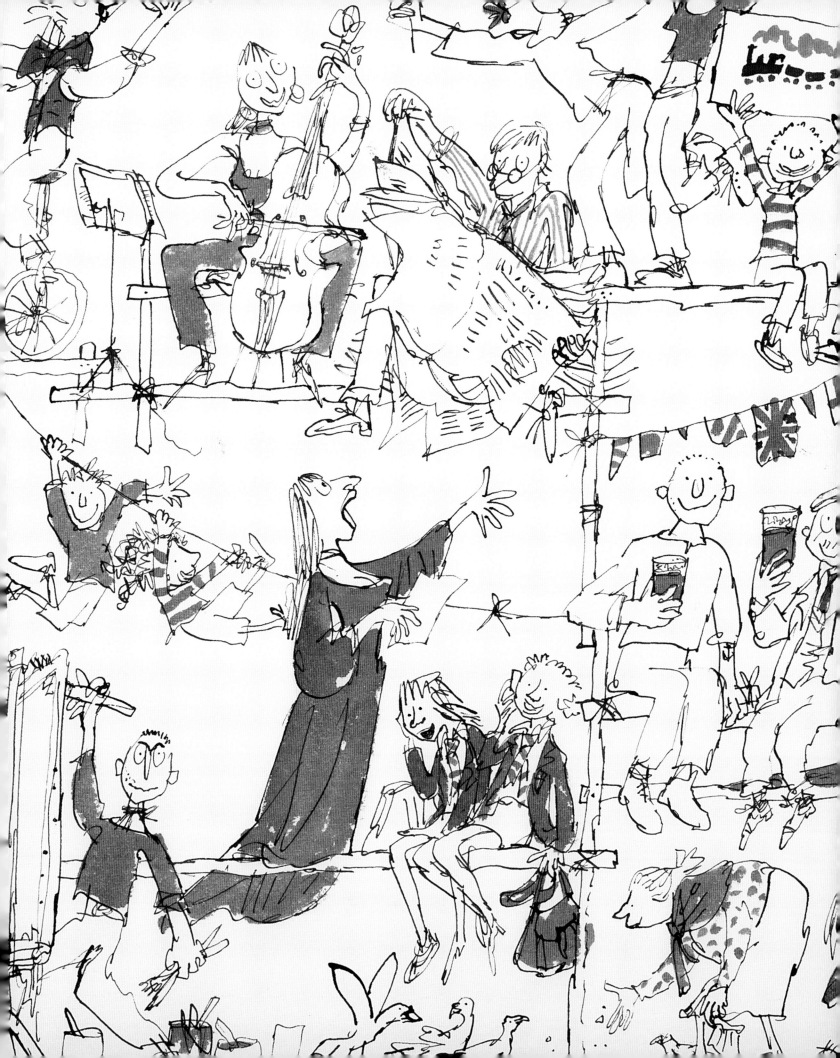

this was a drawing, so it was scratchy, in black and only one other colour. It was produced on the drawing board but printed five storeys high. The cast of characters was such that you might meet now that you had arrived in London. Like the National Gallery youngsters, they were arranged on a light scaffolding which couldn't possibly support them – graphic rather than real – though it was a real metal scaffolding that supported the huge canvas itself.

An image that was not much enlarged, but was certainly out-of-doors, appeared on one of a set of deckchairs produced in 2006 by the Royal Parks and illustrated with pictures and quotations. My version of what you might like to find on a deckchair was a sunbathing woman: but she was purple with green hair to remind you that she was a fiction. At a photo opportunity to announce the appearance of the chairs, beside the Serpentine in Hyde Park, the organisers had the idea of producing a brave young woman in the same colours, which also gave me the chance, in the half an hour after the photo-shoot, and no doubt before hypothermia set in, to draw her from life, in a moment of art imitating life imitating art.

Projects which are out in public spaces seem to go on appearing. In 2007 Tom Maschler, who for thirty years has been commissioning and casting a discriminating eye over the drawings that I have done for Jonathan Cape, invited me to illustrate a bus. It was his own initiative – indeed he bought the bus himself. The Book Bus travels around Zambia visiting schools and orphanages. It's a peripatetic library run by volunteers and which organises visits by artists and writers. In 2009 the project extended to another bus in Ecuador, the inspiring initiative of the parents of a group of gap-year students who had lost their lives in an accident there in 2008.

The deckchair for the Royal Parks

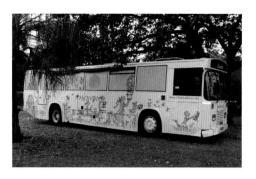

The Zambia Book Bus and its decoration

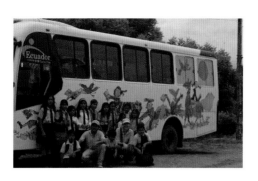

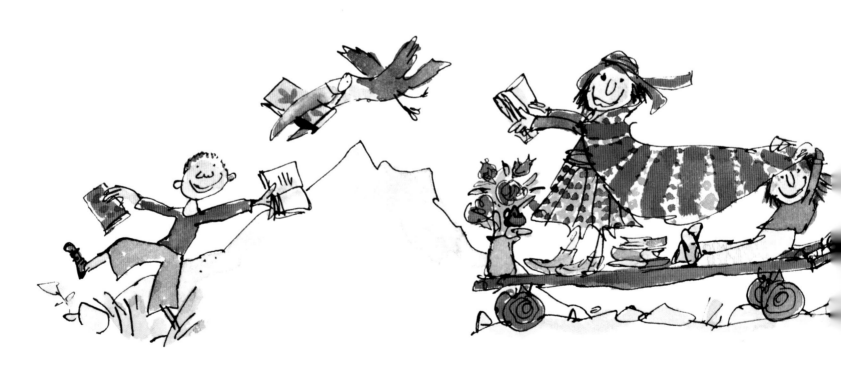

The Ecuador Book Bus and its decoration

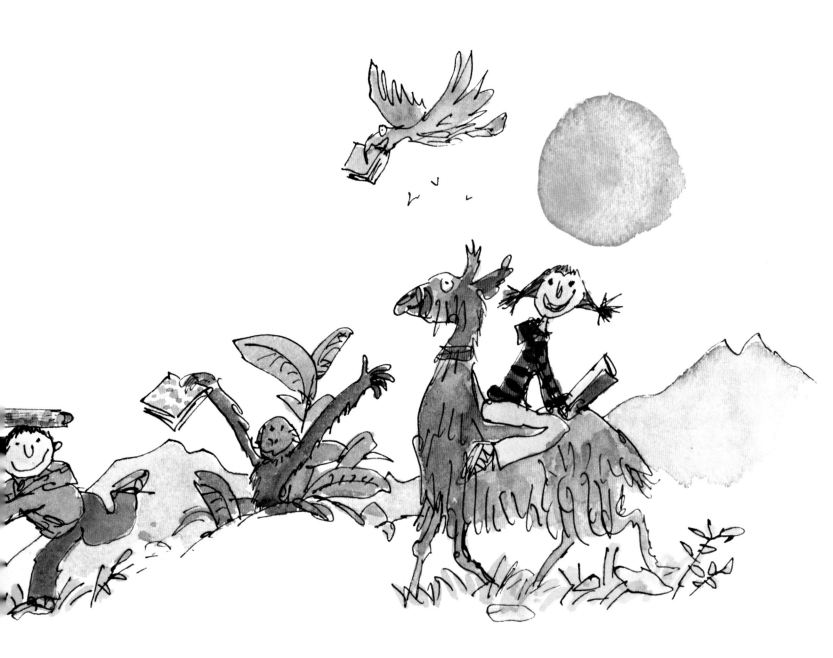

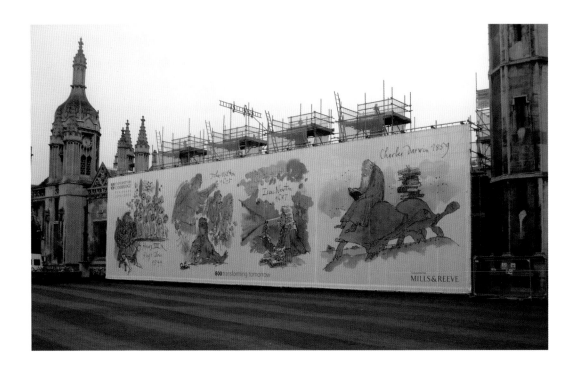

In 2009 I was invited to produce a series of pictures to help celebrate the 800th anniversary of Cambridge University. A bit over fifty years before I had gone up as a grammar school boy to Downing College to read English at the feet of F.R. Leavis. I wish I had more to say about my time as an undergraduate apart from reading books, visiting plays or films, going to life classes at Cambridge Art School and doing some drawings for the student magazine *Granta*.
A recent interview on Desert Island Discs revealed a pathetic lack of outrage or dissipation, to the contempt of one or two reviewers in the popular press. At any rate at some point Cambridge discovered that it owned me, with various happy results for me. In 2003 I was made an Honorary Fellow of my own college, and for a year President of its alumni association, and then, in 2006, there was the award of an honorary D. Litt of the University itself. So that when, a year or two later, seated on a bench on the Downing lawns, I was invited to produce a set of pictures for Cambridge 800, I had every reason to say yes.

Our original plan was a sort of Bayeux Tapestry of the University's history, but it quickly became apparent that this was impracticable with the time and resources available. What we settled on was a sequence of pictures – I called it an Informal Panorama – featuring significant figures in the University's history – Milton, Newton, Byron, and other more recent luminaries. The panorama, once drawn, existed in varying sizes, of which the most important version was about four feet high and seventy feet long. This version, after outings to a number of celebratory occasions, now has a permanent home in Addenbrooke's Hospital in Cambridge. Part of it appeared in large enough form to conceal scaffolding in front of King's College, and small enough to be a Christmas card and other items of merchandising for the Fitzwilliam Museum.

The Informal Panorama as hoardings in front of King's College, Cambridge

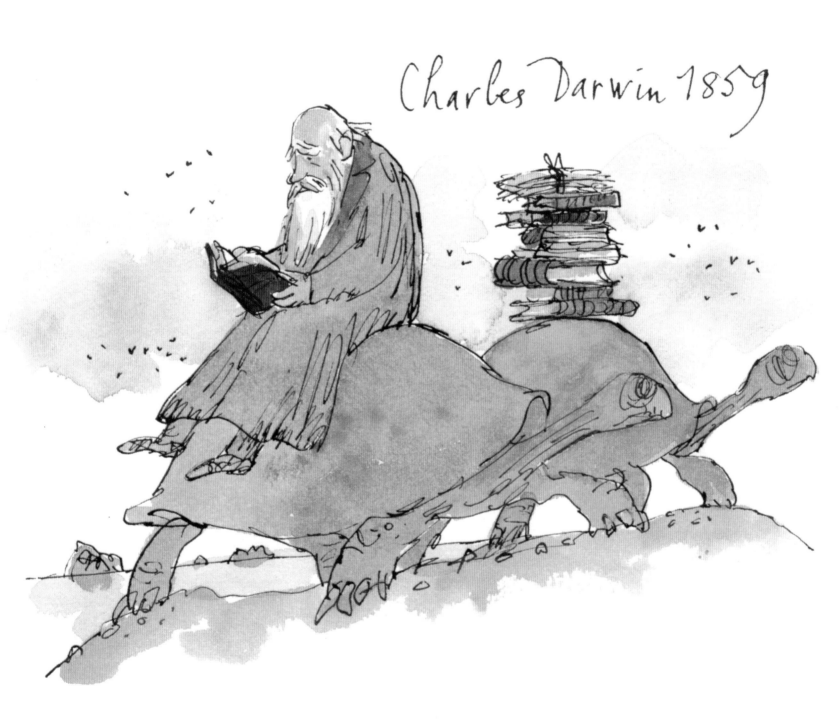

Charles Darwin 1859

Fleeing Scholars 1209

Henry VIII &
King's Choir
1544

Byron 1805

De Winton and Thring:
the rules of Football 1848

James
Clerk
Maxwell
1850

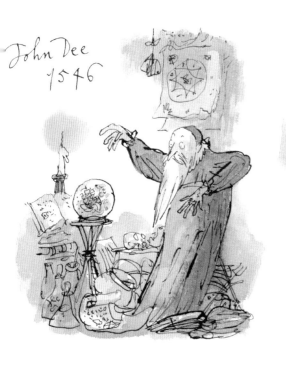

John Dee
1546

Oliver Cromwell 1617

Wilberforce 1776

Frank Whittle
1936

Dorothy Garrod
1939

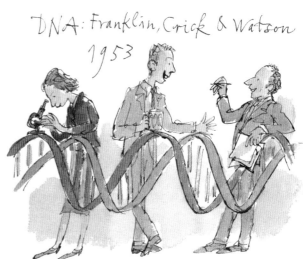

DNA: Franklin, Crick & Watson
1953

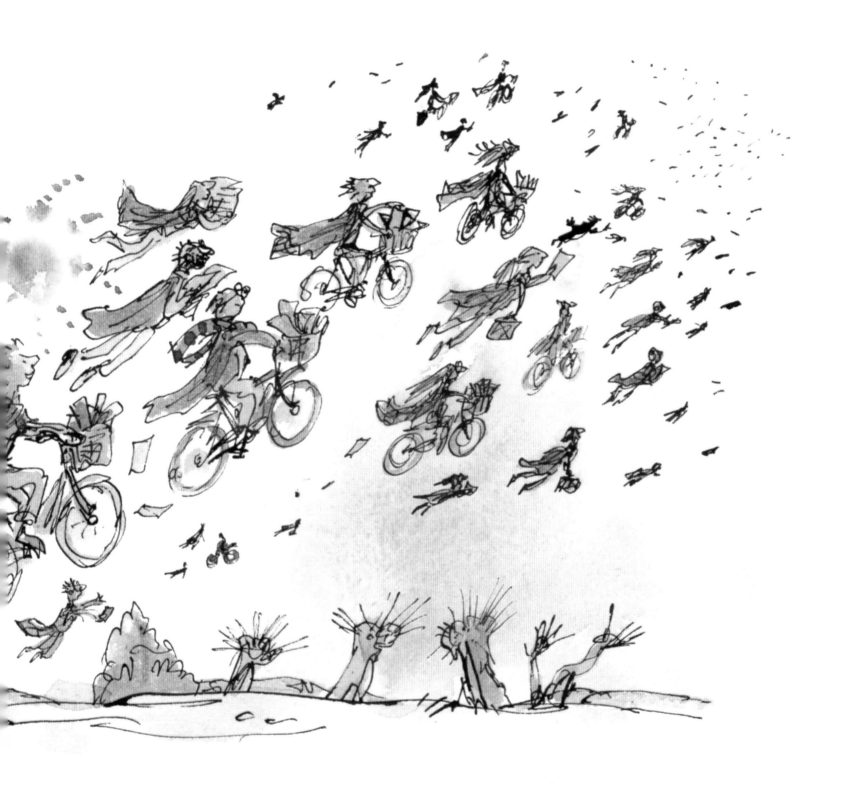

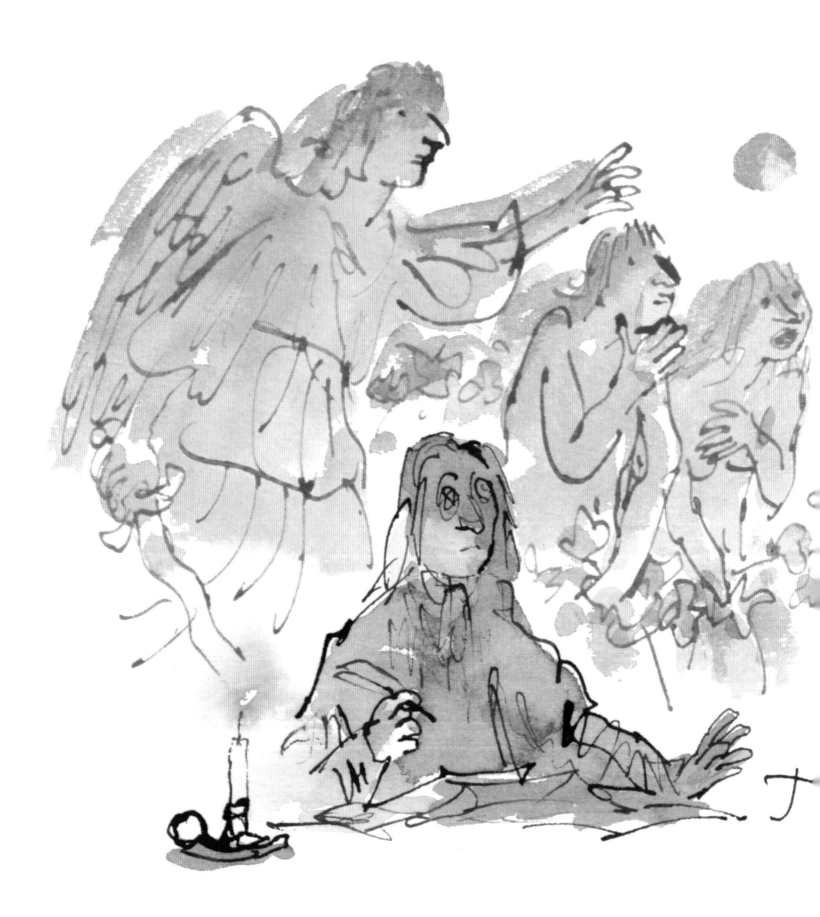

Isaac Newton
1687

n Milton
1625

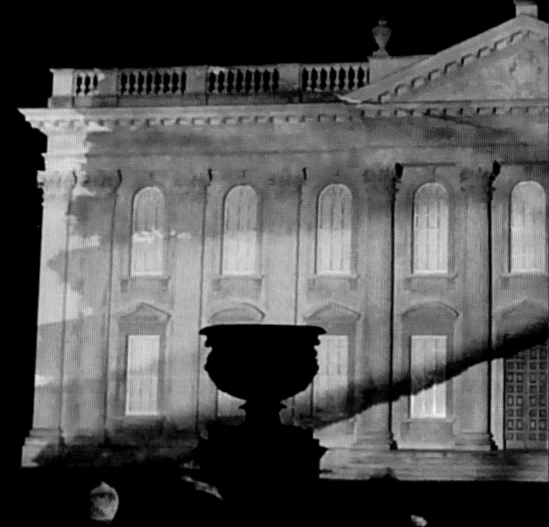

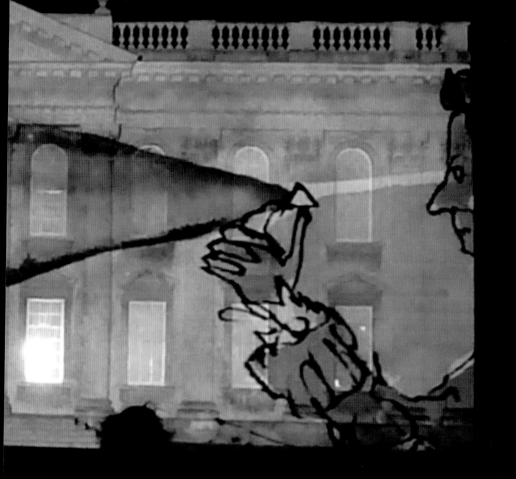

Isaac Newton: from the light show on the Senate House Cambridge

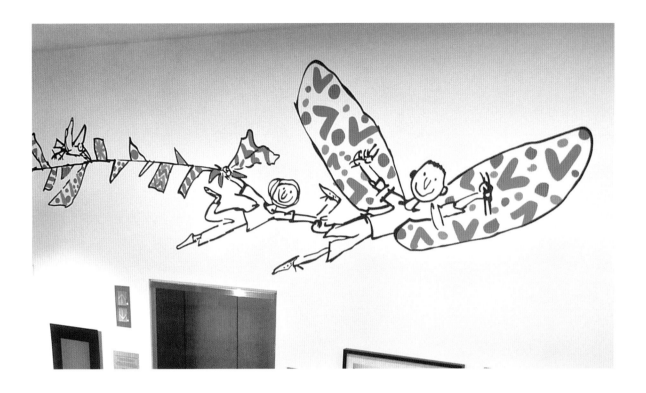

All these projects, as I have suggested, owed their practicability to the extraordinary fidelity of digital printing at any size. However, the invitation to draw a scene of theatrical characters to appear on the white walls of the Unicorn theatre for children and young people in Bermondsey on the London South Bank required a different answer. The idea for the drawings was not hard to find, and was prompted by a production that I saw forty years ago by the Royal Shakespeare Company. The play began with the cast uniformly dressed in white jump-suits, to which they added elements of costumes as they went into character. I've always remembered it as expressive of what theatre performance is about, and I adopted it for the Unicorn drawings. My characters are entirely black and white except when they blossom out into cloaks, trousers, hats, all of extravagant colour.

The more difficult problem was how to get them on to the wall and indeed how in a few years' time they could be cleaned and restored. Fortunately Lexi Burgess was in charge of the logistics of this project, and I was taken by the solution he brought to it. From an enlarged transfer of the original drawing the pictures are actually sign-painted on the walls, and so completely repeatable. The pressures and variations of the reed pen they are drawn with are preserved, but evenly black and flat. One has the interesting sensation that they are somehow printed on the wall, while being conscious that it isn't so. Of course the visitor need not think of this; what is needed is that he or she should be cheerfully welcomed, and accompanied up the stairs to the auditorium with a suggestion of the theatricality to come.

I had imagined that this might provide the practical solution to another task, one proposed to me by Ghislaine Kenyon. Her husband Sir Nicholas Kenyon had recently taken over the running of the Barbican Arts Centre. In the middle of his office stood, in a curiously Barbican-like way,

Wall decorations for the Unicorn Theatre

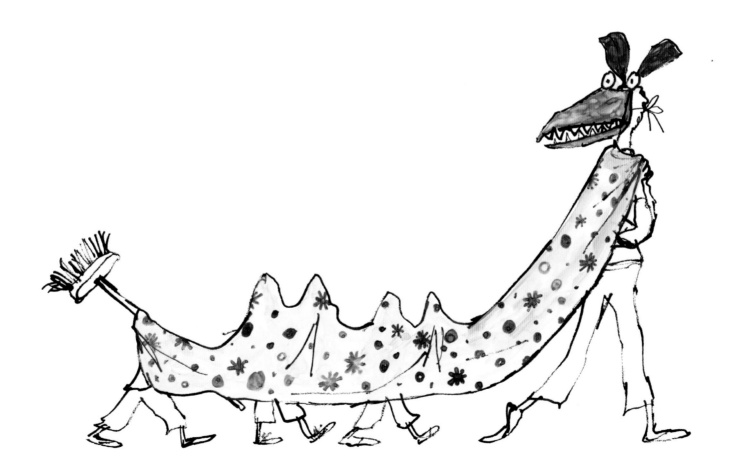

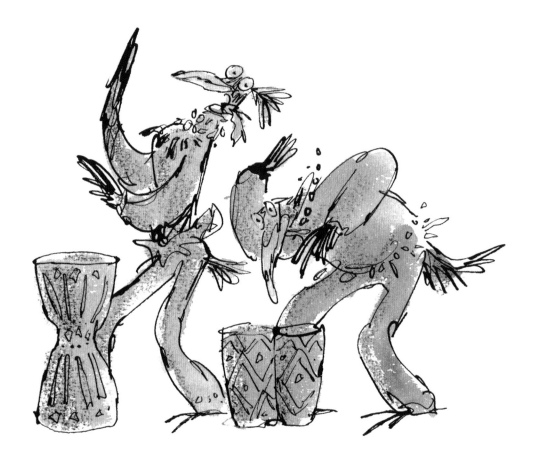

a stout and unavoidable pillar: could I do something that might lend it a more engaging character? When I came to look at the pillar it became clear that a sign-painted response, as at the Unicorn, would not be appropriate. The visitor to the office would be just too intimate with the work – almost literally rubbing elbows with it. The other question was the subject matter. I felt it ought to be some kind of performance and if possible at least gesturing at the multifarious ventures of the Barbican Centre. I considered a number of ways of setting about this, but in the end I found an answer in an unexpected quarter – unexpected in that it was one already familiar to me. I called in the cast of *The Life of Birds*. The advantage of this approach was that I could draw a variety of artistic activities without specifying individual performers, and indeed the fact that they were all birds gave the thing a certain unity. I soon had a sequence of them pursuing a gamut of artistic activities, and they became A Barbican Ornithology.

Back to the original question: how to get them on the pillar? I had various ideas about sticking on separate drawings or creating a banner that could be draped like a curtain, but I once again sought the guidance of Lexi Burgess, who provided an answer I wouldn't have guessed at: wallpaper. A sturdy washable wallpaper but wallpaper enough for its joints to be scarcely visible, with the effect that my performers appeared to be printed on the pillar, and the pillar itself, I hope, becomes the background to them rather than so overbearingly itself.

Maybe, though now safely at home in Nicholas Kenyon's office, these bird performers will become a little restive. Perhaps some of them will want to escape into other parts of the complex spaces of the Barbican building. I hope so.

Scenes for 'A Barbican Ornithology' and, overleaf,
the pillar in the Director's office at the Barbican Arts Centre

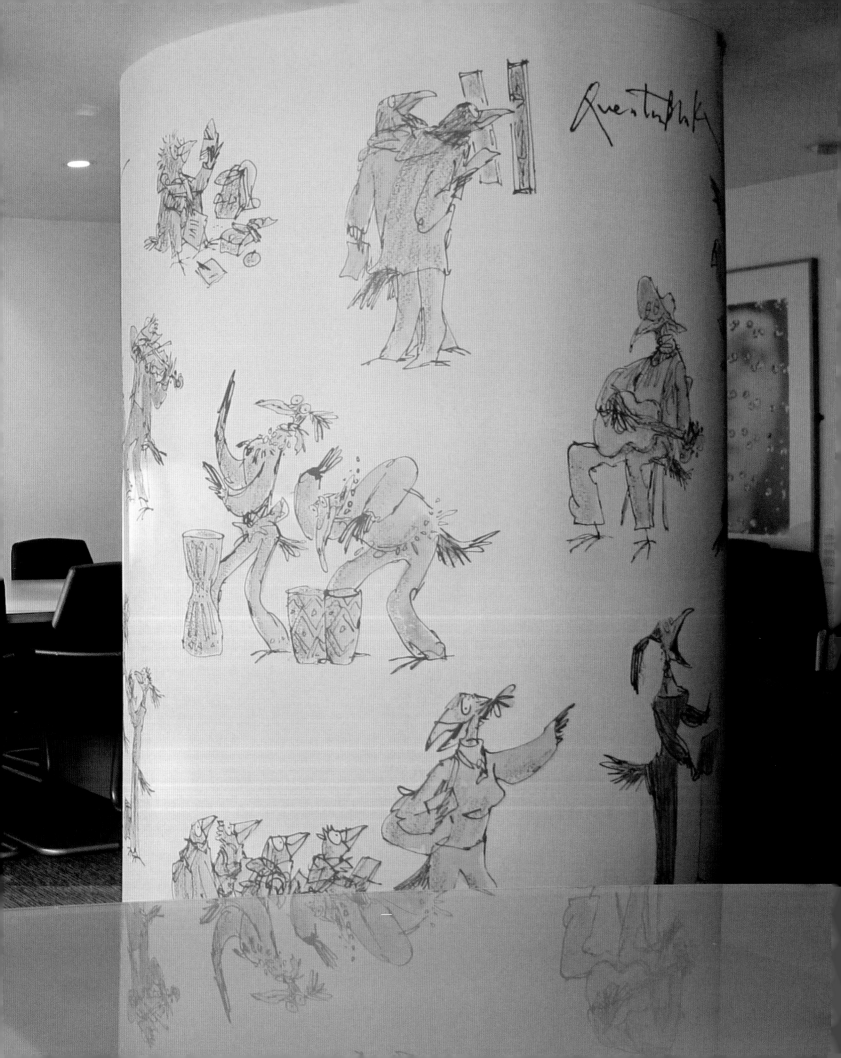

Hospitals: Old and Young

Curiously, I am able to put a precise moment on the beginning of the work for hospitals, which has been amongst the foremost of my activities in recent years. The meeting at which Stephen Barnham and Nick Rhodes, directors of the Nightingale Project, proposed that I might produce a series of pictures for the refurbishment of the Kershaw Ward for elderly residential patients in the South Kensington and Chelsea Mental Health Centre took place in Carluccio's café in Fulham Road in December 2005. It happened to be on my birthday. The question of age wasn't entirely inappropriate, either, since being approximately the age of my prospective audience I felt gave me if not a qualification at least a sort of licence.

I can also remember something of the way I set about it, because I had brought with me as samples some greetings cards, including one of an elderly lady swinging from one branch of a tree to another – that picture in itself having originally been drawn for a poem in John Yeoman's book *The Family Album*. In fact the trees became a basic feature of the sequence of fifteen or so pictures – they gave me a flat decorative format which wove together a number of activities, and they also indicated that we were in a not quite real parallel world where a certain vivacity of movement reflects, I hope, the mental enthusiasms of my spectators.

The tone of all these drawings is humorous, the style a form of caricature that I used in children's books or in drawings for magazines. If there is levity it isn't at all because I want to make fun of the characters I am depicting, and I was interested later to come upon some observations in an article by Sickert that I hoped and felt were relevant. Sickert was always acutely responsive to the graphic arts as well as to oil painting and here, writing in a magazine called *The Speaker*, in November 1896, he describes drawings by Japanese artists, and how they present 'simple daily works placed before us in a whimsical light'. 'This quaint, gently-grotesque touch' he goes on,

For the South Kensington and Chelsea Mental Health Centre

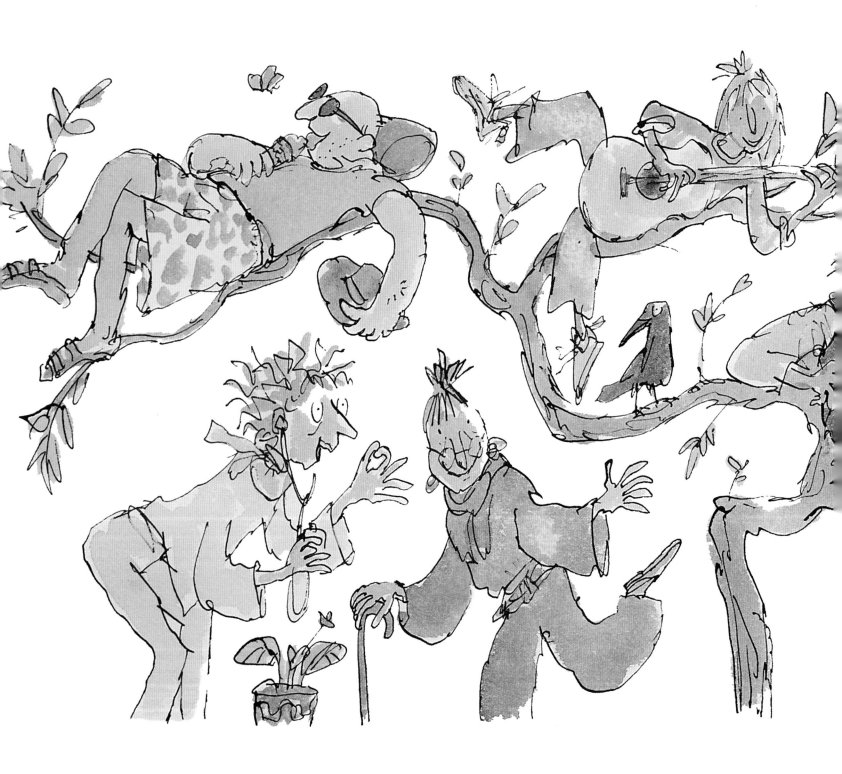

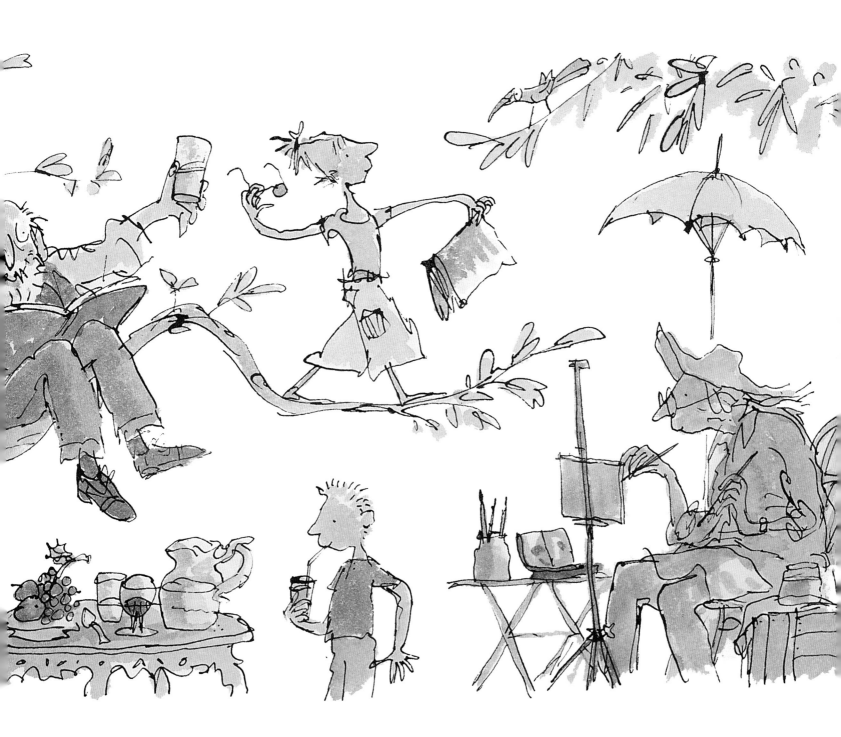

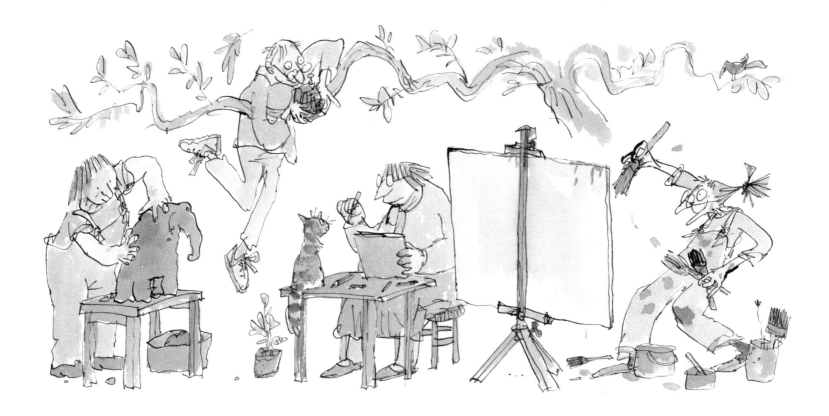

'brings the Japanese artist into closer relationship with his subject than we are able to get: poking fun at his models, he rallies them into a friendship…' I hope that something like this might happen with my Kershaw residents.

Essential to this series of pictures, and to all the hospital series mentioned here, is the fact that they were drawn in the studio and then produced as what are known in England (but, strangely, not in France) as giclée prints. A giclée print is not an original in the way an etching or lithograph is; it is a reproduction. Nevertheless, it can be printed, at whatever size, by a highly qualified printmaker, and on the same paper as the original, to which it is extremely faithful. At the same size it is quite difficult to tell the original and the printed version apart. There are special practical advantages to this method in the hospital situation. I keep the originals, so that what the hospital is buying is the right to reproduce, which reduces the cost dramatically, as does the similarly reduced insurance value. In the last resort any print can be replaced, as it can also be repeated, at the same or at a different size, for another hospital with similar requirements.

This first set of Kershaw prints were mounted flat on their appropriate walls, without frames but under very shallow Perspex boxes, so that although they are not murals, nor are they already-existing pictures brought in. What you see are, in a sense, illustrated walls.

Once this first Kershaw series was in place I was invited to produce pictures for the individual patients' bedrooms. The first sequence of pictures required a certain continuity of approach, but here I felt I could freewheel from picture to picture, picking up on some of the elements of the existing works without staying close to them. There are cats and birds (some of which came out

For the South Kensington and Chelsea Mental Health Centre

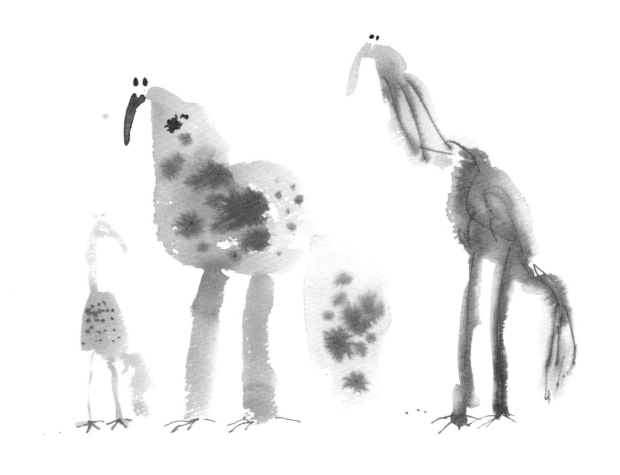

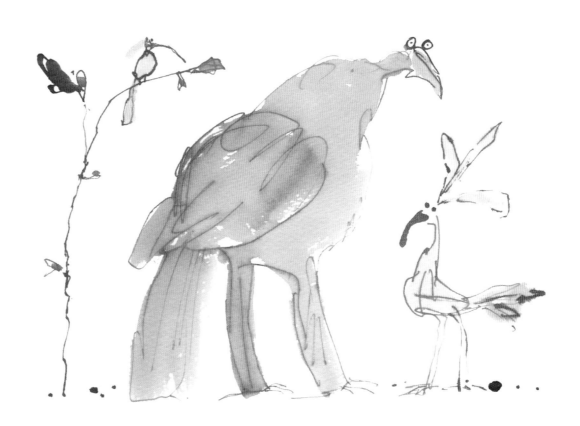

For the South Kensington and Chelsea Mental Health Centre

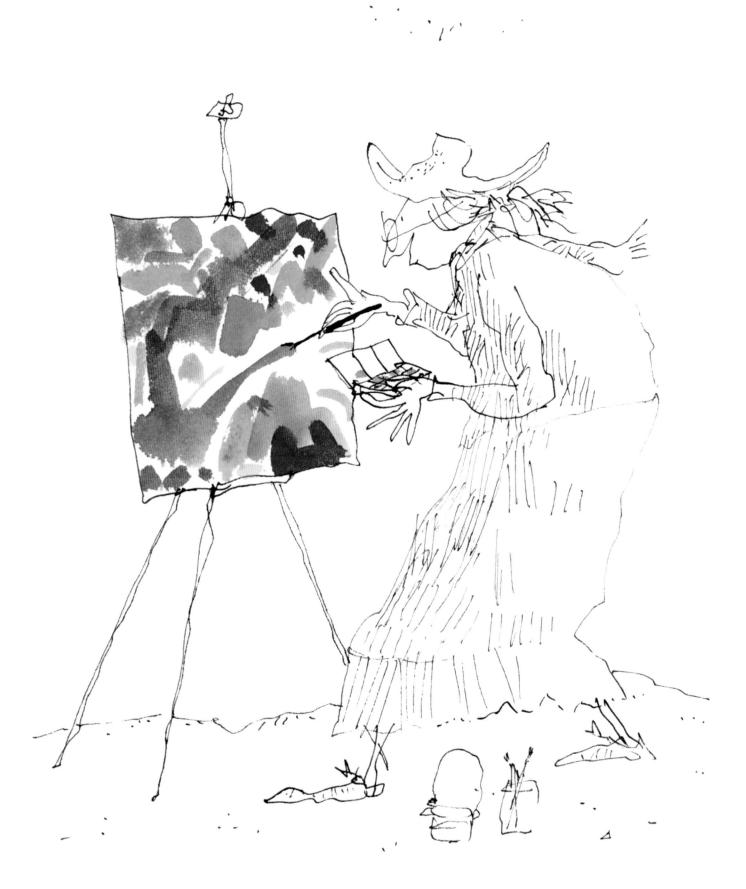

looking as though they might have psychological problems of their own), artists and readers, and a number of grey and gold pictures of old and young together. None of these pictures needed to be as narrative, or be committed to any precision of image, as the first set. I felt able to move on from one to the other, varying mood and technique. So enjoyable were these exploratory forays that though the initial request was for nineteen pictures, one for each bedroom, I found myself eventually with sixty-five. My friends of the Nightingale Project accepted them all – 'we have plenty of hospital bedrooms'.

I have subsequently produced two other series of pictures for elderly patients' residential centres. With one, for the Woodlands Centre at Hillingdon Hospital, I went a slightly different way to work. I did a sequence of black-and-white drawings with a reed pen which were enlarged in printing, and then areas of colour (fans, flowers, aromas) were added by hand to the printed drawings. I think I had some idea of suggesting that even quite monochrome lives could have bursts of colour. Another set of pictures was called 'Our Friends in the Circus' and shows the elderly, assisted by the young, setting about circus acts with a certain aplomb, and in a comfortably less extreme form than is usual, except perhaps for the fire-eating. Perhaps it's because of its open defiance of any possible health and safety regulations that this has proved to be one of the most popular in the series.

It was once again thanks to Ghislaine Kenyon and our collaborator in Paris, Patrice Marie, that I found myself offered the prospect of producing a series of pictures for the day reception centre in the Hôpital Armand Trousseau in the city. The hospital is for children of all ages up to eighteen with both medical and psychological problems. Many of the children are from immigrant African families. Once again there was no clear-cut brief. In fact having to create a brief for yourself,

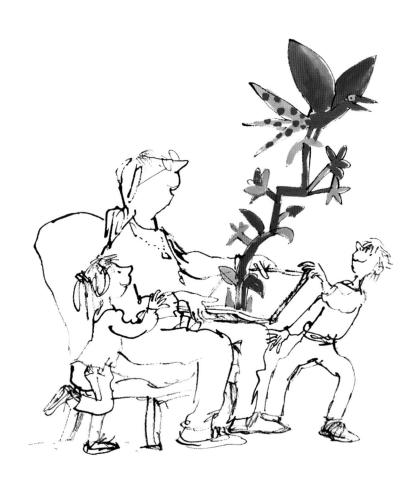

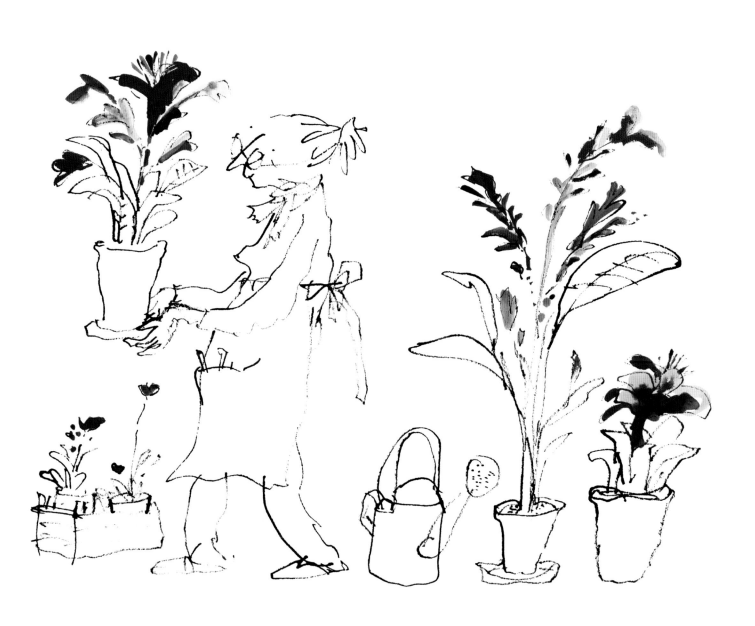

From 'Our Friends in the Circus'

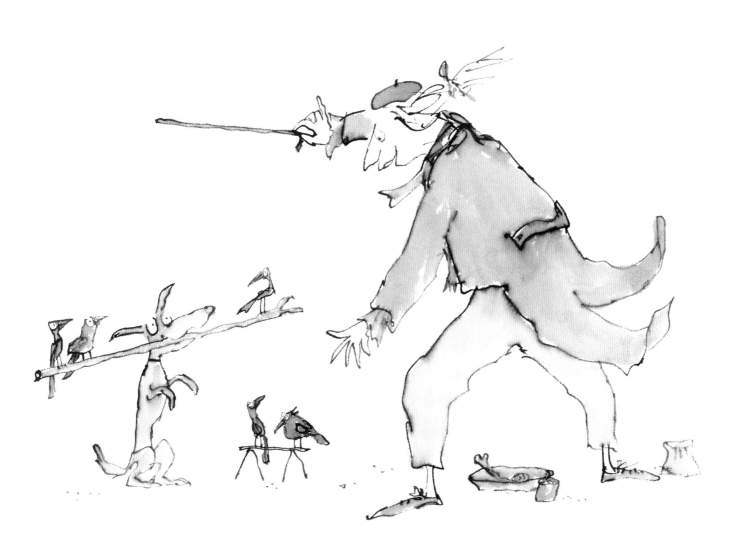

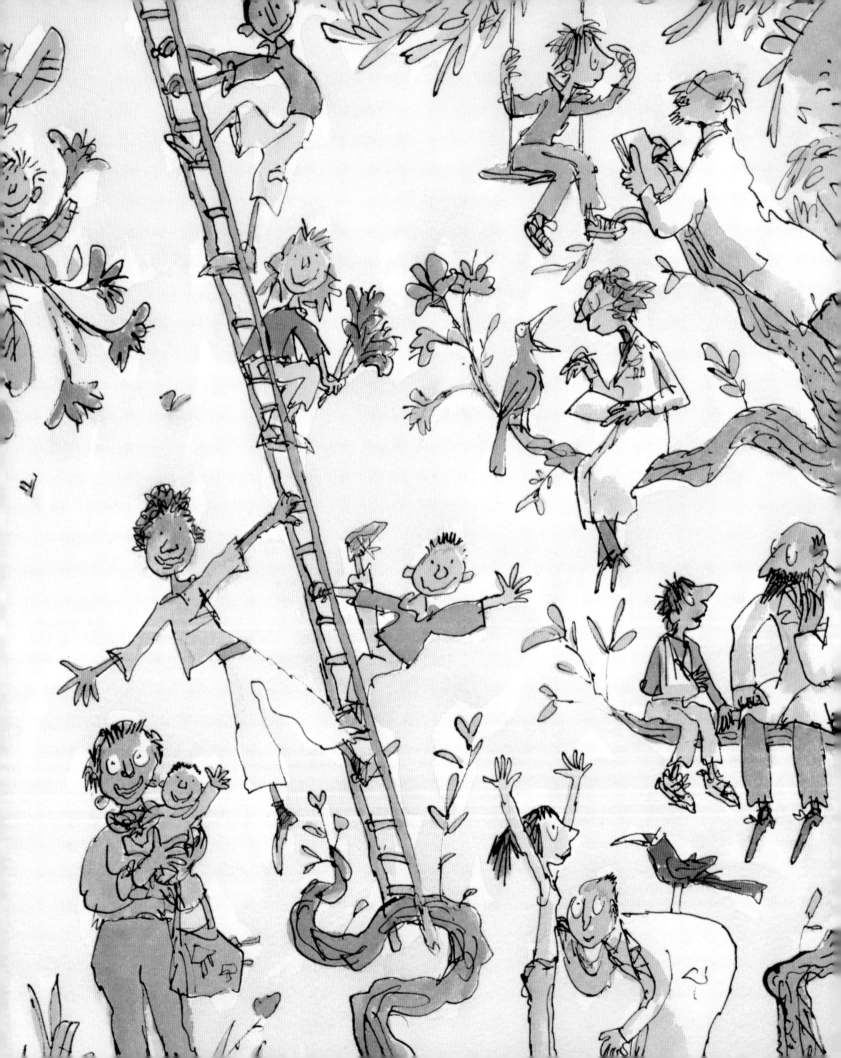

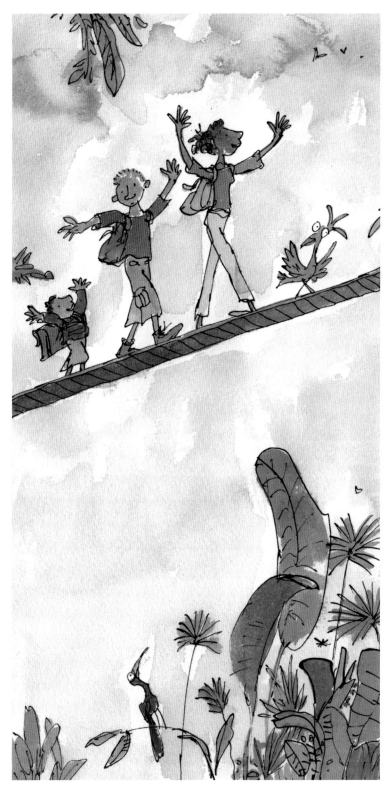
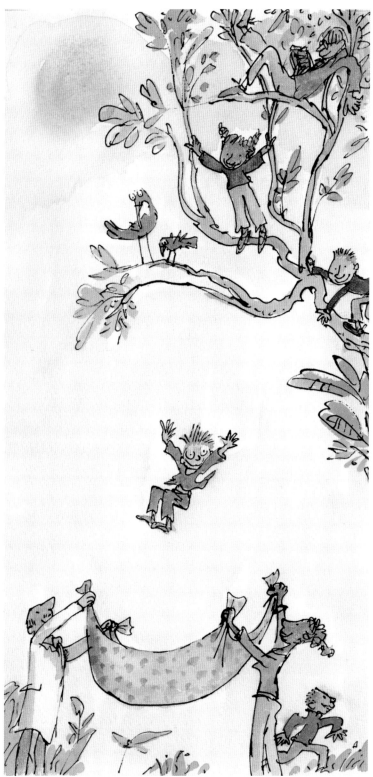

For the Hôpital Armand Trousseau, Paris

225

as it were, is part of the fascination of the exercise. Hanging about in the reception area to draw the young patients, and talking to the medical staff, aided my sense of what ought to happen. In the final pictures all the different clients managed to appear, in varying states of optimism or despair, together with a number of helpers and specialists (one or two of the doctors managed to identify themselves, even though I didn't actually attempt any portraits).

Once again we are in trees, so that every incident is well in view at the same distance. It's a mise-en-scène that allows both comforting situations, on platforms and in hammocks, as well as nervous wobbly ones. The fundamental idea, of course, is that if you jump (or fall) out of the trees and there is always someone there to catch you.

There is a similar metaphorical parallel life in a sequence of pictures carried out for the Alexandra Avenue reception centre in Harrow. Trees again, but this time very strange, patterned ones, because the fiction is that we are on Planet Zog. The parallel, of course, is between our experience on an alien planet and that in an almost equally alien hospital. The young patient should be able to identify certain medical procedures: at the simplest level, when an alien sticks its tongue out it's really worth seeing. The largest scene takes up one wall in the general waiting room. Printed on fabric, it's almost fifteen feet wide, and there is a proportional range of activities to note and I hope to speculate about. I don't think I have ever made any claims that pictures like these have a therapeutic effect, at least beyond helping to put people at ease. However, it's impossible not to hope that sometimes they might have, and so I especially appreciate the observation of Gilles Chazal, Director of the Petit Palais Museum, when I described this picture to him: 'If you had to wait long enough you might get cured before you got to your appointment.'

From 'Welcome to Planet Zog'

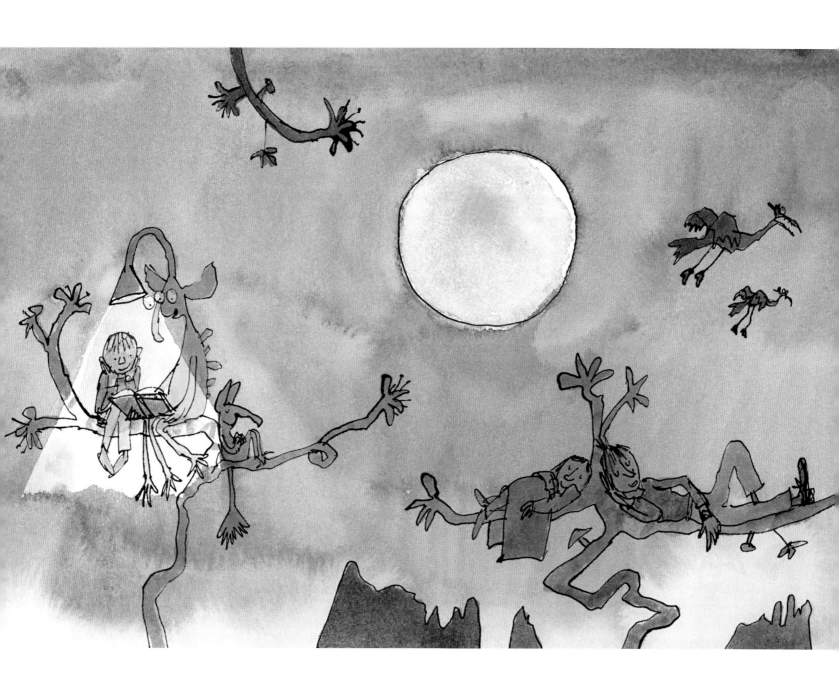

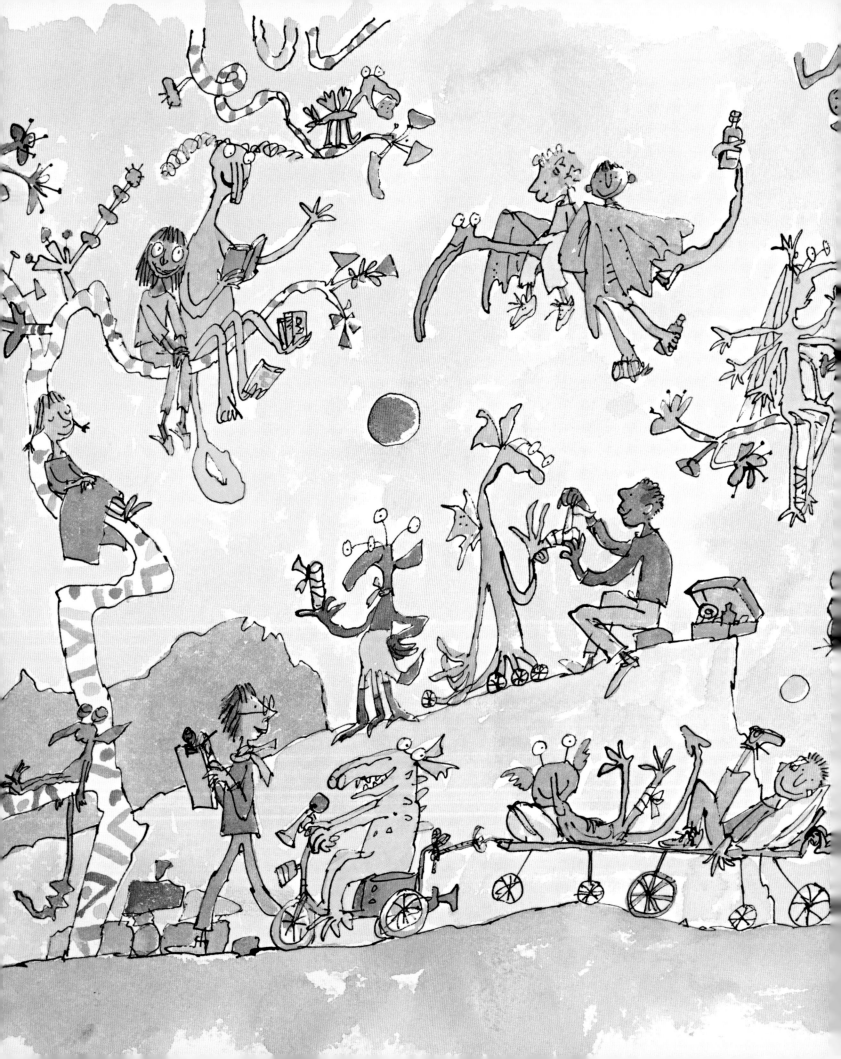

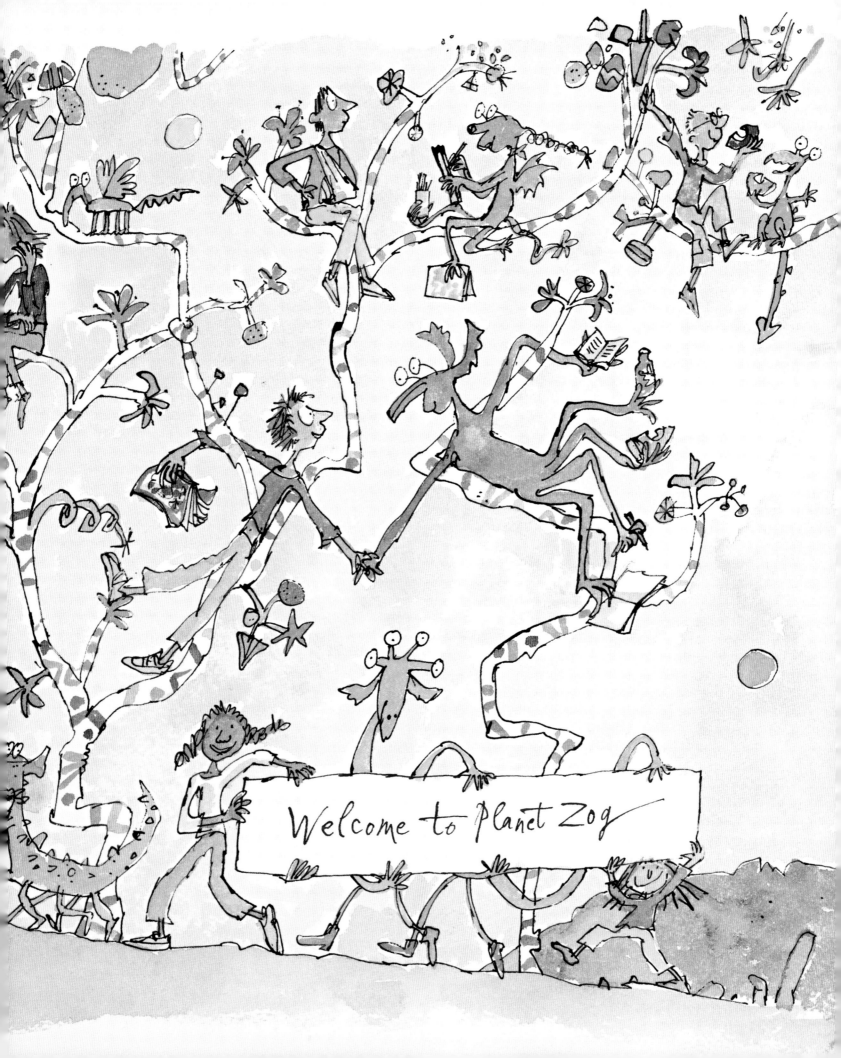

Welcome to planet Zog

Hospitals: Versions of Reality

My three most recent projects for hospitals are in a rather different mode from their predecessors and closer, in one or two ways, to reality. Since starting work on hospital projects I have also produced pictures which emerge from the hospital experience without necessarily being destined for hospital walls; and so it was I found myself in the room that serves as my studio in France drawing people swimming about under water. I have no idea where they came from. They are accompanied by an assortment of fish, and occasionally one or two small crocodiles, but their distinctive feature is that they are dressed in ordinary everyday clothes. They are drawn with a brush and in a more naturalistic style than any of the other hospital pictures so far, which makes it even more possible for them to behave as though nothing untoward was happening.

Though I thought that this series might have some hospital use I didn't know what it was until I got the drawings back to England and showed them to Stephen Barnham of the Nightingale Project, who knew immediately where they belonged, in the corridors of the Gordon Mental Health Centre for adults in Vincent Square. I set about extending the series, and extending the range of age and ethnicity and class. I could see them now as everyday people finding themselves in an unusual situation but still unfazed. (Just one of them, by contrast, looked to me as though he might be a psychiatrist, and he had some very odd fish alongside him.) The drawings were done in black indian ink but each printed in a different subdued colour.

When some of them were put on show in the Royal Academy Summer Exhibition they proved popular with a wider audience, who bought them and wrote to me about them. What was of more concern to me, however, was their effect on their original intended audience. That is harder to judge, but I got some help from a feature written for the Times by Juliet Rix. Amongst the conversations she had in the preparation of it was one with a psychiatrist at the hospital who

From 'Life Under Water'

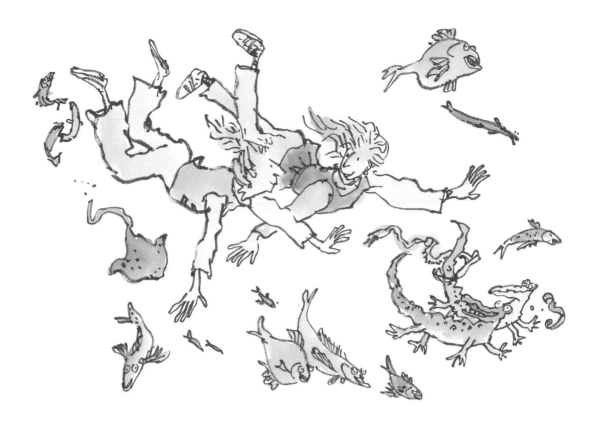

had reported her own surprise when one of her patients, profoundly depressed, had nevertheless reacted positively to the pictures. They obviously had significance for him. Naturally this is gratifying in itself, but what is particularly of interest to me is that drawings are not simply entertaining or distracting, but in their own way can actually speak to people. More evidence was eventually forthcoming from the next series of pictures that I embarked on; ordinariness and everydayness were also a feature of them. They were for the Eating Disorders Unit at the Vincent Square Clinic. In order to get a sense of what might be appropriate I was able to visit the unit and meet with a small group of both staff and patients. Patients, I discover, are now called service-users, and some of them are in a state induced by their anorexia that is distressing to set eyes on. Nevertheless, they are characteristically young, intelligent, scrupulous and self-critical. They tell me that as far as they are concerned I can draw anything I like – though it's acknowledged that food is a sensitive issue. The rooms to have drawings include the dining-room, where, as one young woman puts it, 'I've got enough on my plate as it is.'

It seemed to me that what was in order were pictures which did not avoid reference to some of the issues that concerned them, but which are, I hope helpfully, relaxed and at ease – so that food may appear just as part of everyday life (may even be just crumbs for the birds) and self-image becomes a self-portrait or a snapshot. The pictures are drawn with quills, which give a slightly untidy sort of line, and coloured with watercolour, which softens away at the edges. If the images are comfortable I nevertheless hope they are not sluggishly comfortable; mostly there is action and interaction in them. What was very noticeable to me was that, by contrast with all the other pictures described here, there's no element of metaphor present at all. Indeed if they were taken away from the context of an Eating Disorders Unit I suspected that it might not be easy to establish their original practical purpose.

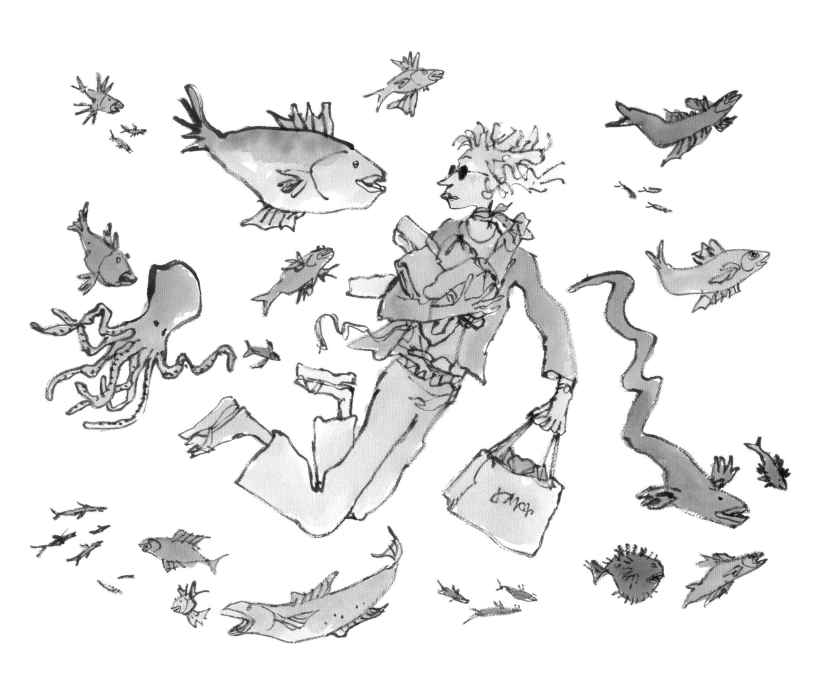

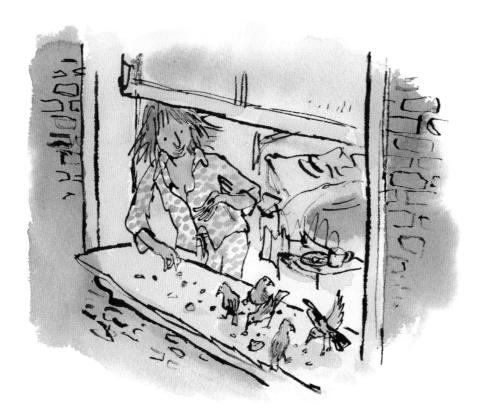

One valuable response was that of one of the clients of Vincent Square who gave me a photograph of herself with her white, fluffy, engaging dog; and subsequently wrote me a letter of appreciation from herself and her fellows. The dog became happily incorporated in one of the Vincent Square pictures. Very unhappily, its owner did not survive to see it: a reminder, if one needed it, of the tenacity of such psychological afflictions.

Another response was of particular interest to me. It was from an artist who had also been an anorexic, and who had been introduced to the pictures by Dr Nick Rhodes. As I have mentioned, one of the features of this kind of hospital exercise is that there is no precise brief; in fact the answers to such an imagined brief don't ever get into written form, but are found in the rough preparatory drawings. Consequently it had a special value for me to read, in the commentary which this artist produced, an acknowledgement that the effects that I had been gesturing at had actually been experienced.

'As we recognise in these drawings our most personal responses when confronting a mirror, and the peak of our indecision at the bottom of the mountain of undistinguished clothes, we do not feel criticised at all, but understood and accepted with benevolence'.

'The little girl in the yellow dress reminds me that enjoyment and happiness come with connection and creativity… She shows me that it is not perfection but imagination that nourishes our dreams.'

The most substantial of these hospital projects has an aspect of reality but also now, once again, metaphor. What it is not about is illness. When we had been having discussions about the Hôpital Armand Trousseau project there had been mention of a maternity ward, but that wasn't in the end what I found myself doing. However, the idea remained at the back of my mind. Sometime later in a television interview I was asked the familiar question about whether there was anything that I hadn't yet done that I would like to attempt. At that moment I think I was simply looking for a suitable answer to fill the space when I mentioned a maternity ward, and I had no inkling of how I might set about it or what it might come to mean for me, nor did I have any expectation of what I had said being followed up. Nonetheless, I did receive enquiries from members of the staff of three hospitals, and Scarborough, which was perhaps the best set-up to deal with such an initiative, followed through. It now has nine digital prints of drawings, specially produced, on the walls of its maternity department.

At the same time Patrice Marie in Paris, who had been instrumental in bringing about the Armand Trousseau project, had in his researches come upon an even more exciting prospect. The University Hospital of Angers – the Centre Hospitalier Universitaire d'Angers – was on the point of building a new free-standing maternity wing. Visually, I had my answer ready – mothers swimming underwater with their babies – but when I try to remember how they came about I only encounter a sort of vacancy. I already had the idea of swimmers, and that seemed appropriate to the idea of amniotic fluid, to the fact that for a while babies can swim naturally, and even, here in France, to the coincidence that the hospital is on the banks of the River Maine, which has been known to flood from time to time. I am not, however, aware of a moment when the swimmers became mothers and babies and became a different metaphor. What I do have are notebooks with rough drawings exploring possible positions, of protection, discovery, recognition – and experimental drawings attempting to arrive at the most appropriate drawing implements. A brush seemed to be the right thing for the clothes of the previous swimmers, but not for naked flesh – for that smoothness a reed-pen seemed the better answer.

The staff and management of the Angers hospital were wonderfully wholehearted and enthusiastic about the project, and the sequence of drawings extended to nearly fifty, to appear in every kind of space: delivery rooms, waiting rooms, midwife stations, and so on. For the waiting and other rooms fathers had to appear, and there were even pictures for sadder spaces, where unsuccessful pregnancies had to be interrupted, and even where relatives could have sight of the small person who had failed to survive.

None of this can be brought about without a certain amount of discussion. If I felt daunted when I found myself seated opposite a committee of six or seven midwives in white coats, any apprehension did not survive the immediate evidence of their perceptiveness in both professional and visual questions. I was reminded of the support and encouragement I had found in the Petit Palais, not least in an observation from M. Edmond Vapaille, the director of the hospital who had administrative control of the scheme. 'The important thing is', he said – I half anticipated some kind of financial consideration to be proposed – 'The important thing is the exchange of look between the mother and the baby.'

For the maternity wing at the University Hospital of Angers

As I began to see the drawings reproduced in the enlarged form in which they would go on to the walls of the new maternity, it occurred to me that they had perhaps some kind of odd relationship with seventeenth century rococo decoration, the ribbony seaweed providing the attendant decorative flourishes. At that time the nudity would have been accepted as in order – classical, even seductive. My young women, however, were real, contemporary. If women are found with no clothes on in present-day paintings they generally acknowledge their art situation; they are in some sense or other posing. The difference for me was that mine were metaphorical, but real, and appeared in spaces that were in one way public but at the same time existed for a specially private experience.

The drawings, I should perhaps explain, are not drawn from life. You produce them from memory – of life-drawing classes and of life – and by trying to find the positions and gestures with the drawing implement by imagining them on yourself. At the same time I suppose you are imagining yourself in such a life situation. 'How do you know that?' asked one of the hospital staff, pointing out that I was not a woman (nor as it happens, a husband or father). But that is one of the attractions of drawing. Once started it can sometimes take you further than you ever thought you could get.

As I have explained the mothers and babies are drawn with a reed-pen, in Indian ink, and coloured with watercolour, mostly a non-naturalistic watery colour, blue or green. After a certain amount of experiment I realised the thing not to do is to paint the water. Moved about only on the bodies, watercolour is able to suggest the human forms and the movement of the water at the same time. That there is no other presence of water takes the pictures further into a parallel reality – there's more sense of a celebration in the mothers' and babies' liberty of movement. They might almost be flying.

One side of the new maternity building is a glass façade, and in the windows are close-ups of young mothers' heads and some of those exchanges of look between mother and child. I hope that on seeing them visitors will have a sense that they are arriving at an institution of great professionalism but also somewhat has sensitivity, optimism and perhaps even a certain elation.

This project was one of the most gratifying I have ever been engaged on. In its turn it produced two sequels. First, at the inauguration of the new maternity wing at Angers, the impressive woman who runs the intensive care unit drew my attention to the fact that those babies in need of special treatment had to be taken from the maternity unit to her department via un couloir triste – a sad corridor. Could the pictures of the maternity be extended along that route? As far as I was concerned, given the approval of the hospital, they certainly could. I knew immediately what I wanted to do. It needed water once again, but this time the metaphorical attendants – nymphs or nurses – would wade, the babies floating or carried in an assortment of baskets and boxes. The real-life babies go on from the intensive care unit, so that everyone is proceeding in the same direction, on the right or left hand side of the corridor; a corridor now, I hope, happier than before.

For the maternity ward corridor at the University Hospital of Angers

For the Rosie Hospital

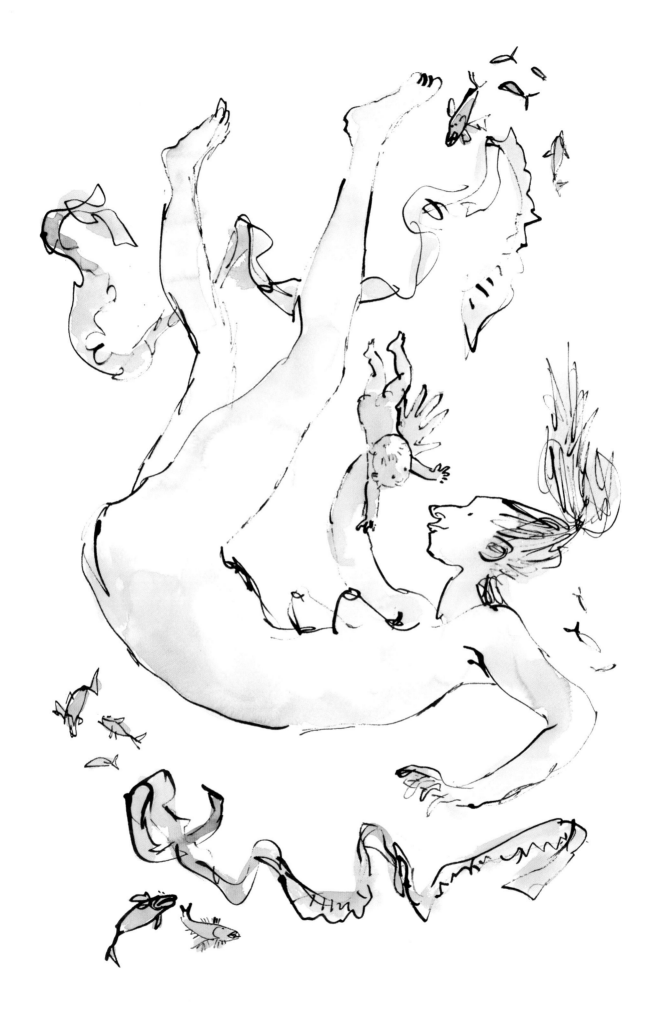

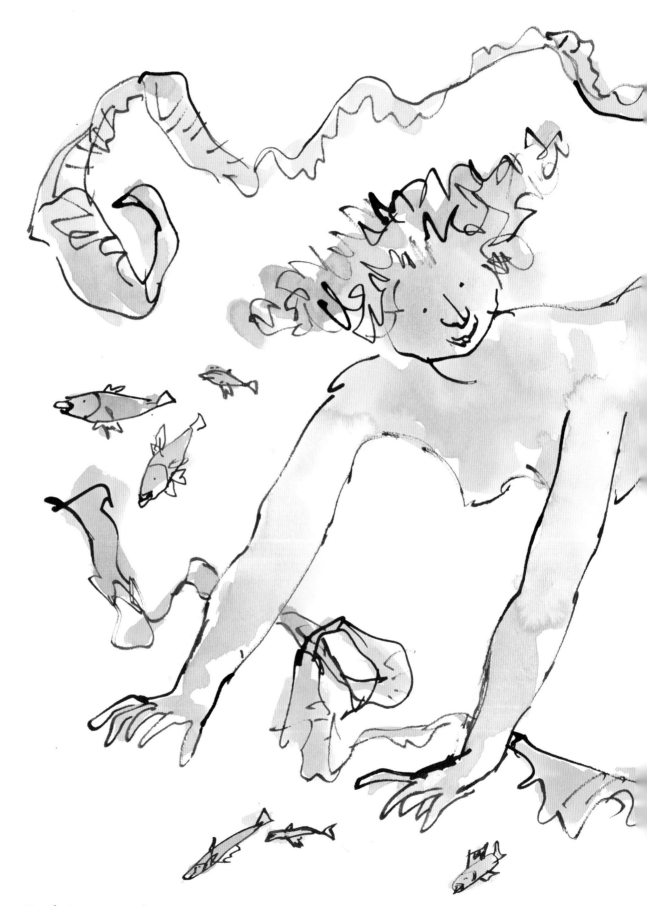

For the Rosie Hospital

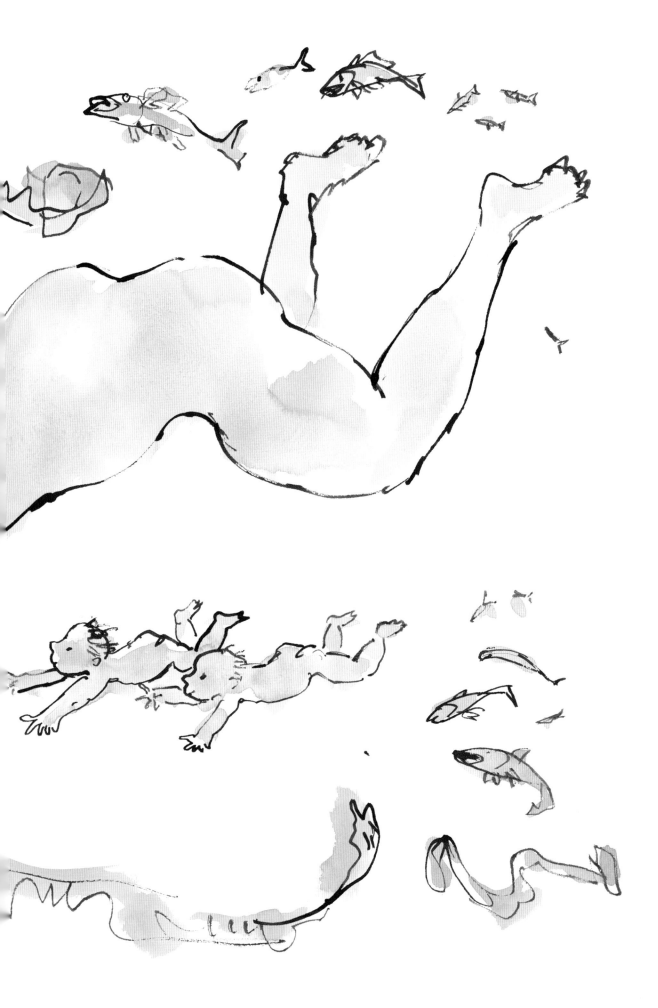

While the Angers maternity pictures were being installed I received an invitation to put on a show at Clare Hall, the Cambridge postgraduate college that, though it doesn't have a separate gallery, has attractive spaces to show works of art, and a tradition of exhibitions. I proposed a selection of the Angers works both as prints and originals and as a large wall-hanging, which we produced specially for the dining room of the college. The organisers were happy that it would introduce a Cambridge audience, already familiar with the Cambridge 800 pictures, to a different aspect of my work. The exhibition was called Swimmers.

One of the visitors who came to it was Dr Mary Archer, Chair of the Addenbrookes NHS Trust, whom I had met at the installation of the Cambridge Panorama at Addenbrookes the previous year. She explained to me that the maternity department is called the Rosie Hospital, and at that moment there was in construction a new wing which included an integral Birthing Centre where there would be ten birthing rooms. Other parts of the Rosie had works of art already commissioned for them, but nothing was in hand for the rooms where you actually give birth. Might the Angers approach suit the Rosie too?

On a subsequent visit it became clear that there was also the need for pictures in the reception area and in one or two sites in the connecting corridors, but the main opportunity was for two pictures – one horizontal, one vertical – in each of ten birthing rooms. Some of these spaces were similar in proportion to those in Angers, so at least in principle it would be possible to reprint some of the same images. However, the more I gave it thought the more it seemed better to produce as far as possible a new set of pictures. I remembered that when the Angers work was complete the senior surgeon had invited me to give an explanatory lecture to all the staff of the unit. It would, he pointed out, help them to feel that the pictures really belonged to them; and as far as possible I would like the Rosie team to have a similar sense of possession. So I found ten variations of young women swimming from left to right and from right to left, with their babies and ten more vertical variations, in blue and green but also in sunny colours.

As I write this there are swimmers already in place on the walls of the Birthing Centre, and others, printed and framed, on their way to Angers. It enables me to bring this book to a sort of conclusion, though not, I hope, such projects. I still find it extraordinary how many other variations have come my way since Michael Wilson invited me to draw on the walls of the National Gallery and I still hope that I shall have more escapades – for whom? where? printed on what? – beyond the page.

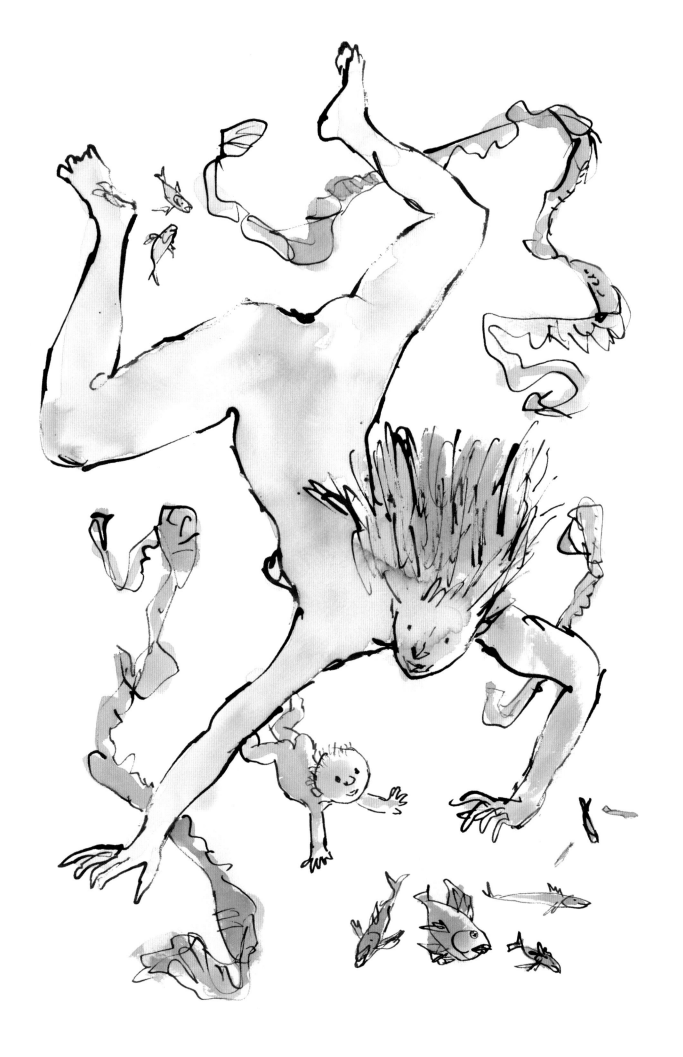

Index

Page numbers in *italic* type refer
to pictures.

Exhibitions

2001
Tell Me a Picture
National Gallery, London
Curated and illustrated

2002
Chris Beetles Gallery

November 2002– December 2003
UK tour until 2005 and worldwide facsimile tour
until 2008
Magic Pencil
British Library
Curated and participated

December 2003– June 2005
Quentin Blake: Fifty Years of Illustration
Gilbert Collection, Somerset House; and UK tour

October 2004– January 2005
Quentin Blake at Christmas
Dulwich Picture Gallery

April– June 2005
Roald Dahl and Quentin Blake
Peonza Festival, Santander, Spain

May 2005–May 2006
In All Directions: Travel and Illustration
Hayward Gallery and UK tour
Curated and participated

June 2006–November 2007
Frabjous Beasts, Holburne Museum of Art, Bath;
and UK tour
Curated and participated

March– April 2007
Quentin Blake: A Celebration
Chris Beetles Gallery

November 2006– March 2007
Quentin Blake: The Theater of the Page
Eric Carle Museum of Picture Book Art,
Amherst, Mass. USA

August–October 2006
Roald Dahl / Quentin Blake: The Illustrations
National Theatre, London

March–May 2007
*Theatres of the Imagination: Quentin Blake
and Emmanuele Luzzati*
Italian Cultural Institute, London

July 2007– December 2009
*Snozzcumbers and Frobscottle: The Wonderful World of
Roald Dahl and Quentin Blake*
Seven Stories, Newcastle; and UK tour

October 2007– January 2008
Quentin Blake at the Kelvingrove
Kelvingrove Art Gallery and Museum, Glasgow

July 2009– February 2010
Il Mondo di Quentin Blake
Museo Luzzati, Genoa

December 2009–February 2010
Only Young Twice!
Chris Beetles Gallery

21–25 June 2010
Royal College of Psychiatrists
Exhibition of prints during annual conference in Edinburgh

December 2010–January 2011
Frabjous Beasts and Frumious Birds
Chris Beetles Gallery

January– March 2011
Quentin Blake et les ages de la vie
Exhibition of prints and originals
Angers City Library

October–December 2011, on tour until 2013
As Large as Life
Prints for hospitals
Compton Verney, and UK tour

8 March–30 April 2012
Quentin Blake: Swimmers
Clare Hall, Cambridge

26 May–27 August 2012
Quentin Blake Exhibition
Royal Horticultural Society Garden, Rosemoor, Devon

11 December 2012–January 2013
Quentin Blake: new etchings, lithographs and drawings
Marlborough Fine Art, London

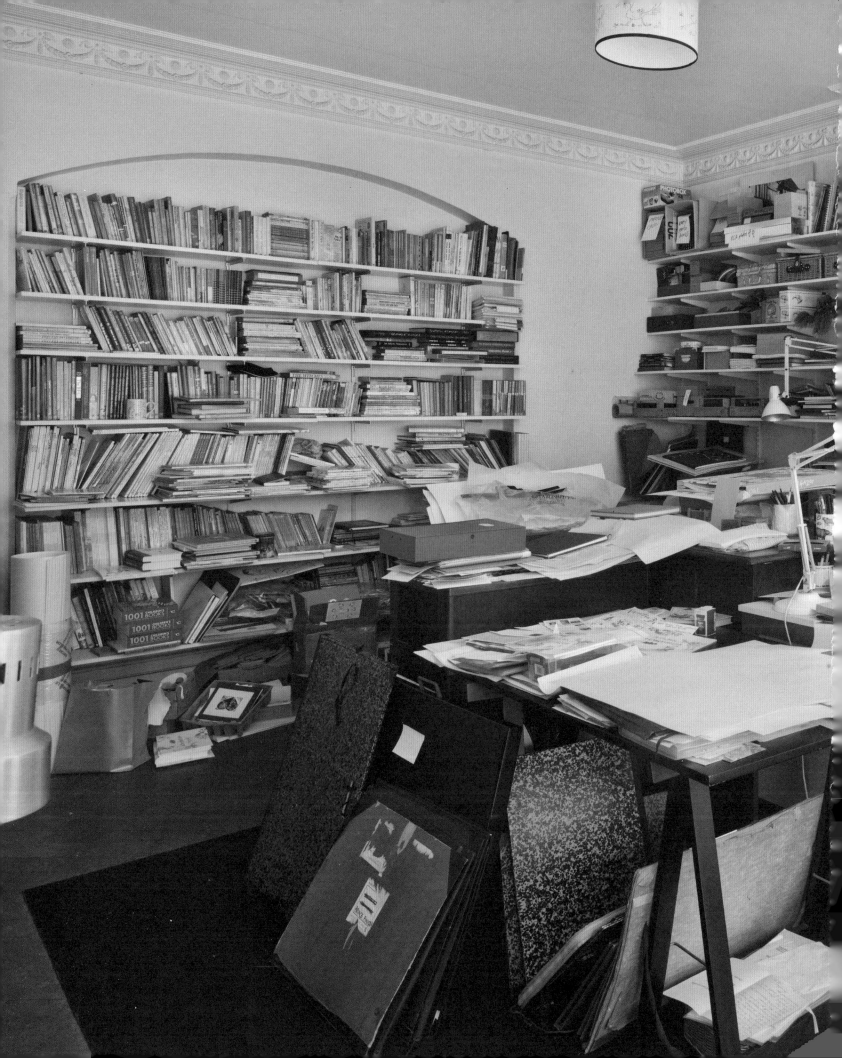